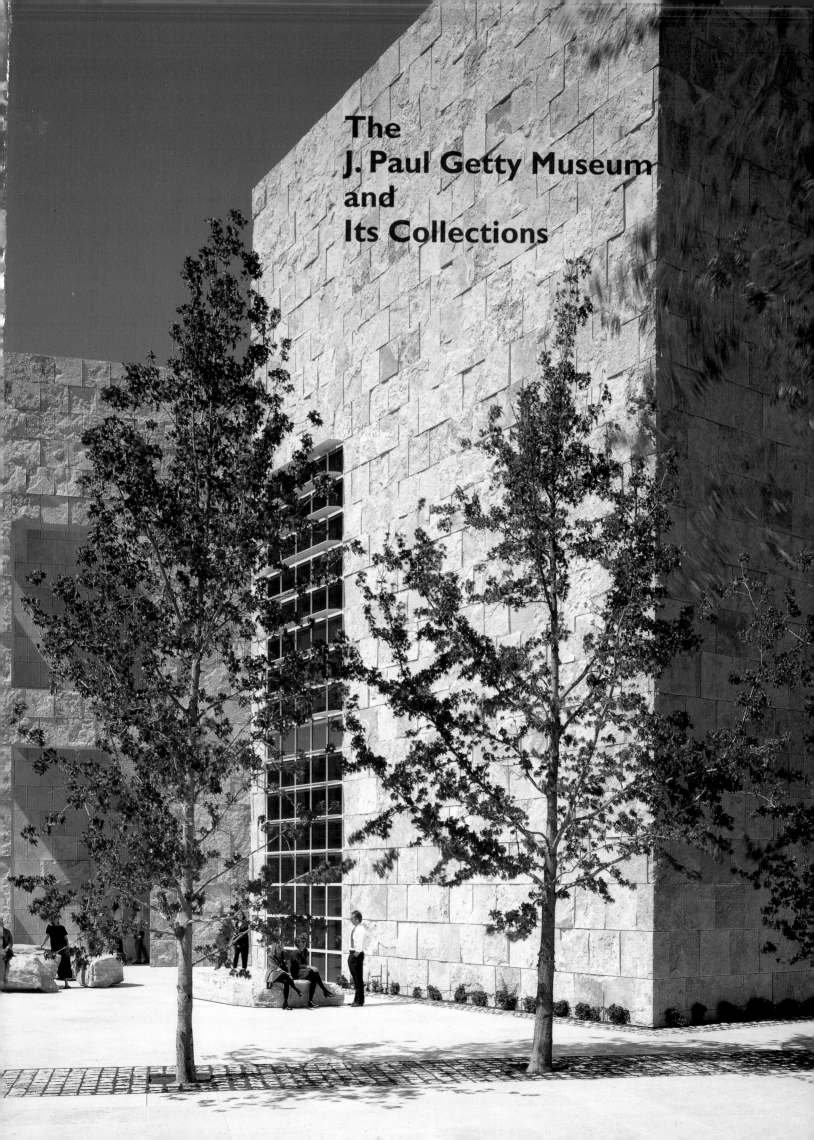

The
J. Paul Getty Museum
and
Its Collections

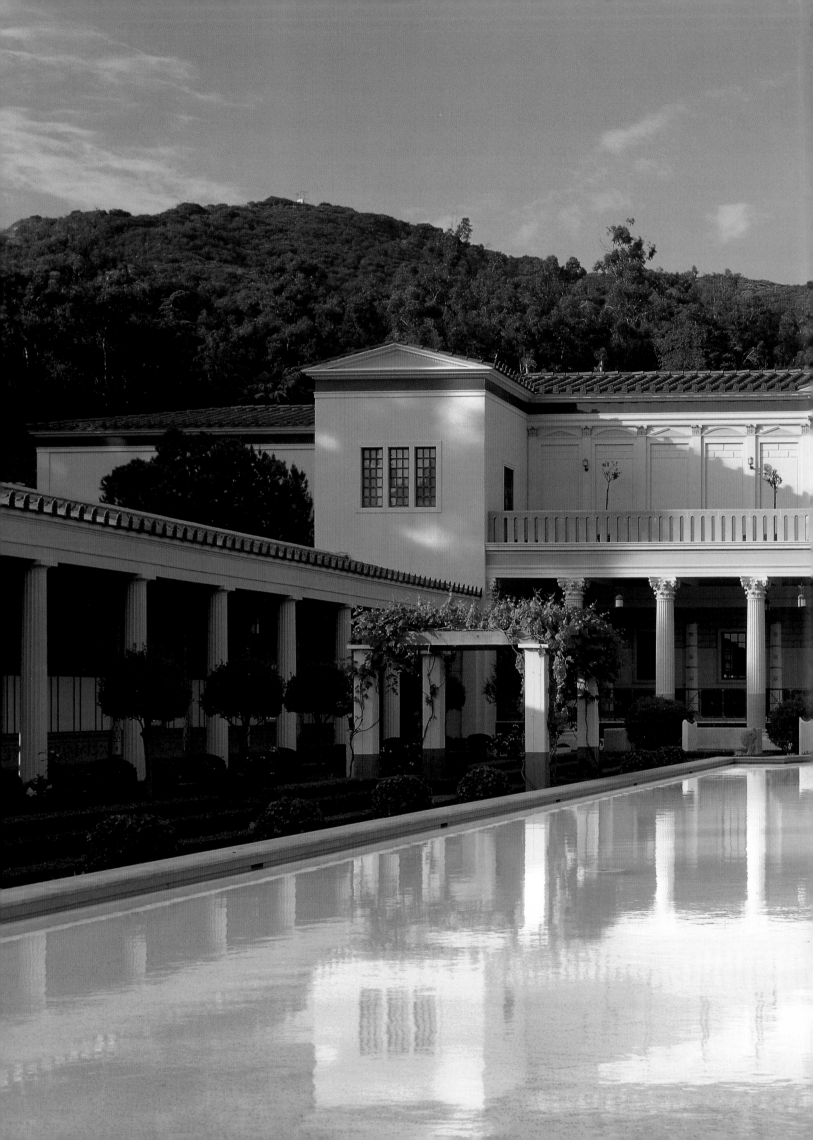

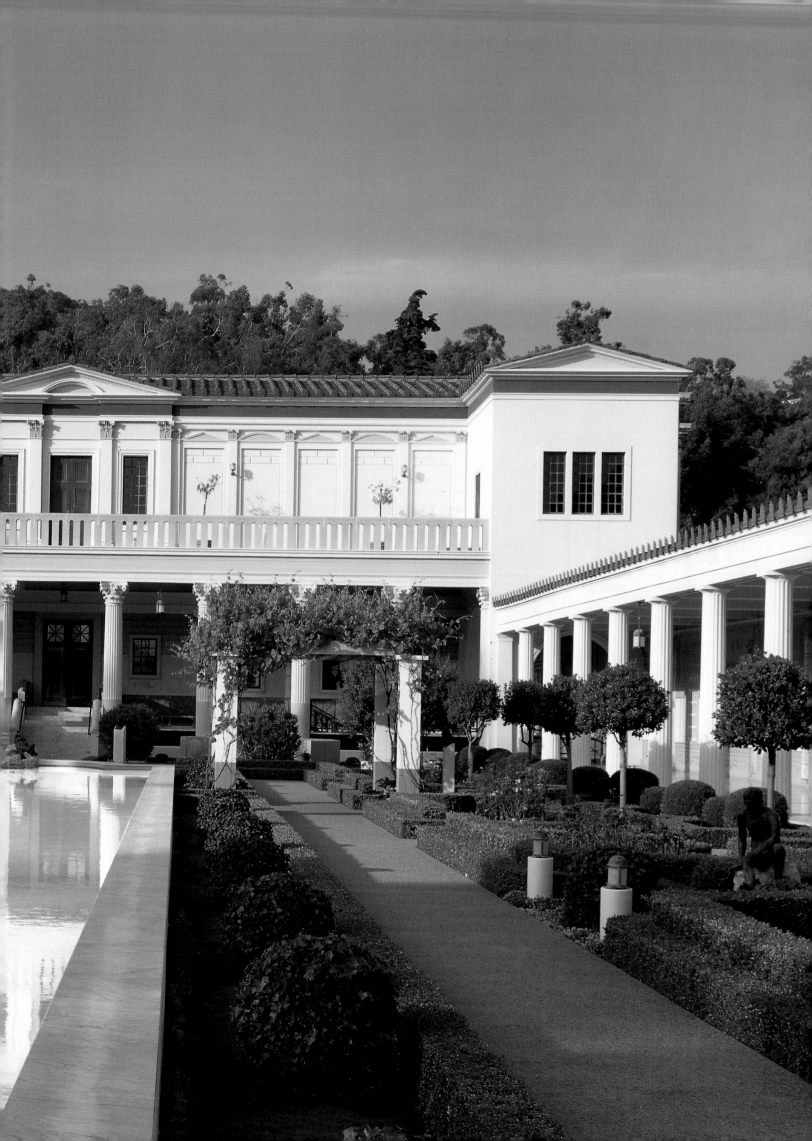

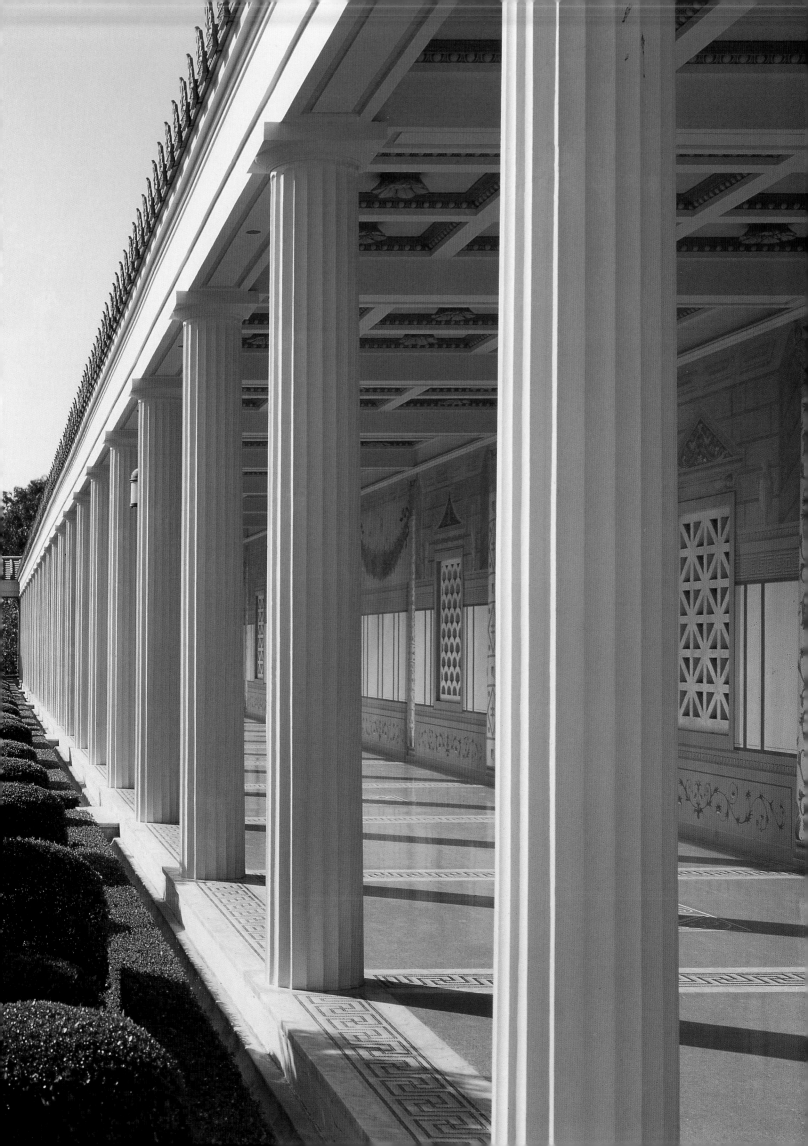

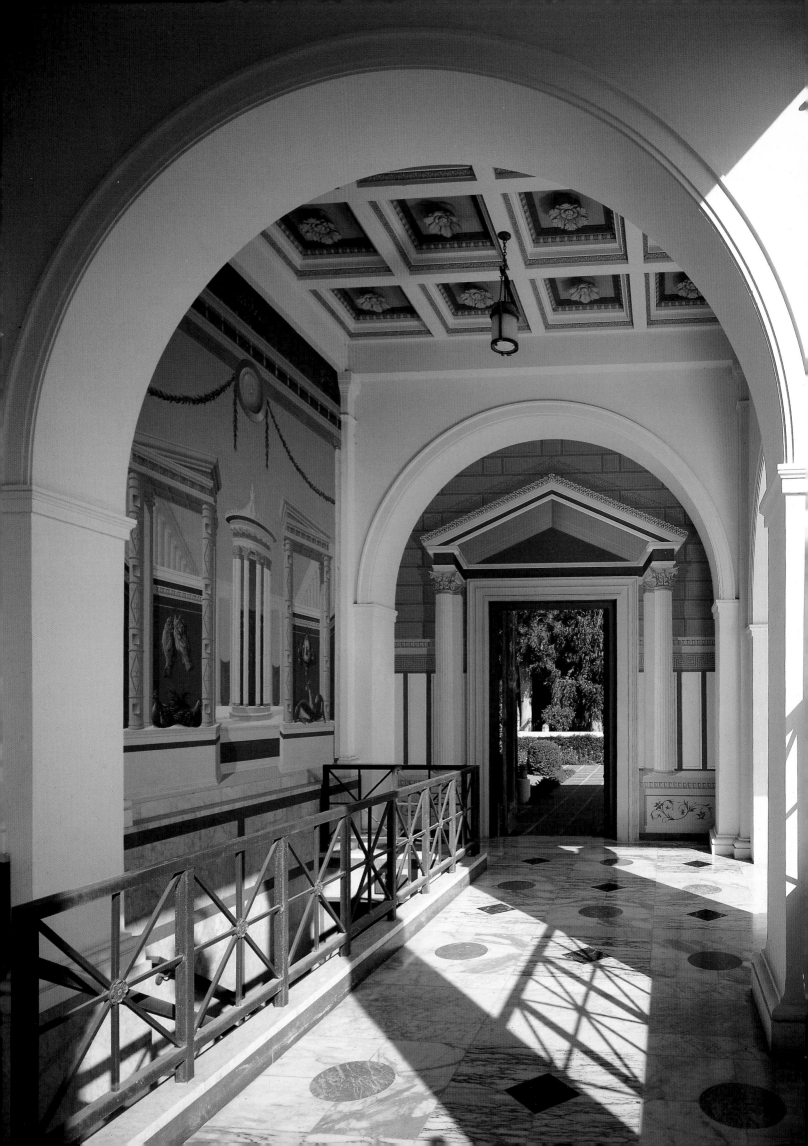

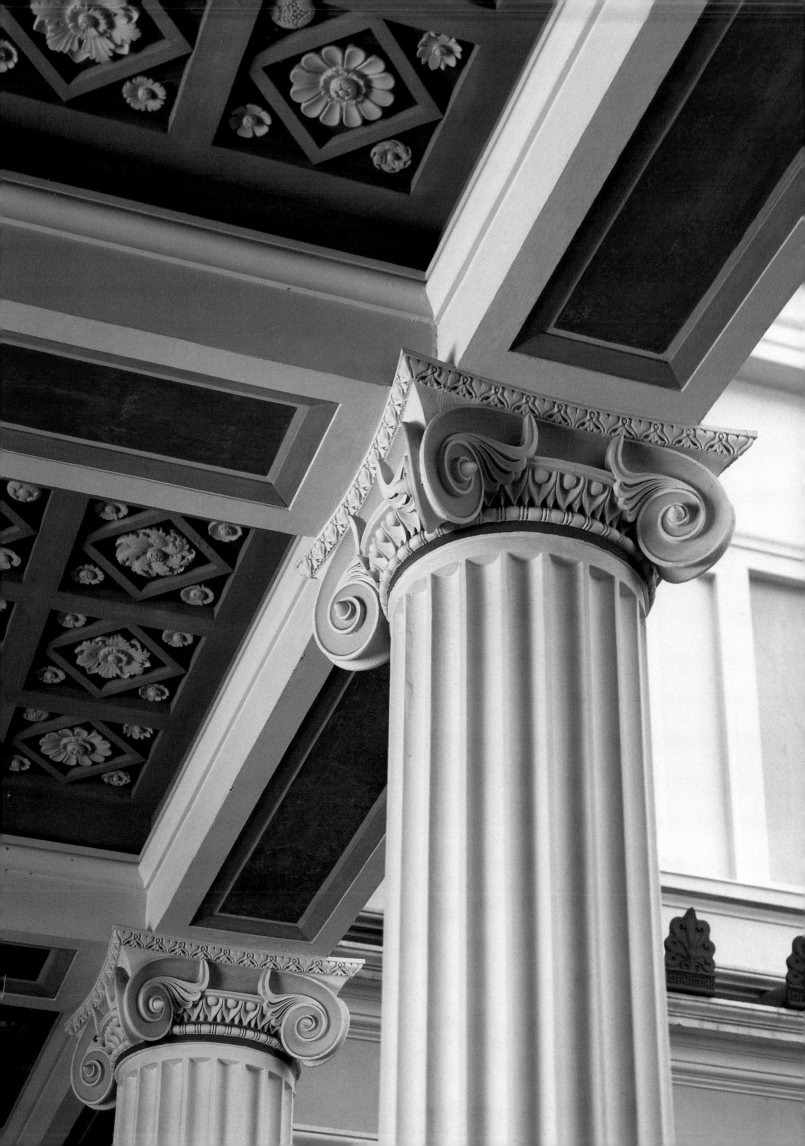

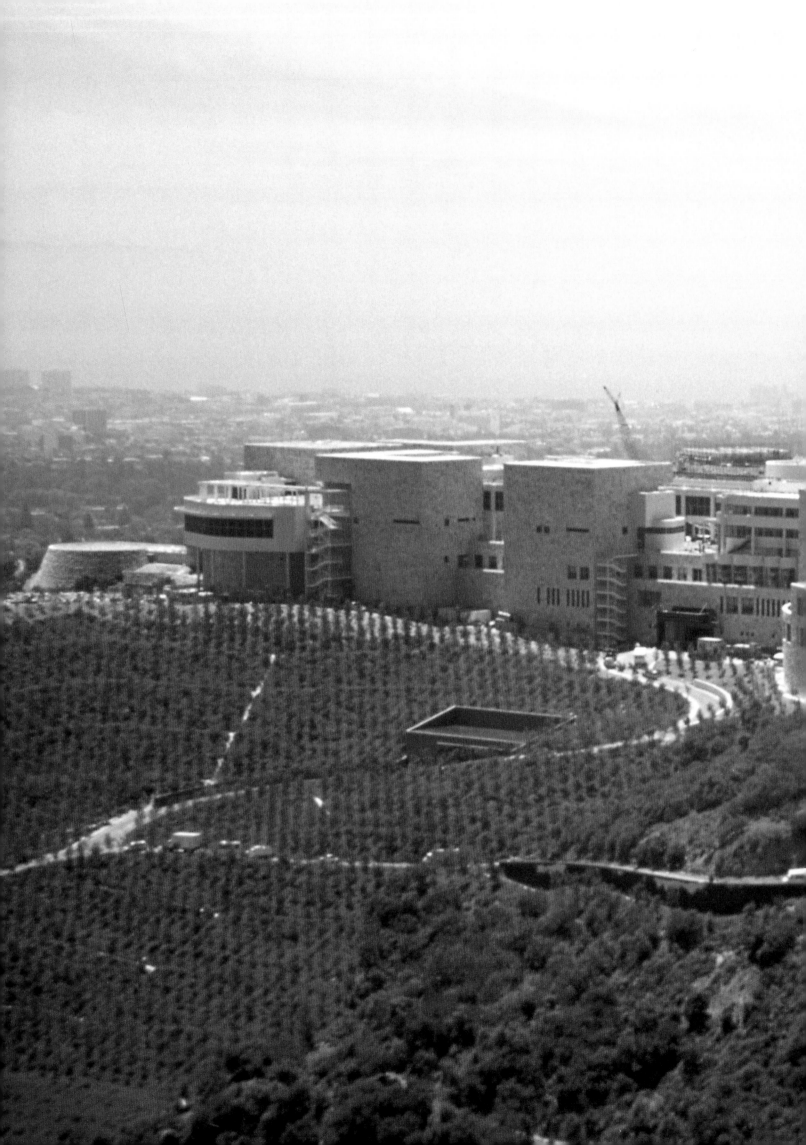

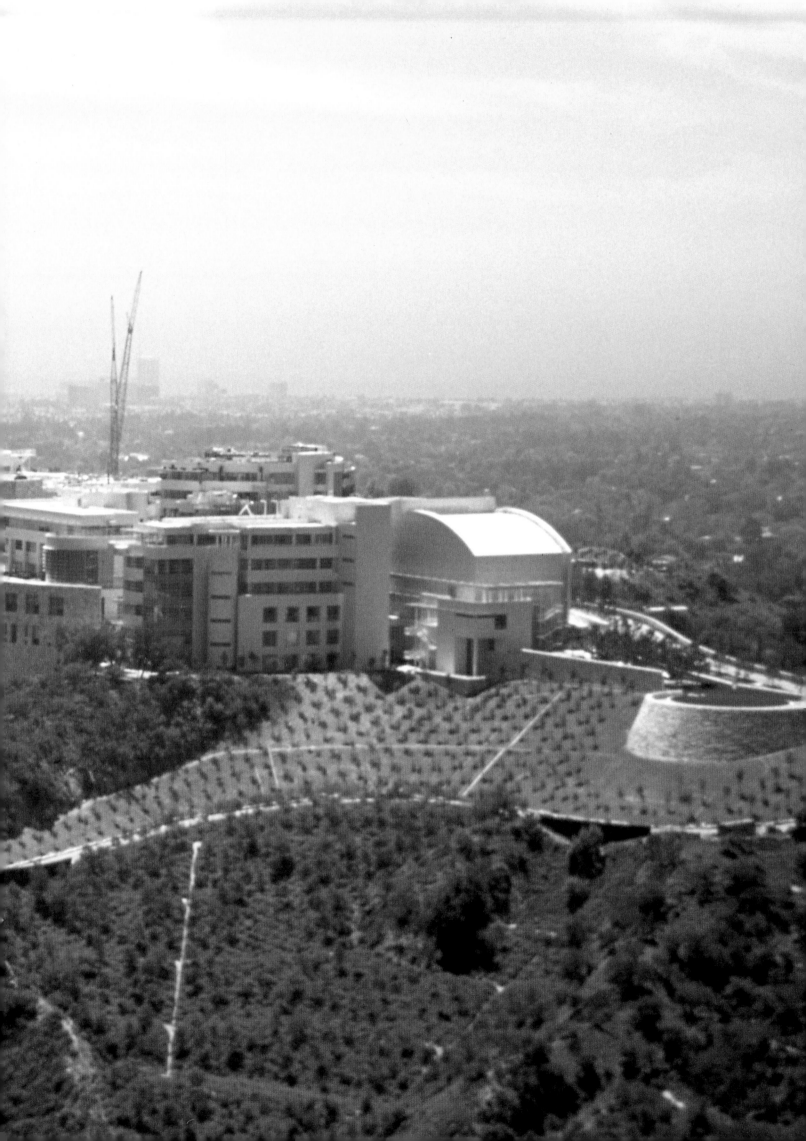

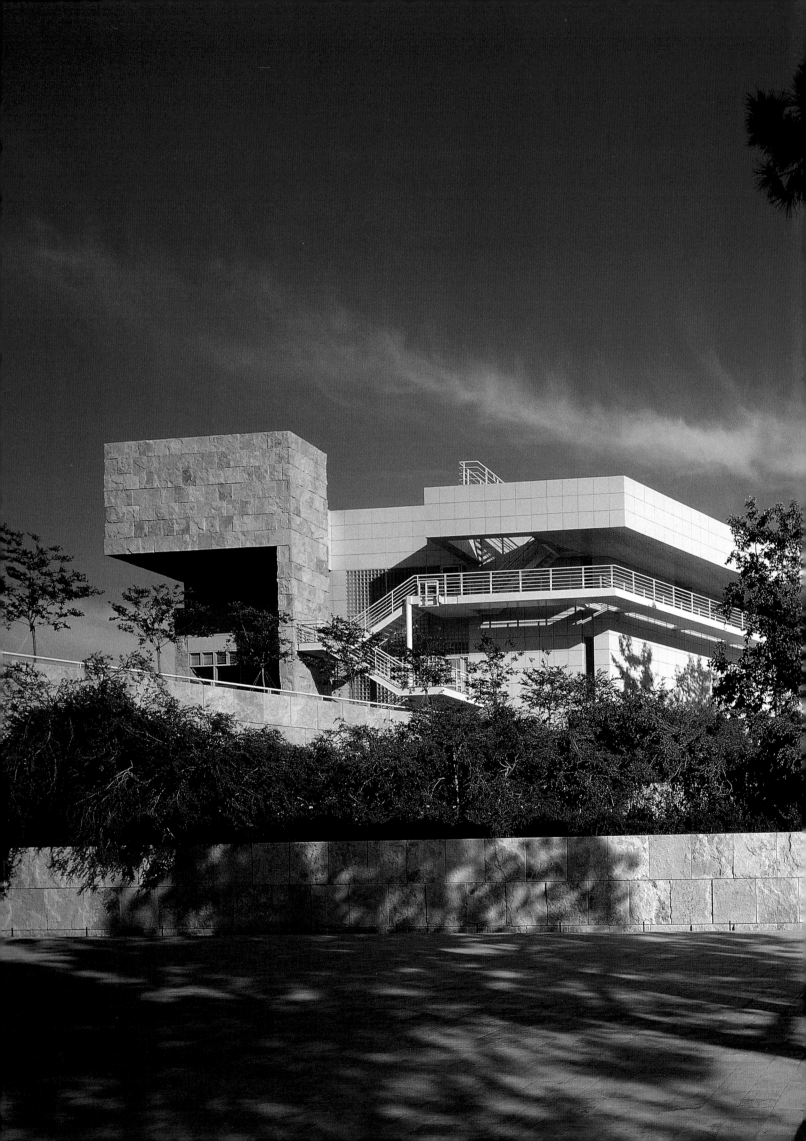

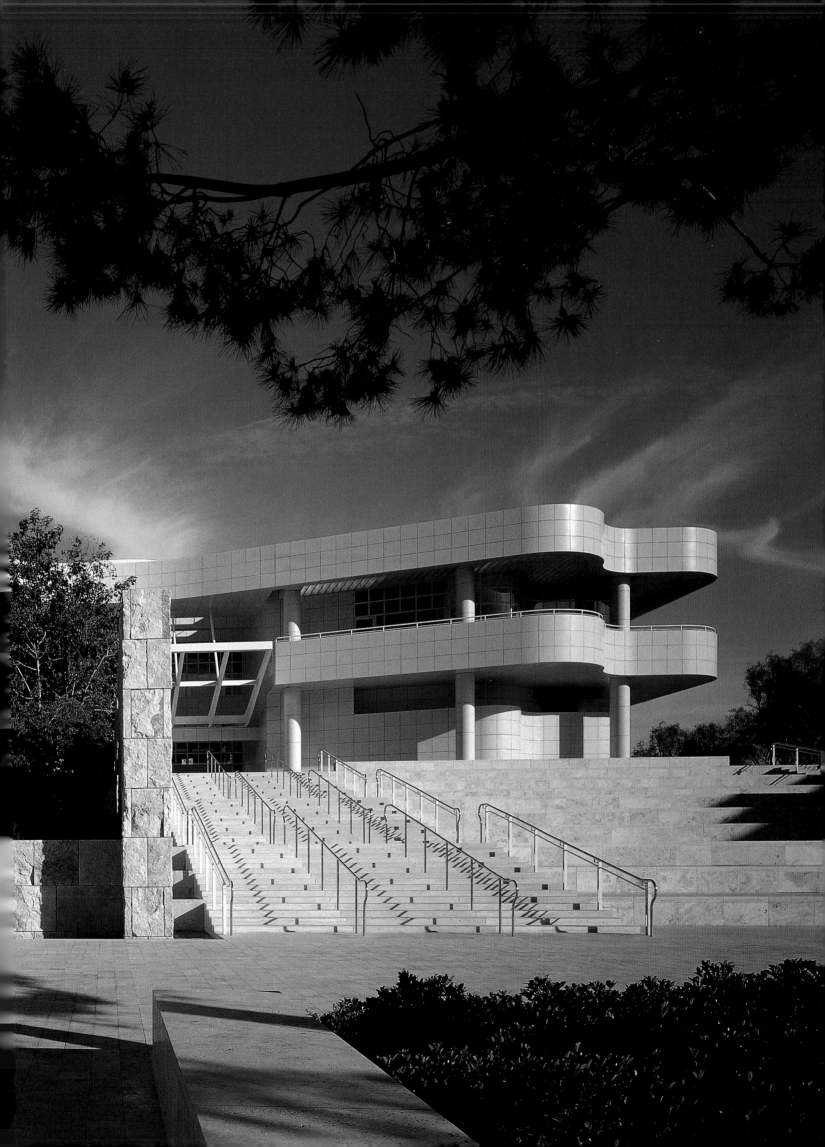

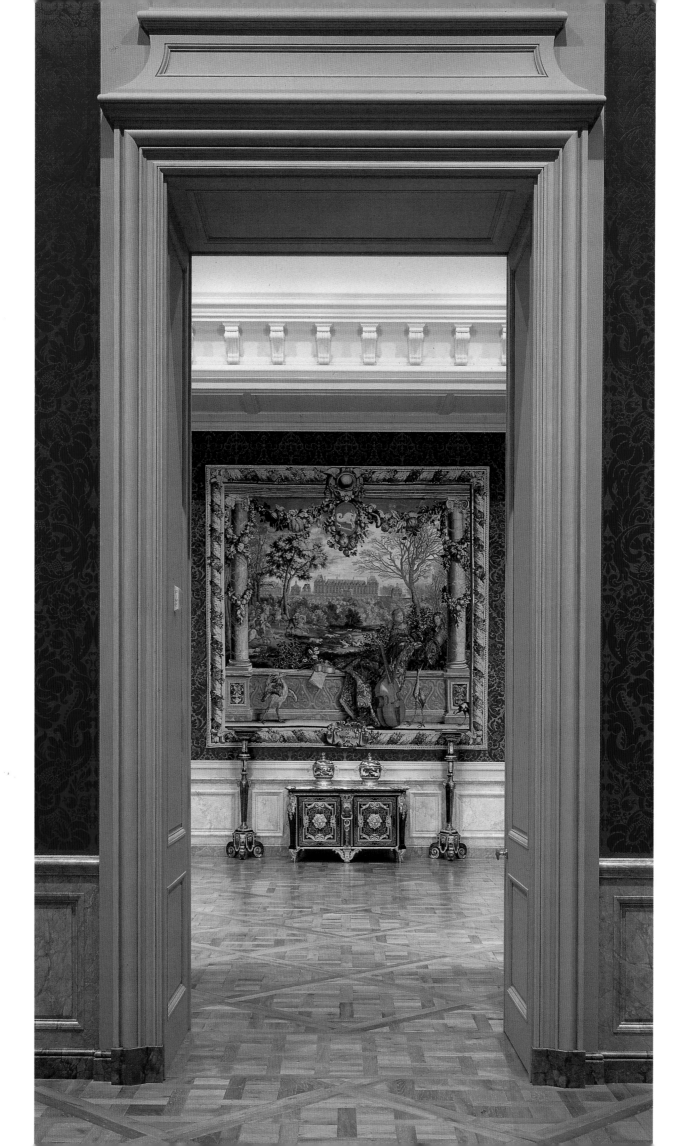

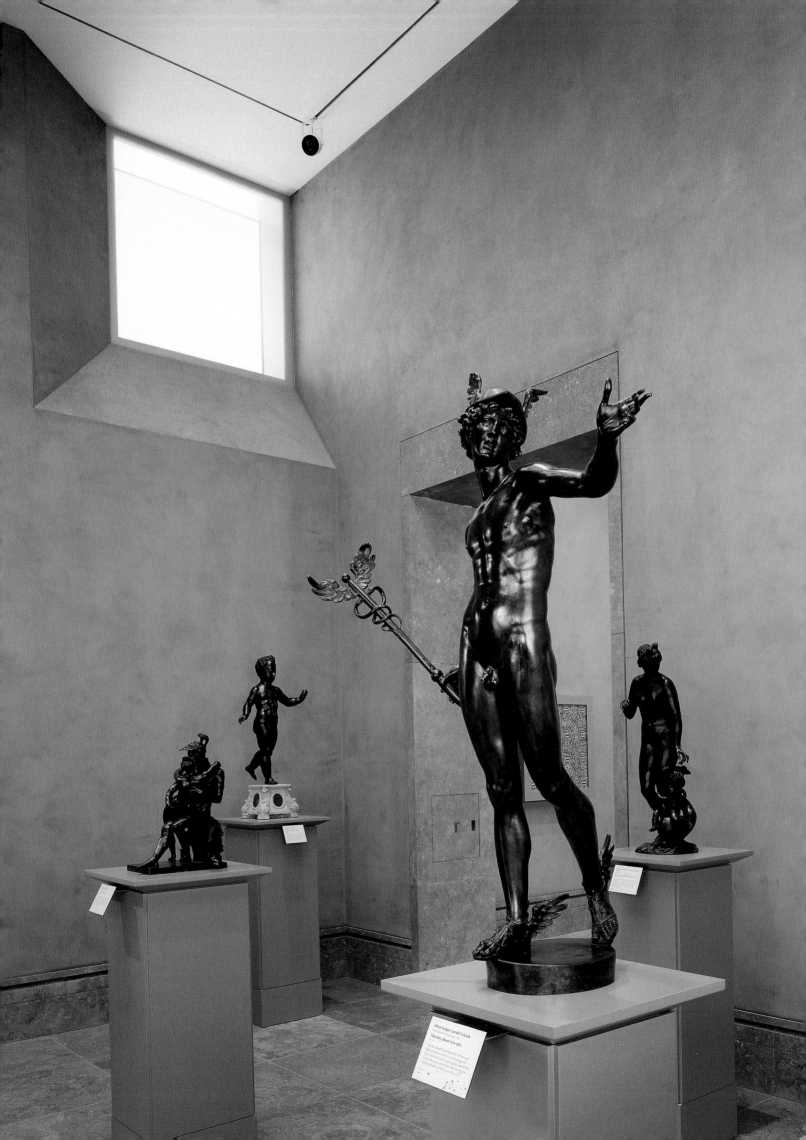

The
J. Paul Getty
Museum
and Its
Collections

A Museum
for the New Century

John Walsh

Deborah Gribbon

THE J. PAUL GETTY MUSEUM

LOS ANGELES

Christopher Hudson, Publisher
Mark Greenberg, Managing Editor
Katy Homans, Designer
Elizabeth Burke Kahn, Production Coordinator
Charles Passela, Ellen Rosenbery, Jack Ross, Louis Meluso, Photographers

Library of Congress Cataloging-in-Publication Data

J. Paul Getty Museum.
The J. Paul Getty Museum and its collections: A Museum for the new century /
John Walsh, Deborah Gribbon.
p. cm.
Includes index.
ISBN 0-89236-475-0. ISBN 0-89236-476-9
1. J. Paul Getty Museum. 2. Art—California—Malibu. 3. Getty, J. Paul (Jean
Paul), 1892–1976. I. Walsh, John, 1937– . II. Gribbon, Deborah Ann. III. Title.
N582.M25A86 1997
708.19439—dc21 97-12170
 CIP

on the front cover: A gallery for seventeenth-century paintings in the new
J. Paul Getty Museum. On the left is Anthony van Dyck's *Agostino Pallavicini*, on
the right, Jacob Jordaens's *Moses Striking Water from the Rock* and, through the
doors, Jan van de Cappelle's *Shipping in a Calm at Flushing*. The marble portrait
bust next to the Jordaens picture, of Jacob van Reygersberg, is by the Dutch
sculptor Rombout Verhulst.

on the back cover: The J. Paul Getty Museum in Malibu

page i: A courtyard outside the pavilion housing the decorative arts collection at
the new Getty Museum

At the Villa

pages ii–iii: The Outer Peristyle Garden looking toward the porch of the
Museum

pages iv–v: The colonnade along the north wall of the Outer Peristyle Garden
and the gardens laid out in the Roman style

page vi: A corner of the Outer Peristyle in the Villa in Malibu with illusionistic
mural paintings

page vii: Ionic capitals and coffered ceilings of the Inner Peristyle Garden

At the Getty Center

pages viii–ix: An aerial view of the Getty Center under construction, looking
west across the San Diego Freeway

pages x–xi: The new Getty Museum seen from the Tram Plaza

pages xii–xiii: The Upper South Terrace of the new Getty Museum

page xiv: The decorative arts galleries, looking from the tapestry gallery into the
room displaying furniture by André-Charles Boulle, the seventeenth-century
French cabinetmaker. Visible in the Boulle gallery is the tapestry *Le Mois de
Décembre, Le Château de Monceaux* from *Les Maisons Royales* series

page xv: The eighteenth-century Italian paintings gallery with Giovanni Battista
Pittoni's *Sacrifice of Polyxena*; through the doors is Thomas Gainsborough's
Anne, Countess of Chesterfield

frontispiece: The Renaissance bronze sculpture gallery, with Johan Gregor van
der Schardt's *Mercury* in the foreground

PRINTED IN ITALY

Contents

J. Paul Getty (1892–1976)

Foreword

Harold M. Williams

In my opinion, an individual without any love of the arts cannot be considered completely civilized. At the same time, it is extremely difficult, and sometimes impossible, to interest people in works of art unless they can see them and know something about them.

—J. Paul Getty, 1965

This book appears on the occasion of the opening of the Getty Center, which includes a new building for the J. Paul Getty Museum. The Museum is dedicated to the task Mr. Getty put in such modest terms: interesting people in works of art by letting them see them and know something about them. The Getty Center, of which the new Museum is part, has a broader purpose, however.

The J. Paul Getty Museum was established through the creation of a trust in 1953. A small private institution housing Mr. Getty's art collections, the Museum was located on his property overlooking the Pacific Ocean near Malibu. Its expenses were met from year to year by Mr. Getty himself. During the construction of the Malibu museum building in the early 1970s—a reconstructed Roman villa—he created an endowment for its operation and supplied funds from time to time to purchase works of art. (The trust was, and still is, a private operating foundation. As such, it operates its own programs and is required to spend 4¼% of its endowment in three out of four years.)

Mr. Getty's unexpectedly large bequest in 1976 permitted his trust not only to strengthen the Museum but also to envision more wide-ranging contributions to society through the visual arts than the Getty Museum alone could make. Beginning in 1981, a year before the proceeds of the estate were finally received by the trust, I was given the task of developing an overall plan for the most effective use of the resources. I was soon joined by two experienced colleagues, Leilani Lattin Duke and Nancy Englander. For a year we explored the issues facing the visual arts and consulted with hundreds of professionals in the United States and abroad. In 1982 we recommended to the trustees that commitments be made in three major areas of the visual arts and humanities in which the needs and opportunities appeared greatest: scholarship, conservation, and education. We went on to create five new programs to fulfill these commitments.

The Getty Research Institute for the History of Art and the Humanities is dedicated to innovative scholarship in the arts and provides a unique environment for research, critical inquiry, and debate. The Getty Conservation Institute works internationally to further the appreciation and preservation of the world's cultural heritage for the enrichment and use of future generations. The Getty Information Institute makes art-historical information more accessible through the application of advanced computer technology, collaboration on the setting of international standards, and the integration of art information into the communications systems of the future. And the Getty Education Institute for the Arts is dedicated to improving the quality, content, and status of arts education in the nation's schools through advocacy, professional development of teachers, demonstration programs, and the development of theory and curricula.

The Museum Management Institute had been created in 1979. It became part of the Getty in 1984 and is now the central activity of the Getty Leadership Institute for Museum Management. It provides museum professionals with training in the latest management theories and practices. The Getty Grant Program was created in 1984 to strengthen the fields in which the Getty is active by funding exceptional projects undertaken by individuals and organizations throughout the world. Appendix A gives brief descriptions of each of the Getty programs.

Over the years these programs have become recognized leaders in their fields. They have helped to establish priorities, advance important dialogue and debates, and make possible

crucial projects that might otherwise have gone unrealized. The results of these activities can be seen in sites and monuments that have been conserved around the world, in class-rooms and galleries all across the U.S., in new directions in scholarly research and a wide range of publications, and in diverse cultural and educational institutions around the greater Los Angeles area.

A distinctive characteristic of the Getty's work is intellectual exchange and collabora-tion among professionals in different fields. Much of what the Getty organizations under-take singly or in combination is interdisciplinary by nature, whether it is the study of the techniques of ancient bronze sculptures, the teaching of art to school children, an exhibi-tion of manuscripts from the seventeenth-century capital of Persia, or the organization of a film series on the image of the city. When several Getty programs combine their efforts, the result can be unusually rich and innovative. Now that all the Los Angeles operations of the Getty have been brought together at the Getty Center, the potential for achievement increases greatly. In a few years the much-loved Villa will re-open, renovated to serve a broader purpose as a collaborative center for comparative archaeology and cultures, in-cluding the Museum antiquities collection. The Museum, the Research Institute, and the Conservation Institute will collaborate closely in this expanded mission.

The Museum's growth since 1981 has required a major commitment of resources and a good deal of discussion about the sort of experience we wanted to be able to offer visi-tors. It is a source of particular satisfaction—to the staff, to the trustees, and to me—that the institution described in these pages is one where the public can encounter extraordi-nary works of art in a setting that is inviting and that allows individuals to make their own discoveries. The Museum's dedicated staff has broadened and strengthened the collection almost beyond recognition. They have increased its exhibitions and educational activity, reached out to a much broader audience, and planned for a future of even more extensive and imaginative service to the public. I am grateful to that staff and pleased that this book will make its achievements better known.

J. Paul Getty's personal fortune provided the financial resources to create the multi-faceted institution that bears his name. But his legacy also resides in the ambitious pur-pose he bestowed on that institution—"the diffusion of artistic and general knowledge," in the words of Mr. Getty's indenture. In all that we do, at the J. Paul Getty Museum and through the Getty institutes and Grant Program, our goal is to fulfill that purpose.

Introduction

At the Getty Museum, one era has followed another very quickly.

During the Ranch House era, from 1954 to 1974, the Getty Museum was a small, pleasant, private place with a deservedly modest reputation. During the Villa era, from the opening of its new building in 1974 until the early 1980s, the Museum was better known for its Roman imperial architecture than its art collection, although attendance increased dramatically and the collection became stronger. During the Getty Trust era, from about 1982 to the present, J. Paul Getty's immensely generous bequest allowed the Museum to build its collection, improve its public services, and broaden its audience. As we write, yet another era is beginning—call it the Getty Center era—with another museum in a new location. Bigger than the first, better equipped, closer to the population of the city, and drawing three times the former attendance, it forms part of an interdisciplinary complex with an exciting future.

We were given the chance to think about what one "museum for the new century" might be and to go about creating it. The result is a new museum devoted equally to the traditional (well-displayed collections, exhibitions, scholarly publications) and the forward-looking (a strong commitment to education, a broadened audience, a setting designed for visitors' comfort and pleasure). At the same time we are busy planning for the next era beginning in 2001, when we will reopen a branch at the Malibu site.

This book offers a brief history of the life of J. Paul Getty, his art collecting, and the museum he founded. It traces the growth of the Getty Museum, touches on the activities undertaken in the past fifteen years by the Getty Trust, and describes the new museum buildings at the Getty Center and the Getty Villa of the future. Finally, we portray the art collections, which are now so different from those of the early eras.

The Museum we inherited in 1983 had been well run by the previous director, Stephen Garrett, and his deputy, Stephen Rountree, who was our colleague at the Museum for a time before turning his skilled hand to directing the Trust's operations. We are thankful for the example they set, and for the work of Otto Wittmann, the distinguished retired museum director and Getty trustee, who at the time was serving as interim chief curator and who continued to oversee the growth of the collection as chairman of the acquisitions committee. He was succeeded ably in the latter job by Herbert L. Lucas, Jr. The late Franklin D. Murphy, a trustee of unequaled energy and persuasiveness, was especially influential in setting the policies of the Museum and shaping the Trust's mission.

Our greatest debt, however, is to Harold M. Williams, president and chief executive officer of the J. Paul Getty Trust since 1981, who has encouraged us steadily during our time here. He and the entire board have given us a remarkable measure of trust in operating the Museum and making acquisitions, for which we remain grateful.

We have had gifted architects to create a new Getty Museum and to renovate the old one. Richard Meier, aided by his chief partner, Michael Palladino, has been a close collaborator with us during the past dozen years, and has attended thoughtfully to our program in the process of designing beautiful buildings to accommodate it; in the Meier office, Nils Finne, Thomas Graul, James Crawford, Richard Irving, Christine Killian, and Michael Gruber were especially important for the Museum's part of the project. Thierry Despont devoted his broad knowledge of eighteenth-century practice to the design of the decorative arts galleries, greatly aided by John Robbins and Luis Gonzalez, and by Larry Tobiason in the actual execution; Despont also applied his sure taste to the finishes of the other galleries in association with the Meier office. The plantings in the courtyard and elsewhere in and around the Museum were designed by the most attentive and agreeable of collaborators, Laurie Olin of Hanna/Olin. We are also grateful on behalf of our visitors to

the artist Robert Irwin for the central garden, which is both a welcoming landscape and a joyous work of art.

The Getty Center was built with inspiring devotion by the Dinwiddie Construction Company (which also built the present Museum in Malibu). In the front line for Dinwiddie were Gregory Cosko, Peter Mills, Ronald Bejac, James Hearn, Jerry Washington, and Duane Kinney. The renovation of the Villa in Malibu was designed by Jorge Silvetti and Rodolfo Machado and their office, in particular Tim Love, Peter Lofgren, Conrad Ello, and Mimi Love. Working in association with Richard Sholl of Langdon and Wilson (the original architects of the Malibu Museum), they have created an intelligent, sensitive plan. As head of the building program at the Trust, Stephen Rountree has been a capable overseer and knowledgeable advocate for the Museum; Curtis Williams has been a stalwart colleague; and Barbara Chiavelli has been the faithful daily representative of our interests to architects and contractors alike. Quincy Houghton and Ellen Wirth of the Museum staff were indispensable in ensuring that our part of the Getty Center project ran smoothly.

The creators and shapers of the collections surveyed in this book have been the Museum's curators, past and current: of decorative arts, Gillian Wilson; of paintings, Burton Fredericksen, Myron Laskin, George Goldner, and David Jaffé; of antiquities, Jiří Frel and Marion True; of manuscripts, Thomas Kren; of drawings, George Goldner and Nicholas Turner; of sculpture, Peter Fusco; and of photographs, Weston Naef. They were aided by the head conservators and their staffs: of sculpture and decorative arts, Barbara Roberts and Brian Considine; of paintings, Andrea Rothe; of antiquities, Zdravko Barov and Jerry Podany; of drawings, Nancy Yocco; of manuscripts, Nancy Turner; and of photographs, Marc Harnly. Three key staff members generally have been behind every curatorial project in our time at the Getty: Sally Hibbard, registrar; Charles Passela, head of photographic services (and supplier of photographs for this book); and Bruce Metro, head of preparation. To all these we owe more thanks than we can express.

Supervising the reshaping and invigorating of the Museum's educational activities was the task of Bret Waller in his productive time in the 1980s as associate director, with David Ebitz, and later Diane Brigham, as department head. As head of the Museum's Public Information Department, Lori Starr, now the Trust's director of public affairs, made the Museum far better understood and helped to draw in a broader audience, first under Bret Waller, then under Barbara Whitney; she has been succeeded by Sue Runyard.

The plans for the future of the Villa have been overseen with remarkable wisdom and energy by Marion True, now assistant director in charge of that project as well as curator of antiquities.

During our entire time at the Getty Museum, Barbara Whitney, associate director for administration and public affairs, has made sure that our audiences were well served, the Museum was efficiently run, and architectural projects were smoothly accomplished. Her devotion and optimism have seldom failed to inspire us all.

Finally, we are grateful to Mike Bryan for the indispensable help he gave us in drafting part of the text of this book; to Mark Greenberg for taking on more work than is usually an editor's lot; to Frances Biral for editorial help and for supplying Appendix II; to Bill Hackman of Trust Public Affairs; to Katy Homans for a deft and handsome design; to Stephen Garrett and Stephen Rountree for giving the manuscript their close attention; to Christopher Hudson; to the Trust Publications Services office, Elizabeth Burke Kahn in particular; and to Guy Wheatley and Amy Fisk.

—*J.W. & D.G.*

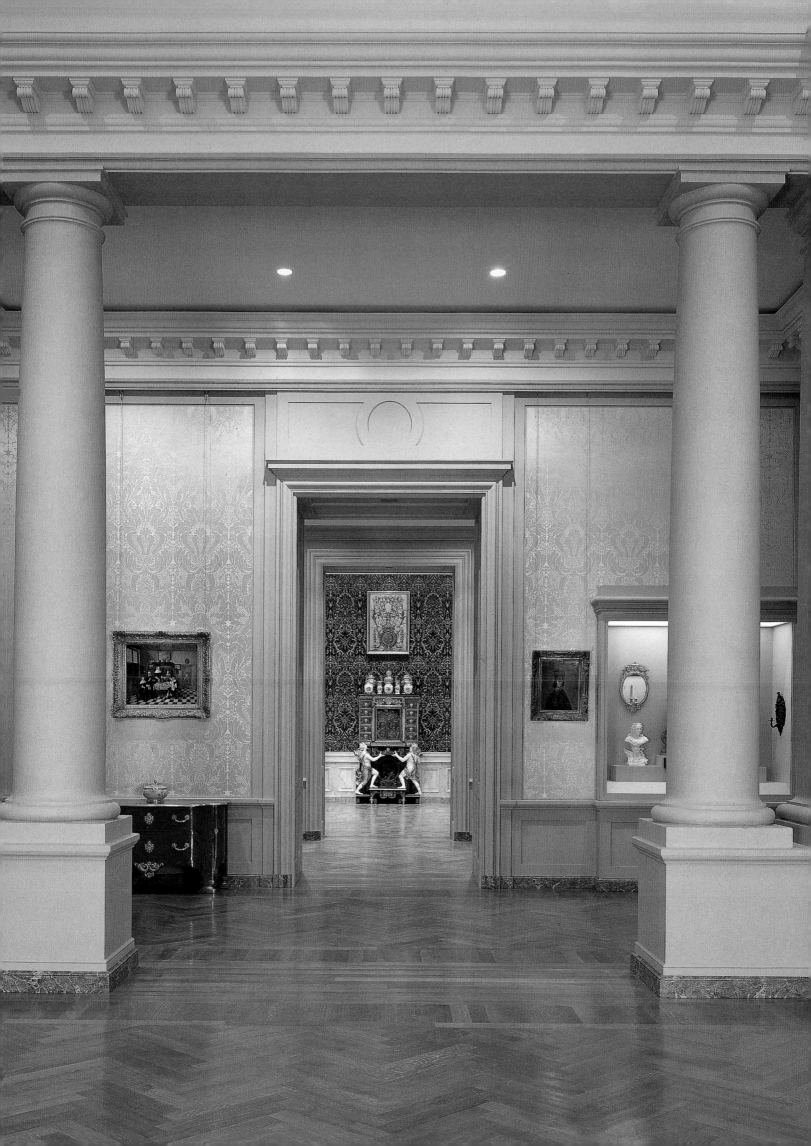

I.

Getty's Career and Fortune

The year 1903 turned out to be a good one for modest beginnings:
the Wright brothers finally got their airplane off the ground at Kitty Hawk, Henry Ford
founded a small company in Detroit, and George Getty, a lawyer and insurance executive
from Minneapolis, journeyed on behalf of a client to the Oklahoma Territory, where he
acquired a new vocation.

A decade later, on the eve of World War I, Getty was a wealthy oilman when he and
his wife, Sarah, sailed to Europe to join their only son, Paul. Born in Minneapolis in
1892, Paul had just completed a year-long tour of the Continent after receiving a diploma
from Oxford in 1913. Relations between the two men were not always good. A conscien-
tious family man and Christian Scientist, George Getty believed that wealth should be
put to work for the benefit of all, and he felt that his son should now get to work in the
family business. But, as Paul himself later acknowledged, he had been something of a
playboy. Before transferring to Oxford, he had accomplished little during two years at the
University of Southern California and then the University of California, Berkeley. On his
earlier trips across the Channel and on a two-month tour of the Far East, he had pestered
his father with demands for money and received admonitions, as well as the money, in
reply. Now Paul Getty had notions of trading on his studies in economics and political
science and becoming a writer or perhaps a diplomat; at any rate, he had no ambition to
become a wildcatter.

The guns of August, 1914, interrupted the Gettys' holiday. The family returned to
the United States aboard the *Lusitania*, and Paul impulsively applied for service in the Air
Corps or the Coast Artillery. What actually happened here is uncertain, but he was not
called for service and assented instead to his father's wish that he join the family business,
with one stipulation: he would commit for only one year in the oil fields; George Getty
agreed that if the partnership did not work out, his son could depart in good favor.

With a stake of $100 a month for expenses, with money available for the purchase
of new leases, and with a written understanding that 70 percent of all profits from new
strikes would go to his father, Paul Getty set up shop in Tulsa in the fall of 1914 at the age
of twenty-one. He drove old cars and paid $12 weekly for room and board. For all his
European polish and English education, oil fields were not new to him, nor was this a
quixotic adventure. He had worked in them in various capacities during his summer
vacations and knew what he was doing—or at least believed that he did. One of the more
bitter disagreements between him and his father during his Oxford years had concerned
Paul's unsolicited advice from afar about how George Getty should run the business.

In the fall of 1915, with his one-year commitment about to run out, Paul paid $500
for a half-interest in a lease on 160 acres near Stone Bluff, Oklahoma. He relates in
his two autobiographies how he obtained this excellent price thanks to a stratagem
developed with the help of a local banker. The oil well came in. Less than two years later
he announced that he had made his first million, but it was not clear whether this was
money in hand or on paper. Either way, there was no doubt that the son had his father's
nerve and Midas's touch in this risky line of work.

Newly wealthy on his own account at the age of twenty-four, Paul returned in June,
1916, to Los Angeles, where his parents had moved in 1906 for the sake of his mother's
health. He declared his intention to enjoy an extended vacation while driving a "spanking
new Cadillac roadster," and he threatened to retire; but at some point he realized that as
much as he enjoyed the extended holiday, he enjoyed working and making money even
more. He must also have understood that he was in the right industry at the right time.
World War I finally ended, the price of oil rose dramatically, and Henry Ford's automo-
biles guaranteed growing demand.

Getty's interest in antiquities was not just intellectual; he visited many of the important classical sites, including Gerasa (Jerash) in Jordan in the early 1950s.

[Top] J. Paul's parents, Sarah and George, and [bottom], the family together in front of their large Tudor-style house on Kingsley Drive in Los Angeles in 1908.

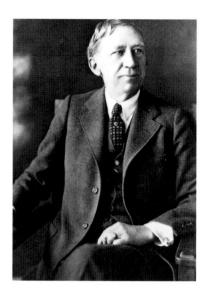

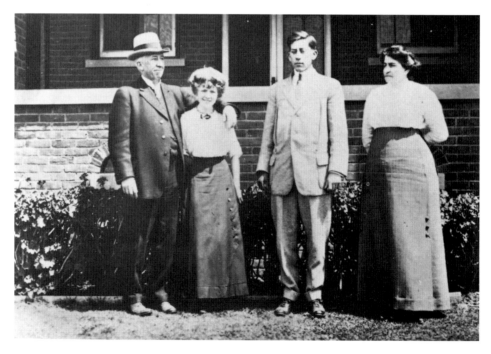

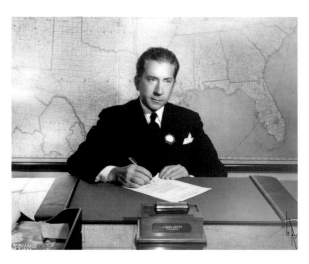

Getty as a small boy, a well-traveled playboy (on his way to the Olympic Games in Amsterdam in 1927) and later, as a businessman who kept company with world leaders, such as Richard Nixon, pictured in the lower left, and with the tame and not-so-tame animals he kept on his estates at Malibu and Sutton Place.

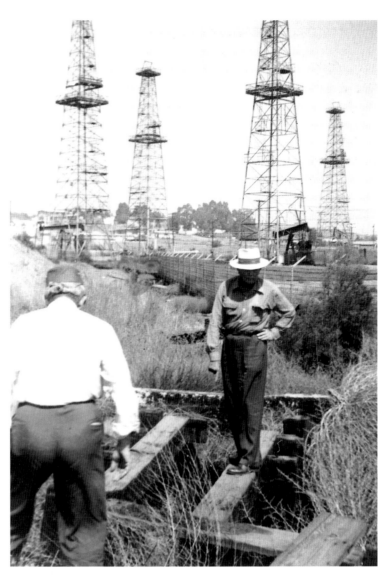

Oil, the source of Getty's wealth, came first from Oklahoma: one of his first oil wells is pictured at left and, at right, the oil fields that grew from those first gushers.

After a break of more than a year, Paul Getty went back to work in the oil fields of Oklahoma and Southern California. In 1921, he convinced his father to take a stake in the Nordstrom lease in Santa Fe Springs, in the Los Angeles basin. George Getty soon shifted the focus of his company's attention to this region. Paul worked for the company and conducted his own drilling on the side. By the time of the stock market crash in 1929 and George Getty's death the following year, the family fortune was secure even in the face of the worldwide financial crisis.

George Getty left a controlling interest in his business affairs to his wife, Sarah. To his son he left $500,000, minus a sizable personal debt Paul owed him. He did not designate Paul as executor of the estate, a decision that surprised Getty—and, according to some associates, wounded him. It did not stop him. Throughout the thirties, Getty and his mother were antagonists as well as partners when it came to business. He spent a great deal of energy and money battling many rivals for control of Getty Oil, and eventually he won.

At a time when stocks sold for pennies on the dollar, Getty perceived that buying the oil of other companies in the form of depressed shares of stock was cheaper than drilling for his own. This contrarian strategy paid off handsomely. In 1934, Getty built a house next to William Randolph Hearst's on the beach in Santa Monica and took up surfing with a custom-built board. On New Year's Eve that year, he was a guest at San Simeon, Hearst's great estate 235 miles north of Los Angeles. Getty was impressed with his host's ability to

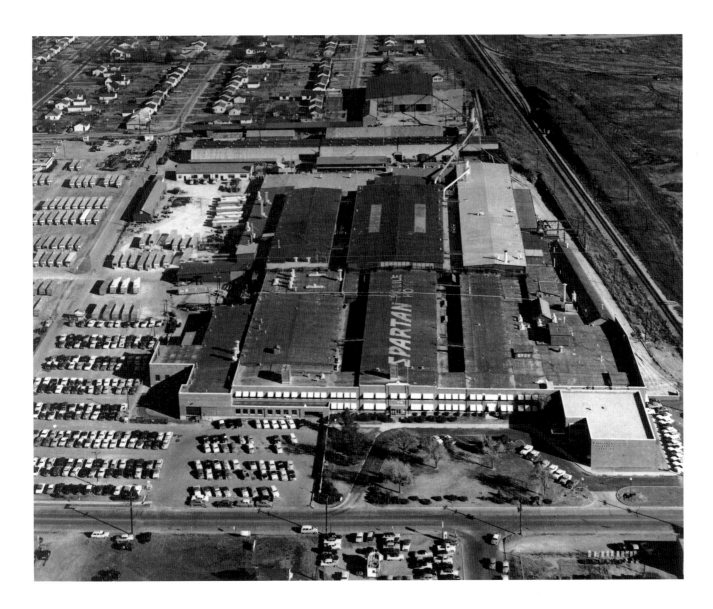

During World War II, Spartan Aircraft in Tulsa, controlled by Getty, was an important supplier of airplane parts. Later, in peacetime, it was converted to the successful production of mobile homes.

buy an incredible variety of things without seeming to give a thought to the cost of any of them. He must have been struck by Hearst's baronial style of life. Hearst had built an architectural fantasy of huge proportions, created a private zoo, and held land as far as the eye could see. The seeds for the Getty Ranch in Malibu and for Sutton Place, his estate-to-be in England, were planted.

On December 7, 1941, the day the Japanese bombed Pearl Harbor, Getty cabled Under Secretary of the Navy James Forrestal: "I am forty-nine but in good health, have owned three yachts and am experienced in their care and maintenance. If [the] Navy can use me in any capacity, please advise. Regards. Paul Getty." In lieu of military service, Getty was asked to convert the assembly lines at the Spartan Aircraft plant in Tulsa to wartime purposes. Spartan was owned by Skelly Oil, which was controlled in turn by Mission Corporation, a holding company that Getty had acquired during his all-out battle for Getty Oil. Getty moved to Tulsa and for four years supervised the production of ailerons, rudders, elevators, wings, and cowlings for an assortment of Allied aircraft. After the war, he and his staff converted the plant to the production of a new design of house trailer built of aluminum. This peacetime venture was an immediate success, and so were the companies created to finance the purchase of these trailers and insure the owners from loss.

The Getty oil companies also performed well throughout the war, providing the capital for Getty to buy one-half of an expensive lease on a 50-square-mile plot of the Middle

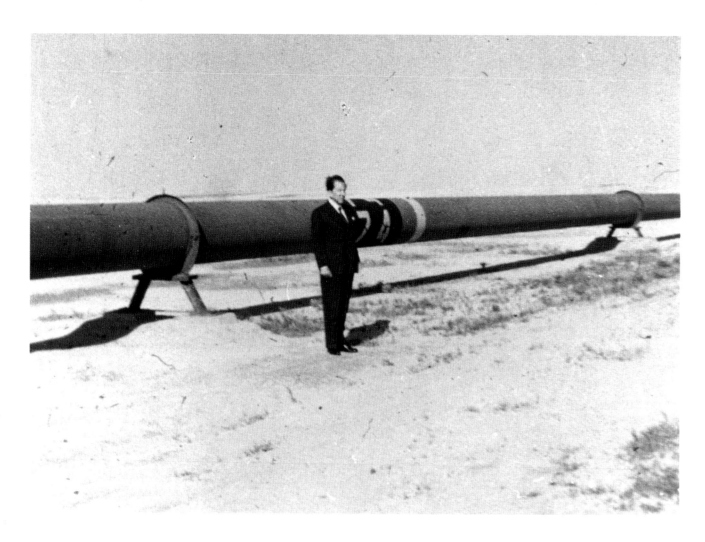

After the war, Getty gambled on finding oil in the Saudi-Kuwaiti "Neutral Zone." The expensive long shot paid off, making Getty one of the world's richest men. [Top] Getty poses next to a desert pipeline; [bottom] he is pictured visiting the Saudi sheiks with whom he negotiated the Neutral Zone purchase.

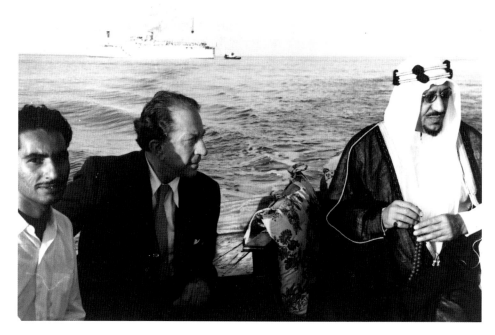

Getty's eldest son, George, manager of the Getty Middle Eastern operations, is pictured here with his father.

East known as the Neutral Zone. Saudi Arabia and the emirate of Kuwait shared control of the mineral rights to the land. Kuwait had already sold its one-half share to an American consortium, and Getty, realizing that any serious player in the world oil market needed a foothold in the Middle East, acquired the Saudis' share, but at the high price of $9.5 million and an exorbitant royalty of 55 cents per barrel—more than twice the going rate at a time when oil sold for $2.00 a barrel. This play in the Neutral Zone was the biggest gamble of this gambler's career, but Getty was confident that there was oil beneath the sand and that its price would not stay $2.00 for long. He was right on both counts, but it took almost four years to find the oil.

Despite the publicity generated by his venture, Getty never set foot in the Neutral Zone during this period. Some biographers give much of the credit for his eventual success there to his first son, George F. Getty II, who was running that branch of the family business; others credit a frustrated J. Paul Getty with the pivotal decision to change drilling procedures. His crews finally found oil in 1953, and the enormous profits funded his move into other oil fields around the world. He was now an extremely wealthy man.

Great wealth was bound to bring celebrity. In Getty's case, the assault on his privacy began in earnest with his designation by *Fortune* in November, 1957, as the wealthiest living American. According to the magazine, this "California expatriate now living in Paris" was worth between $700 million and $1 billion. (The magazine's list of America's Biggest Fortunes didn't actually rank the contenders, but since Getty placed himself in the top category, the conclusion was easy to draw.) An oilman who had been previously unknown to the outside world was soon receiving hundreds of letters a week dunning him for help. In the following years, Getty's sometimes tumultuous and tragic private life would feed both the respectable press and the budding tabloids on both sides of the Atlantic: five marriages and five divorces; five sons, one of whom died as a boy, one of whom (George) died under circumstances that suggested suicide; and, most sensationally, the kidnapping of his grandson, J. Paul Getty III, in Italy in 1973 and the belated $3.2 million ransom payment after the abductors had sliced off the boy's right ear.

Getty challenged Howard Hughes (who was well down in the *Fortune* ranking, joining Joseph P. Kennedy in the $200 to $400 million category) as the media's favorite tycoon. Being an expatriate made him an even better story. He had left Southern California and the United States in 1951 in order to be more centrally located for his worldwide business interests. Britain and Europe were most convenient. Although he often said he intended to return to the States—in 1975, he told a reporter that he was homesick—he never did. He lived for almost a decade in a series of hotel suites in England and on the Continent before settling down in the English countryside in 1960. The press loved the homeless billionaire; his peculiarities were magnified into eccentricities.

In his youth, Getty had been more than generous with his father's money and his own, but he had lost that spendthrift knack and now became famous for being stingy. Some of the stories used to prove the point were true: he indeed did have a pay phone installed at Sutton Place, the 72-room Tudor manor in Surrey, 25 miles southwest of London, to which he moved in 1960. The house was also the international headquarters of the Getty Oil Company, and Getty considered it unbusinesslike to turn over the phones to the long-distance calls of tradesmen, guests, and business associates; but this telephone became emblematic of the man. So did the homilies on the theme "Men, Money, and Values in Today's Society" that he wrote for *Playboy*, which he described as a "frisky and epidermal periodical." The collected articles were published in paperback as *How to Be Rich* (1966) and *How to Be a Successful Executive* (1971).

Sometimes Getty professed pride in his great wealth, in the work and talent required

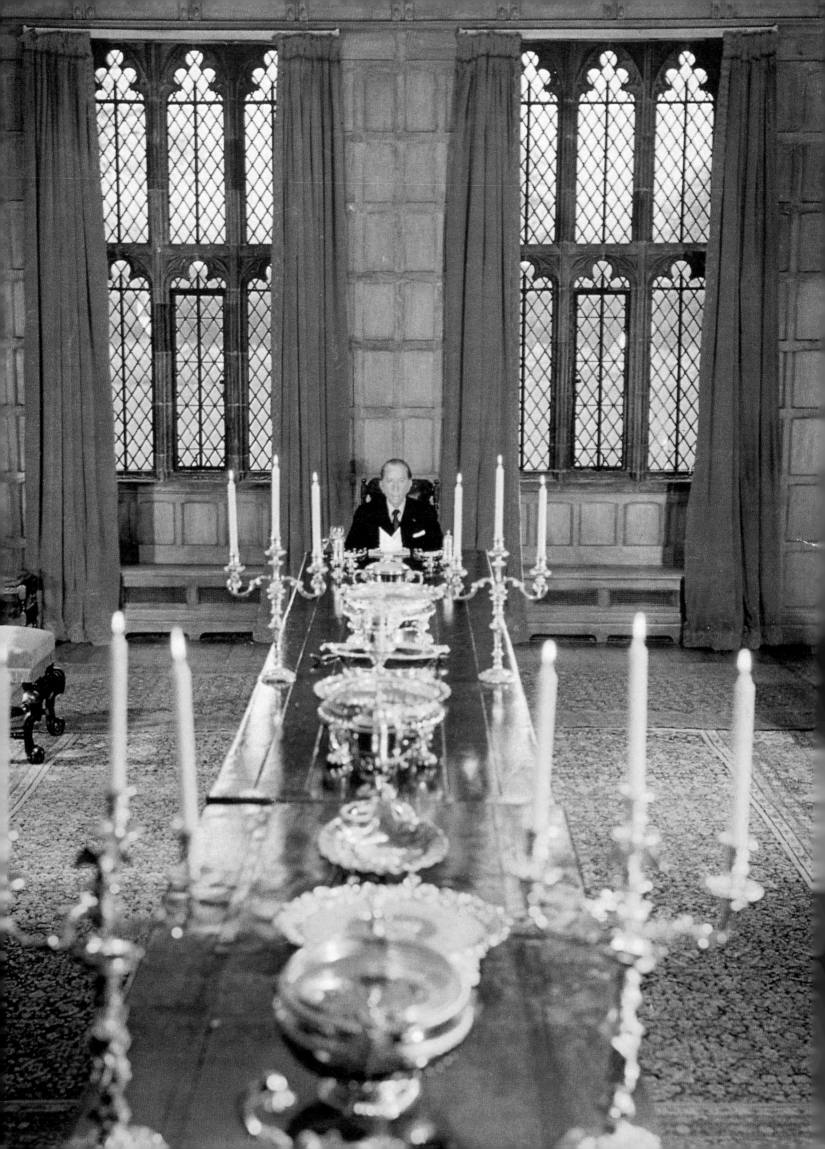

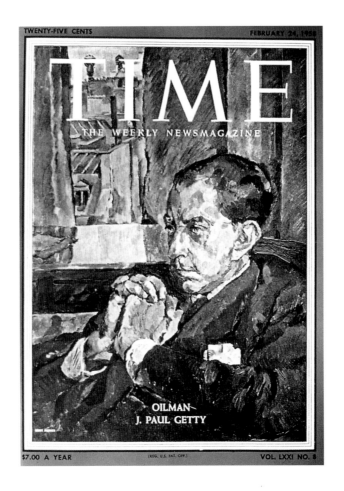

TWENTY-FIVE CENTS FEBRUARY 24, 1958

TIME

THE WEEKLY NEWSMAGAZINE

OILMAN
J. PAUL GETTY

$7.00 A YEAR [REG. U.S. PAT. OFF.] VOL. LXXI NO. 8

to produce it, and in the employment his activities provided to others. He suggested that such success requires thirty-five different qualities, while most people, even accomplished people, have only thirty-four. (He would not say what these qualities were.) He was adamant about the social value of wealth as a measure of capital invested and jobs created, but in a cover story in *Time* he said, "Everybody talks about how much money I make. I wonder what sort of accomplishment it is to make a lot of money." His parsimony was playful at times, but then he could say to a reporter in apparent seriousness, "I've always had a place for every dollar that came in.... Generally, you worry about paying the bills." In 1975, the year before his death, he said about his fortune, "Obviously there's more scope if you've got the price. But there's more scope for unhappiness, too." He wrote a story for *The Saturday Evening Post* titled, "The World Is Mean to Millionaires."

J. Paul Getty was a man of great financial acumen and excellent timing. His was anything but a full-time life of business, however, nor was it an unexamined or unimaginative life. His passion for money and his talent for making it allowed him to indulge another passion: for works of art.

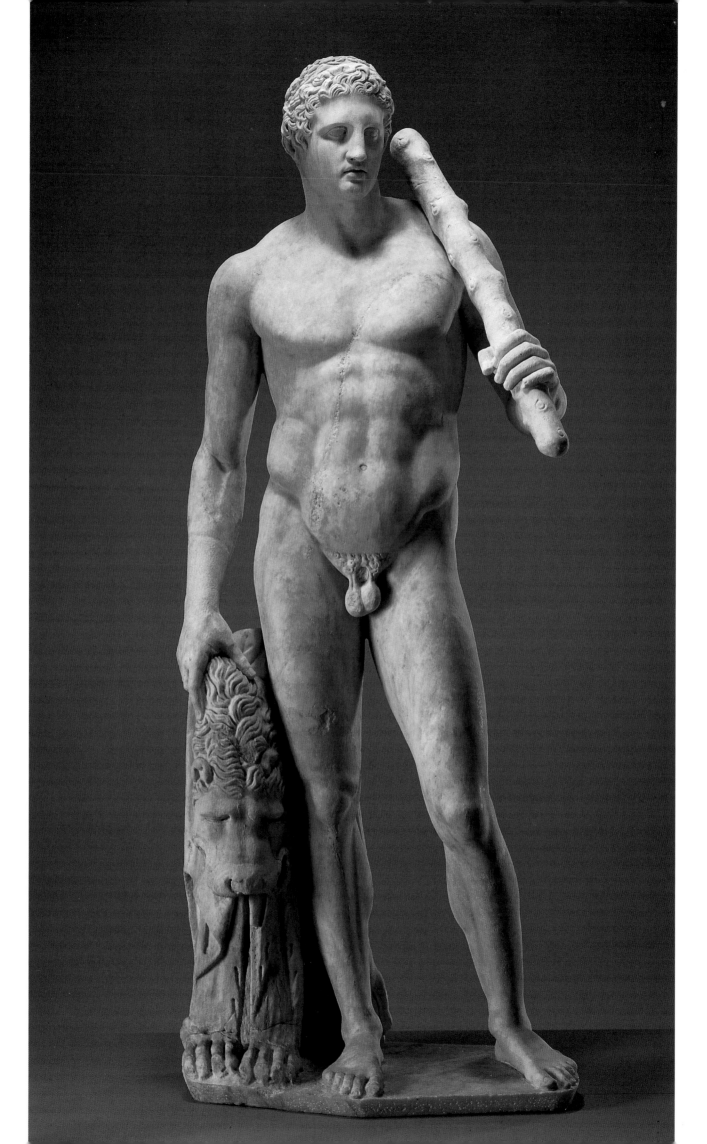

II.

Getty's Collection

"Many of the strong hands that formerly held some of the finest examples
of art on the face of the earth were forced to relax their grip," Getty wrote in *The Joys of Collecting* (1965), describing the years in which he first turned to collecting, the 1930s. The stock market was not the only one that had crashed in 1929. It was soon followed by the art market, and bargains abounded. With his oil cash, Getty was in a position to take advantage of both markets. Then, just as the Depression eased in the late thirties and prices for art might have started to rise again, fears of another war in Europe had the opposite effect, depressing the art market still further. As a result, in the first decade of his career as a collector Getty was positioned perfectly to acquire objects that might have been out of his reach a few years earlier.

When Lord Duveen's wealthy clients balked at the prices he asked for his prized Old Masters, the famous dealer reminded them, "When you pay high for the priceless, you're getting it cheap." One of Duveen's occasional clients could not bring himself to agree with this dictum. Getty told one interviewer, "I don't care to pay unrealistic prices for anything in life." Even as a boy, he had counted his pennies (when he was eleven he wrote in his diary, "I have $15.58 now"); later in life, the art collector counted his millions as well.

In his last years, when he was living at Sutton Place, dealers and his own curators learned to read his body language. If he placed the photograph of a prospective acquisition on his knee and said (as he often did), "That's terribly expensive," he could, nevertheless, be convinced the price was right, but if he placed the photo on the table beside him, that meant no sale. And he never changed his mind unless the price changed first.

Getty did not have unlimited funds for buying art. He was an ambitious businessman who pushed financing to the brink during those years, spending most of his money on more depressed shares of stock, on more oil leases, and on efforts to win operating control of the company that carried his name. As an oilman, he had thought big almost from the beginning, but as a collector of art, he began with more modest ambitions. When he paid $1,100 in March, 1930, for a landscape by the seventeenth-century Dutch landscape painter Jan van Goyen—his first significant purchase of a work of art—he had no aspirations to establishing an important collection. He was not in a position to follow in the footsteps of Andrew Mellon and Samuel H. Kress, for example, businessmen whose much greater wealth at the time let them amass the groups of paintings that would form the backbone of the collection at the National Gallery in Washington. While Getty was buying the modest van Goyen, Mellon was transferring $7 million to the new Soviet government for twenty-one paintings from the Hermitage. Then Mellon bought forty-two pictures from Duveen for an additional $21 million.

Getty settled instead for what would fit his budget and his taste. He was shrewd enough to acquire some of the best pieces of eighteenth-century French furniture in the world. For years Getty had regarded furniture as a utilitarian product, but then he sublet a New York apartment that happened to be well stocked with excellent Régence and Louis XV pieces. Studying them, he realized how wrong he had been. Years later, when he became a conspicuous collector of paintings and antiquities as well, he was often asked why he also spent so much time and money on the decorative arts. He replied that he thought that the finest of these pieces—his own among them—were as great as any Old Master painting. He also wanted fine furnishings for the rooms in which he displayed his other works of art. Another factor, surely, was the depressed price of that furniture in the 1930s, sometimes just a few thousand dollars.

On June 22, 1938, Getty pulled off his first major coup in this field. At the auction at Christie's in London of works owned by Mortimer Schiff, son of the banker Jacob Schiff, he bought a group of great pieces of furniture, including a rolltop desk by Bernard

One of Getty's earliest and best acquisitions was the *Lansdowne Herakles*, a Roman copy in marble of a Greek original of the fourth century B.C. Once an ornament of Lansdowne House in London, it remains one of the most important pieces in the Museum's collections.

Lansdowne Herakles
Roman, ca. A.D. 135
Pentelic marble, H: 193.5 cm
(76¹³⁄₁₆ in.)
70.AA.109

In 1930, long before Getty had real ambitions as a collector, he made the modest purchase of the Jan van Goyen landscape at right. By 1938, he was buying more vigorously and on a far grander scale, securing Rembrandt's portrait of Marten Looten [below] that year, as well as a rolltop desk by Bernard Molitor and the Ardabil carpet.

[Top]
Jan van Goyen
Dutch, 1596–1656
View of the Castle of Wijk at Duurstede, 1649
Oil on panel, 52.5 x 73.5 cm
(20¾ x 29 in.)
78.PB.198

[Bottom]
Rembrandt van Rijn
Dutch, 1606–1669
Portrait of Marten Looten, 1632
Oil on panel, 92.7 x 76.2 cm
(36½ x 30 in.)
Los Angeles County Museum of Art
53.50.3, Gift of J. Paul Getty

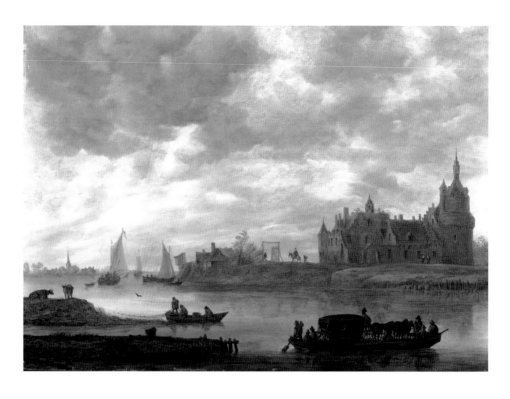

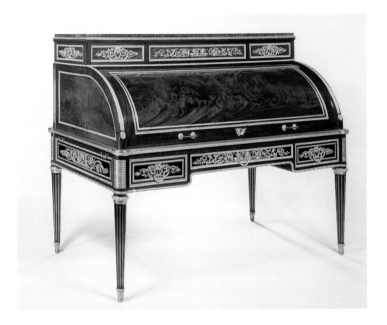

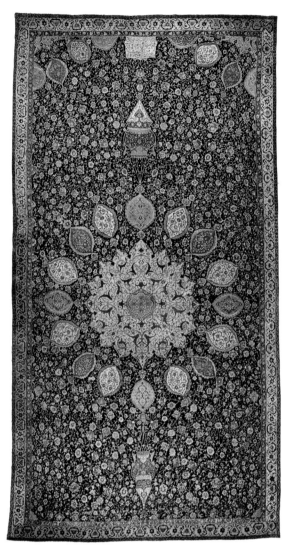

Molitor of about 1790 and a large Savonnerie carpet that had belonged to Louis XIV. That
year, he also bought Rembrandt's *Marten Looten* and the so-called Ardabil carpet of 1540.
The American painter J. A. M. Whistler had said, when he was trying to sell it to the
Victoria and Albert Museum, that the companion-piece to this carpet was worth all the
pictures ever painted.

This was stretching a point, but the Ardabil is nevertheless very large and among
the most brilliantly designed and executed of all the world's carpets. Getty wanted it the
moment he saw it at an exhibition in Paris and eventually bought it from Lord Duveen in
the prewar panic for just $68,000—a large sum for a carpet, but more than reasonable for
this particular one. Getty considered the price to be practically a gift. He knew and loved
rugs; he would drop on his hands and knees to assess the quality of the knots and dyes.
"You can tell a rich man by what he has on the floor," Getty sometimes said, and, indeed,
he put the Ardabil on the floor of his penthouse apartment in Manhattan.

Besides collecting decorative arts, Getty's other chief interest in the early years was
antiquities. Exploring the Vatican Museums in 1939 is supposed to have fueled his interest;
an associate commented later that one of the Roman busts stopped Getty in his tracks
because it resembled a rival in the oil business, W. G. Skelly. Shortly thereafter, Getty
bought portrait sculptures of the empresses Livia and Sabina. He wrote in a letter in 1952,
"I am no worshiper at the shrine of the Renaissance except in painting. So far as I am con-
cerned that was their great gift. In architecture, sculpture, literature, the ancients simply
surpassed them." One year later, he bought the great *Lansdowne Herakles*, a Roman copy

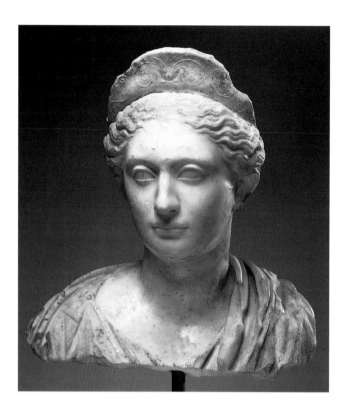

in marble of a Greek original, which remained one of his favorite acquisitions. Getty said he got that sculpture thanks to a tip over lunch at the Ritz Hotel in London, where he was living. The manager of Christie's told him off the record that the Lansdowne family might be ready to sell a piece from its famous collection. Getty was again astonished at the low price he was eventually able to negotiate: $30,000. Before the war, a lesser piece from the same collection had sold for $140,000.

As a businessman, Getty occasionally strayed from petroleum, but not often. As a collector, he found a middle ground between what he called super-specialization, which would not have suited a man with his broad background, and the omnivorous approach of a William Randolph Hearst. On his visit to San Simeon in 1934, Getty had been amazed by the publishing tycoon's vast collection, but he would later mention this as the kind of scattershot buying he wanted to avoid for himself. He drew a distinction between the eclectic, which he advocated and practiced, and the anarchic, for which he had little respect.

At all times Getty bought what he liked and liked what he bought. He made this a principle and repeated it often, having first begun to practice it in 1933, when he bought ten paintings by the Spanish Impressionist Joaquin Sorolla y Bastida. These sunny, broadly painted pictures were out of fashion and cheap, but Getty's diaries make clear that he never considered himself a serious collector of paintings anyway. At one point, Getty did express regret that he hadn't been attracted to the French Impressionists in his early years of collecting, because that was one area in which great paintings had been available at reasonable prices, never to be seen again.

Getty not only made it a point to like what he bought, but also to know what he bought. One of his business maxims was, "No man's opinions are better than his information," and he applied it to collecting as well. Although he had not been an outstanding university student, he did have a voracious appetite for any subject that interested him. Being reasonably competent in French, Spanish, German, Italian, and Latin, he put these languages to good use in his collecting adventures. During his early tours of the Continent he had visited the major museums and admired their contents, but he did not feel the

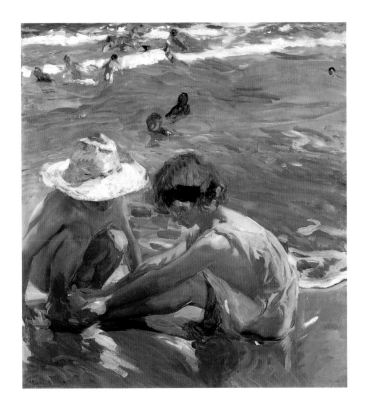

A couple of years after his purchase of the van Goyen landscape, Getty bought—simply because they pleased him—ten paintings by the Spanish Impressionist Joaquin Sorolla y Bastida.

Joaquin Sorolla y Bastida
Spanish, 1863–1923
The Wounded Foot, 1909
Oil on canvas, 109 × 99 cm
(43 × 39 in.)
78.PA.68

calling. When the passion finally struck, it was serious. He was no mere dilettante, no "checkbook collector," as other rich Americans had been disparagingly labeled, nor was he collecting for the sake of conspicuous consumption. Instead, he was gratifying a genuine interest and making good investments at the same time. His diaries from around the world chronicle in detail his visits to museums and archaeological sites and record down to the dollar his conversations with art dealers vying for his business.

A classic example of Getty's desire for a good buy and his belief in information was his purchase in 1938 of what was sold as a copy of Raphael's *Madonna di Loreto.* The work was auctioned by Sotheby's in London as part of the exiled collection of the Bourbons and was so obscured with restorers' overpaint that few people thought it could be anything better than a copy of Raphael's original, which, after being last located at the Casa Santa in Loreto in 1717, had been lost. But Gerald Brockhurst, an English artist who had just painted Getty's portrait, suggested to Getty that the foreshortening of the Virgin's right arm had all the earmarks of Raphael's own hand. Getty bought the painting for $200.

This was the kind of mystery he relished. Cleaning revealed a beautifully painted picture: if this was a copy, it was a very fine copy, perhaps an autograph version by Raphael, conceivably the long-lost *Madonna di Loreto* itself. Indeed, by the mid-sixties the painting was generally accepted as the original and was later lent to the National Gallery in London, where it was shown next to Raphael's *Aldobrandini Madonna.* Such an outcome would be the epitome of success for any collector. Getty's $200 purchase was now insured for $2 million, and he made certain that visitors knew it. When one of the authors of this book, John Walsh, at the time a paintings curator at the Metropolitan Museum, visited Getty at Sutton Place in 1973, the old man very soon steered him to the picture and told the story of his triumph in detail. But questions remained in Getty's own mind, as he acknowledged in his book *Collector's Choice* (1955). Associates from those days believe that he spent more time researching the provenance of this painting than on any other collecting project. (Shortly after his death it came to light that the actual original is the version in the Musée Condé at Chantilly; today, the Getty version is believed to be an excellent early copy.)

Getty's fascination with life in antiquity made Alma Tadema's spectacular recreation of a Roman festival a logical purchase. Hanging in a reconstructed Roman villa, it has remained one of the Museum's most popular pictures.

Lawrence Alma Tadema
Dutch/English, 1836–1912
Spring, 1894
Oil on canvas, 178.4 × 80 cm
(70½ × 31½ in.)
72.PA.3

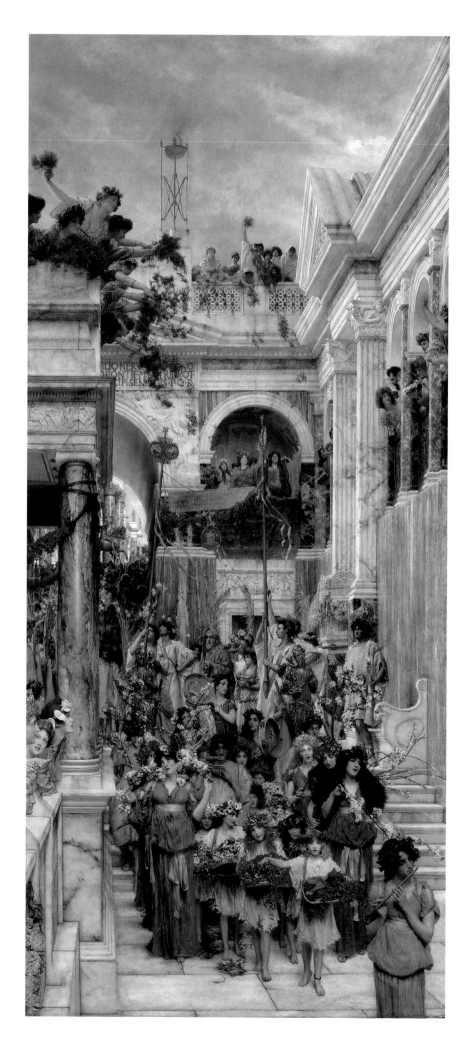

In buying a painting he thought was the original *Madonna di Loreto* by Raphael, Getty believed he had gotten a masterpiece for next to nothing. It was indeed widely accepted as by the master's hand, but today it is generally regarded as a very good old copy.

After Raphael (Raffaello Sanzio)
Italian, 1483–1520
The Holy Family (Madonna del Velo; Madonna di Loreto),
possibly mid-sixteenth century
Oil on panel, 120.5 x 91 cm
(47½ x 35⅞ in.)
71.PB.16

Like many collectors, Getty tried to quit several times but never succeeded. On October 17, 1949, he wrote an associate, "I think my French furniture collection is now complete." Eleven months later he wrote, "My collection needs a Cressent commode." (An odd slip—Getty already owned a Cressent commode that he had bought twelve years earlier.) Two years later, in 1952, while he was involved in his business gamble in the Middle East, he suggested to a friend that he was about to quit buying art except for ancient sculpture. The next year, he acquired one of his finest and most famous pieces, the double desk by Bernard II van Risenburgh. This kind of vacillation became the pattern, and he joked about it in *The Joys of Collecting.* Getty was now collecting with an eye on posterity. He said, "I don't think there's any glory in being remembered as old moneybags." He understood Lord Duveen's distinction between an "accumulation," which will amount to nothing but an inheritance problem for the heirs, and a "collection," which can be bestowed on some worthy institution and confer on the donor an immortality almost equal to that of the greatest artists. A friendship beginning in 1953 with the most famous of all living connoisseurs, Bernard Berenson, drew Getty further in that direction. Berenson could be caustic in his dismissal of a painting or sculpture as "fifth rate" or even "tenth rate," judgments Getty did not wish for his own legacy, in business or in art. His beginnings as a novice collector were several decades in the past. Now he sensed a higher responsibility.

III.

The House-museum in Malibu

The property was in Los Angeles just off the Pacific Coast Highway at the border of Malibu, about a mile north of the intersection with Sunset Boulevard and opposite TED'S RANCHO RESTAURANT—BREAKFAST ALL DAY. These 64 acres of subtropical canyon land were known as the Cañon de Sentimiento. They were a small part of the Rancho Boca de Santa Monica, which itself had been part of a large land grant in the nineteenth century from the Spanish government to the family of Francisco Marquez. And in 1946, this property was for sale.

Getty already owned a house on the beach next to Hearst's in Santa Monica, but here was an opportunity to acquire his own ranch just up the road. The stucco hacienda on the property was diminutive compared to Hearst's audacious San Simeon to the north, but it offered a stunning vista of the ocean. Getty bought the place from Judge Clyde Parker for a reported $250,000, rechristened it the Getty Ranch, and made renovations to the house. He and his fifth wife, Louise (Teddy), and their infant son, Timmy, born in 1946, used the house on weekends before Getty left California and America for good in 1951. Soon enough, however, Getty's art collections would give him another use for the ranch.

In those postwar years, although he was involved in his worldwide business, including the major venture in the Neutral Zone, Getty was more and more engaged in his art collection and aware of its potential value for the public. When he had bought Rembrandt's *Marten Looten* for $65,000 in 1938—one-third its price a decade earlier—and word had spread that the painting was about to leave Dutch soil for the New World, the negative public reaction in Holland had been immediate and intense, especially since the painting had just returned home in 1928 after decades in foreign collections. Sensitive to the delicacy of the situation, the "unnamed American" who now owned the picture lent it to the Fine Arts Pavilion of the 1939 New York World's Fair. A decade later, he went a step further to redress the Dutch grievance. In *The Joys of Collecting*, he described returning to the Netherlands posing as a journalist engaged in researching the significance of the four lines of illegible script on the letter held in Looten's left hand. His purpose, he wrote, was to meet incognito one of the Dutch academics who had been incensed about the sale and to assure him that the picture was still working hard on the other side of the ocean as an emissary for Dutch culture.

The experience apparently made a great impression on Getty. Four years later, he presented both the *Marten Looten* and the Ardabil carpet as gifts to the Los Angeles County Museum of Art, where they became the most important works in a very modest collection. These donations were a fine gesture—so were Getty's gifts to other museums at about the same time—but some colleagues, including his trusted assistant in Los Angeles, Norris Bramlett, approached the neophyte benefactor with a better idea. They suggested that he owned enough art to justify founding his own small museum rather than donating his collection piecemeal to others. This could be created at the Getty Ranch, and if he should return home, as he still said he intended to do, there were bedrooms and the necessary comforts. Why not convert it into a small, charming museum?

And so it came about. Getty established a trust for "the diffusion of artistic and general knowledge" and ordered further renovations to the section of the ranch house that would hold the new museum. For the time being, the property continued to operate as a ranch. In May, 1954, the new J. Paul Getty Museum welcomed its first visitors. Unable to attend the ribbon-cutting, the founder wrote the participants from Kuwait, where the oil that would help pay for this venture was beginning to flow in profusion: "I am sorry that I am unable to join you on this occasion. I hope this museum, modest and unpretentious as it is, will nevertheless give pleasure to the many people in and around Los Angeles who are interested in the periods of art represented here."

A prewar photograph of the Cañon de Sentimiento with the Parker (later Getty) Ranch at left of center, site of the future Getty Museum.

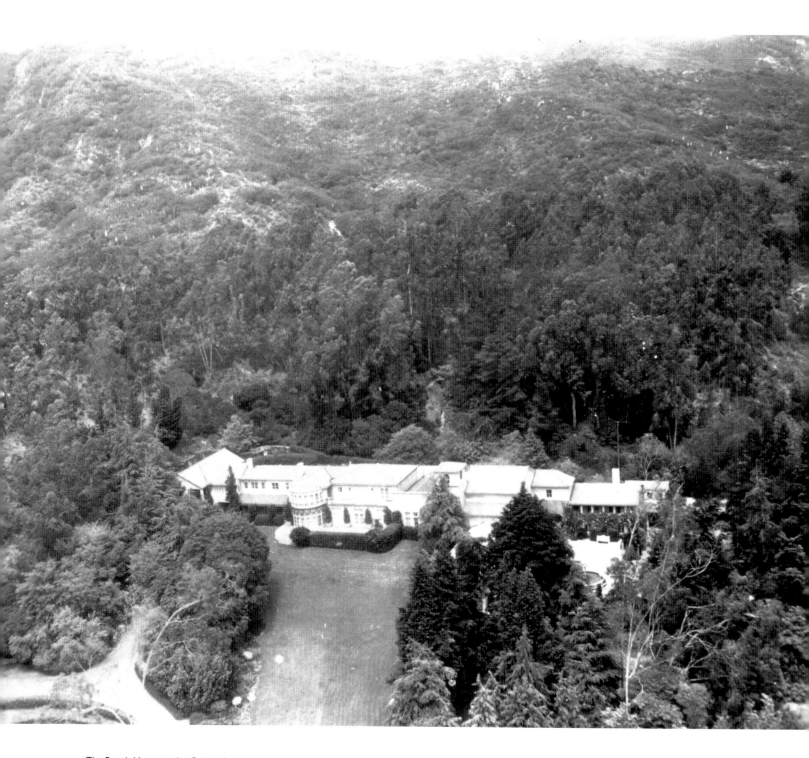

The Ranch House in the Cañon de
Sentimiento, which housed the first
Getty Museum in about 1960.

The grounds of the Ranch House contained a small menagerie with, among other animals, bison and bears.

Hours were three to five on Wednesday and Saturday afternoons, by appointment only. Guests drove up a steep, narrow, rutted dirt road beneath a canopy of eucalyptus and pine and cedar trees, past orange and lemon groves and cages with large guard dogs and one black bear and one brown bear (the only remaining residents of a small zoo that once housed bison, barbary sheep, wolves, and a lioness, among other animals). Passing a spacious lawn, they arrived at a walled courtyard and fountain in front of a side entrance to the house. College students served as "ushers." They were not very busy in those early years: three dozen visitors were a good crowd on any given afternoon.

Large Roman statues, including the *Lansdowne Herakles*, were placed outdoors around a patio, and other antiquities were shown in one room on the ground floor. An adjacent gallery held French furniture and decorative arts and one of the three versions of Hyacinthe Rigaud's famous portrait of Louis XIV "showing the leg" in his coronation robes. Down the hall was a small room with more antiquities; another gallery of French furniture, mainly from the era of Louis XVI; and a small theater with walls of red velvet and hung with twenty-odd European paintings, of which the highlights were the portrait by Gainsborough of the pioneer auctioneer James Christie (which is still exhibited); the *Death of Dido*, then attributed to Rubens, and *The Penitent Magdalen*, then attributed to Titian. From the window in this paintings gallery visitors looked across the lawn to the lower reaches of the Cañon de Sentimiento and the ocean beyond.

The best of the three distinct collections at the new museum was the French furniture from the *ancien régime*, which Getty had been collecting with passion and shrewdness almost from the beginning. There were a substantial number of Greek and Roman statues, however, since Getty was taking antiquities more and more seriously. He did not care for and avoided anything associated with death, so the collection had no funeral monuments or sarcophagi. The most famous single piece was the *Lansdowne Herakles*, which had been unearthed from the ruins of Hadrian's Villa near Tivoli in 1790. Neither the subject nor Hadrian's ownership was incidental to Getty's lifelong admiration of this statue. Herakles was a virtuous demigod; Hadrian was an intellectual, an art patron, and a builder of monuments—heady associations for a modern-day collector and philanthropist. Getty's diaries reveal that he envisioned himself as carrying on the tradition of the great collectors of the past.

Now that Getty had a public home for his acquisitions, he declared null and void one of his periodic assertions that he was no longer in the art market. Aware that his collection of paintings was the least impressive of his three chosen fields, Getty and the staff of the Museum tried to make up for lost time by buying many more pictures. Under the brief directorship (from January, 1954, to March, 1955) of W. R. Valentiner, the German-born

The decorative arts galleries in the
Ranch House, with opening-night
guests, in 1954.

Among the galleries in the Ranch House, [right] the auditorium retained its original function but also served for paintings and decorative arts; [bottom] the long salon was a paintings gallery; [opposite page, top] hallways housed smaller antiquities; [opposite page, bottom] and outside, larger pieces were displayed in the courtyard around a fountain adorned with bronze monkeys.

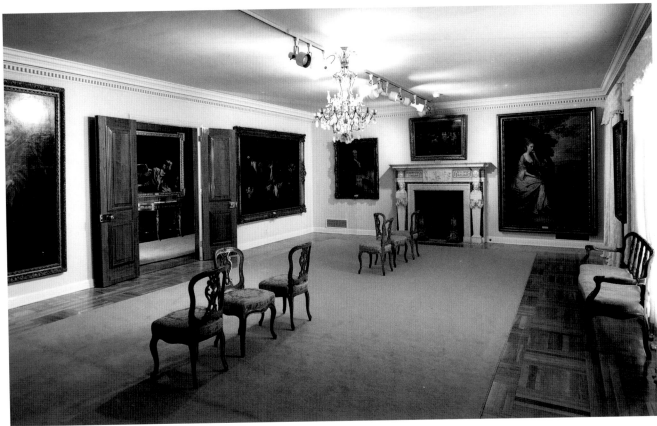

[Right] W. R. Valentiner, director of the Getty Museum from 1954 to 1955, had formerly headed the Detroit Institute of Arts and the Los Angeles County Museum of Art. Under his directorship and that of his successor, Paul Wescher, the collections grew and eventually outgrew the space originally assigned them. [Below] In 1957 a new gallery was built for antiquities.

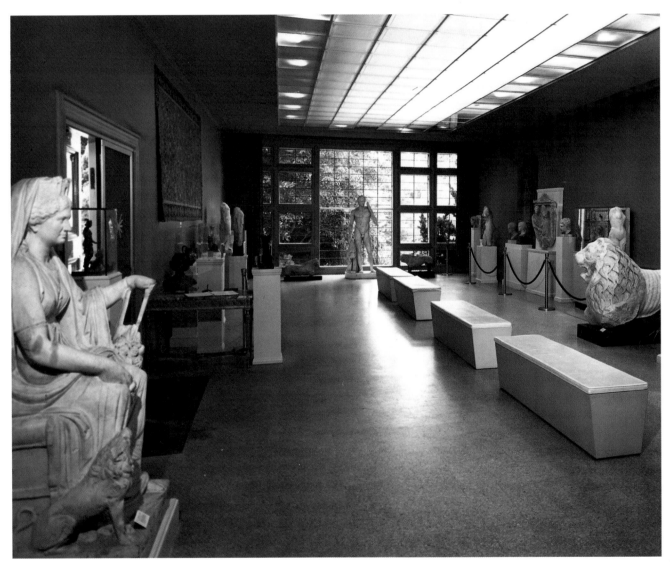

In 1959 Getty moved into Sutton Place, a great Tudor mansion in Surrey, where many of his acquisitions were first displayed. It was from Sutton Place that Getty directed Getty Oil and the Getty Museum in Malibu.

former director of the Detroit Institute of Arts and the Los Angeles County Museum of Art, and under the curatorship of Paul Wescher until April, 1959, the Museum outgrew the patio, five galleries, and several hallways with which it had begun. A large gallery was added in 1957 for the display of newly acquired ancient statues, both large and small. A 7-inch-high Zeus from the late Archaic period, about 500 B.C., caused Getty to write, "No art object in the world is of better quality, or artistic excellence." It was joined indoors by the over-life-size *Herakles*, which was given a position of honor.

Getty had fits of discouragement as the sole supporter of the Museum. Toward the end of the fifties, he decided that his Museum had enough art and would have to wait a while to receive more. Reports from Norris Bramlett (his main source of information, since he had not been back to see the place himself) were often annoying. The graded road up to the Museum from the highway was a chronic problem and Getty complained about the persistent expenses of its repair. More worrisome were the tax status of the Museum and the government's claims that he might be deriving a personal benefit from it. On February 20, 1958, he wrote from the Hotel George V in Paris to Bramlett, "I wish to go on record right here that it is very burdensome to me to be pestered by art dealers and to give up my time to inspecting art objects, getting expertises, conducting negotiations, etc. I think my time might reasonably be worth quite a sum of money, and since I am not in residence, in fact, may never see California again, it is hard to see that I derive personal benefit from these labors…. I think in future, if I buy art objects, I will buy them personally and use them in my own surroundings where I can get some good out of them."

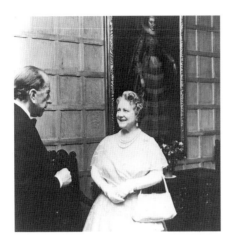

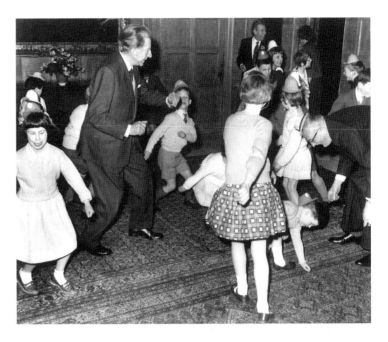

Sutton Place attracted all kinds of
visitors. [Top left] Queen Elizabeth,
the Queen Mother, visits Getty; [top
right] children from a church orphan
home do the twist with their host;
[bottom] the press, of course, came
as often as they could.

A life-size painting of Diana and her entourage by Rubens and his workshop was one of the major purchases of the Ranch House era.

Workshop of Peter Paul Rubens
Flemish, 1577–1640
Diana and Her Nymphs on the Hunt, ca. 1615
Oil on canvas, 284 × 180.3 cm
(111⅞ × 71 in.)
71.PA.14

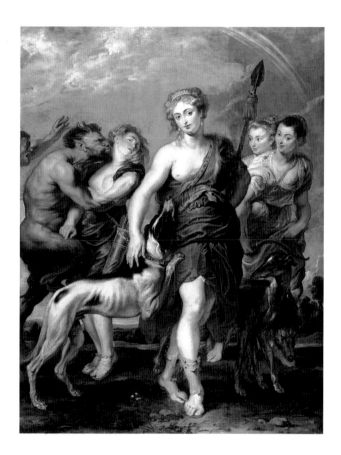

Getty's "own surroundings" at the time were mainly hotels, and had been for seven years. But after he moved into Sutton Place, he had an alternative location for his purchases, one with a great deal of wall space. His spending on art objects picked up again, and, indeed, some of his most expensive purchases of this era—including *Diana and Her Nymphs on the Hunt*, then attributed to Rubens—were hung in the Great Hall at Sutton Place before they were sent to the Museum. While it hung at Sutton Place, the Rubens became another research project for the owner, along with the *Madonna di Loreto*. How much had the master's assistants contributed to the picture, he wanted to know. (Today the consensus is: a great deal.)

In January, 1962, Getty once again called it quits, writing a friend, "I am confident I am no longer a buyer of art objects. I have enough art." He may have been put off by the price for Rembrandt's so-called *Aristotle Contemplating the Bust of Homer*, which had been sold at auction in New York the previous year. In the Museum in Malibu, the paintings were still the weakest part of the collection, and Getty knew it. *Aristotle* would have put the Museum on the map. He nevertheless decided that the market for Rembrandt was too high at the time and did not bid on the painting, which sold to the Metropolitan Museum of Art for $2.3 million in a blaze of international publicity.

As Getty made himself at home at Sutton Place, apparently comfortable with the notion that he might not get back to the United States after all, the Getty Museum in the Ranch House in Malibu continued with a tiny full-time staff and no budget. Expenses were approved ad hoc by Getty himself, who paid close attention. To Valentiner's letter suggesting that more people could learn about the museum if the grounds were made available for receptions and the like, Getty scribbled his reply in the margin, "I don't approve of receptions."

For fourteen years, from 1954 to 1968, the Museum maintained a low profile that apparently suited the benefactor. It was a hideaway of peace and quiet visited by a few thousand people a year at most. Then things changed.

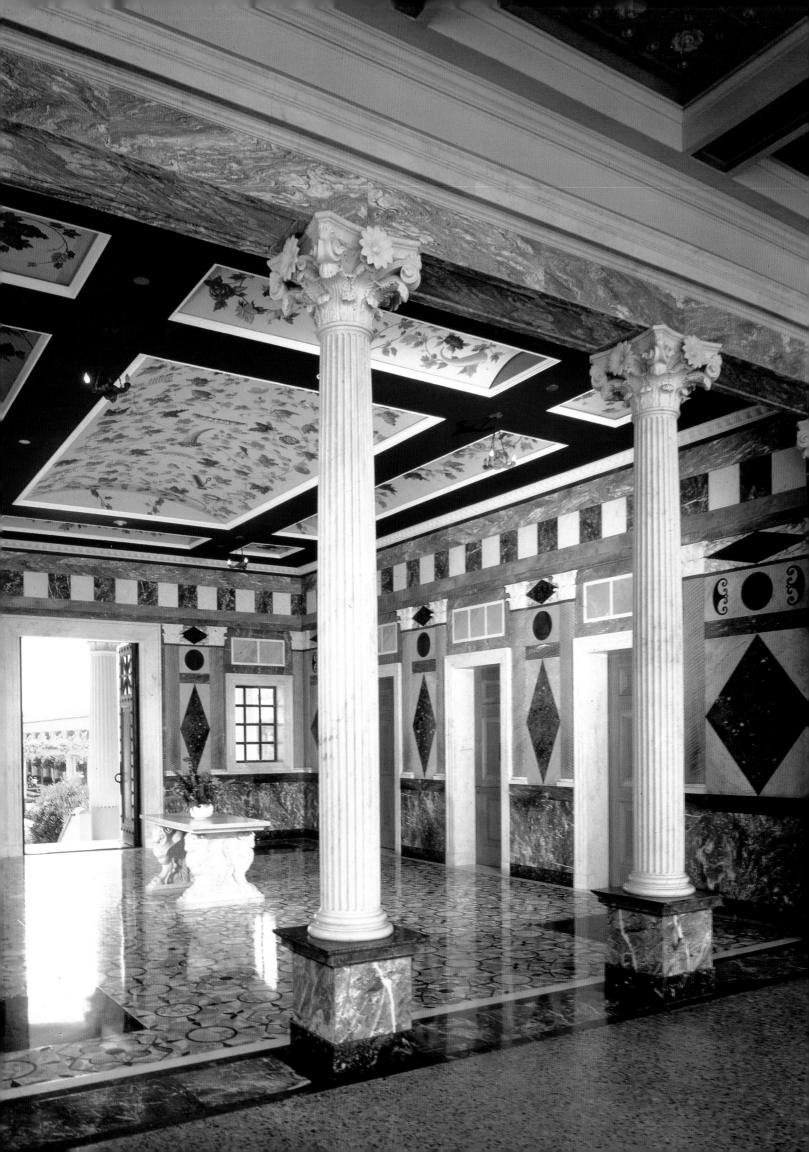

IV.
The
Roman
Villa

For fourteen years, J. Paul Getty appears to have been satisfied with his small, relatively unknown, modestly funded museum. Then, in 1968, one year after celebrating his seventy-fifth birthday, three years after the publication of his book *The Joys of Collecting*, he announced his intention to build a much bigger museum. The years of benign neglect in Malibu were over.

Getty probably had entertained the idea of expansion for years, but as far as can be learned from his correspondence and from the recollections of friends and associates, he had kept it to himself. No doubt he had thought about adding more galleries. A major expansion may also have been prompted to some degree by tax pressures that encouraged a stepped-up schedule of deductible expenses and donations. Whatever the reasons, the expatriate living in England decided to build a major museum in Southern California, where he had not been for seventeen years.

How to realize the new vision? Getty gave permission for an interim expansion into a living room, two little dressing areas, and another hallway. But piecemeal growth was the only possibility at the ranch house, and he now had more than that in mind: a new building.

Should this building adopt the architectural vocabulary of the ranch house, Spanish Colonial and generic Mediterranean with a little Georgian mixed in? In a letter Getty derides that architecture as "more or less of a poor man's Italian Renaissance." Reflecting his belief in the excellence of his group of antiquities and his respect for the values of the ancient world, Getty expressed his wish to highlight this part of the collection. Convinced that works of art were best displayed in "analogous" settings, he even floated the idea of a neoclassical building to house the antiquities, perhaps something along the lines of John Russell Pope's National Gallery of Art. Another possibility he considered was to use the Tudor style of Sutton Place. He also believed that a museum building should have a didactic role. He told an associate that few people from California would get to Italy and Greece to see ancient buildings, and even if they did, they would see them in a derelict state. He would show them what such a building looked like when it was part of the life of those who lived in it.

First, however, the architectural firm that had designed office buildings for some of the Getty companies, Langdon and Wilson, made a series of alternative studies in August, 1968, for southward extensions to the Ranch House. Scheme A, a pair of modest single-story gallery buildings flanking the existing forecourt, was proposed in Spanish Colonial style. Scheme B was a broad two-story building in a kind of stripped-down classical idiom that has overtones of the contemporaneous Music Center downtown. In the autumn, Getty was shown a much grander proposal for the same site, an exercise in academic classicism in the manner of Paul Cret and John Russell Pope that might have looked at home on the Mall in Washington but would have been pretty uncomfortable in a canyon in Malibu. None of these convinced Getty, the only critic who counted. He was adamant about one point: he would not have a modernist building, with the glass, stainless steel, and exposed concrete that he considered all too emblematic of "this glib and brittle age." He disliked these materials for any building, much less for his museum. He had never been a modernist and did not intend to become one now, in his eighth decade.

At some point his thoughts turned to the re-creation of an ancient building. He inquired aloud about a pastiche of Sutton Place and an ancient structure: the interior of the former, the exterior of the latter. This hybrid turned out not to be feasible. Some of his friends and associates were quietly advising Getty that any kind of reconstruction would automatically invite the kind of derision from the professional art world that had been

The vestibule of the Museum, pictured here, shows the lavish use of marble that decorated the grandest villas of Roman antiquity. The geometric patterns on the walls, contrasting with the floral ornament painted in the ceiling bays, were based on those of several different ancient houses. Through the open door the Main Peristyle Garden can be seen.

When Getty decided to build a new museum building on the grounds, he entertained several possible styles: Spanish revival, which suited the locale and the existing Ranch House; the Tudor style of Sutton Place; and the Beaux-Arts Neoclassical idiom of many museum buildings. Shown here are three design proposals by Langdon and Wilson for a southward extension of the Ranch House: [top] Scheme A, in the Spanish Colonial style of much of Southern California architecture; [middle] Scheme B, the pared-down classicism in vogue for large public buildings in the 1960s; and [bottom] the massive Neoclassicism of earlier public architecture.

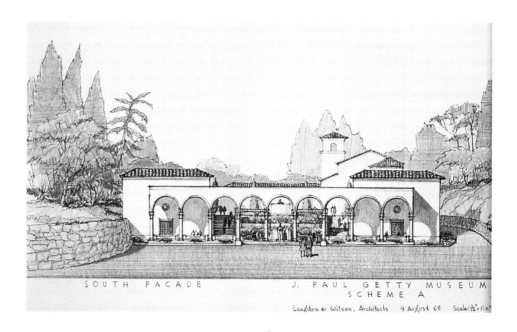

SOUTH FACADE J. PAUL GETTY MUSEUM
SCHEME A
Langdon & Wilson, Architects 9 August 68 Scale: ⅛″·1′·0″

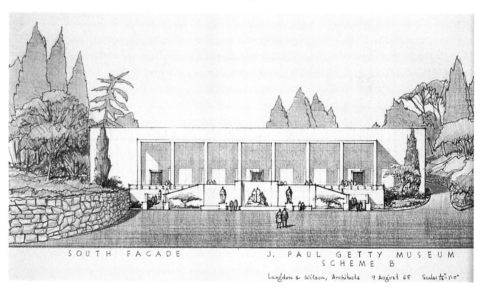

SOUTH FACADE J. PAUL GETTY MUSEUM
SCHEME B
Langdon & Wilson, Architects 9 August 68 Scale: ⅛″·1′·0″

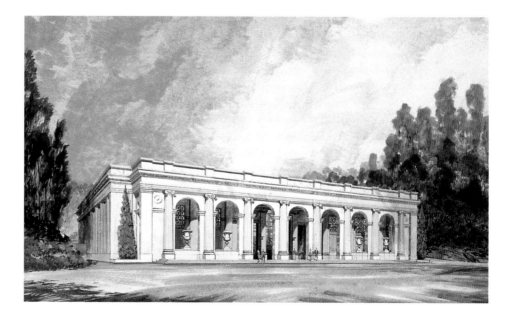

heaped on the Pope buildings in Washington. It would be compared with the Kimbell Art Museum in Fort Worth, designed by the revered modernist Louis Kahn. Construction on that building was just beginning, and there was every indication that it would be greeted as a triumph of the modernist tradition, bare concrete and all. (And in 1972, so it was.)

These warnings evidently had no effect. One evening in 1968, Getty announced his decision to a circle of guests at Sutton Place: the new Getty Museum in Malibu would be a re-creation of the ancient Villa dei Papiri in Herculaneum. Astonishing as the decision was for most people, it may not have been so surprising to those who knew Getty's mind. Getty knew what he was talking about. By then he owned two villas in Italy, one on the coast north of the ancient Roman port of Ostia and the other in Posillipo on the Bay of Naples, where Romans of antiquity had spent their holidays.

Getty was a conservative collector whose tastes were those of the nineteenth-century English aristocracy and the American magnates who emulated them, but he was also a bold gambler as an oilman. In the 1930s, when he was buying depressed shares of stock and contesting control of the Getty empire with his own mother, he had pushed his personal financial resources to the limit. His first foray into the deserts of the Middle East in the 1950s was all nerve. This adventurousness, combined with his conservative bent in art and his lifelong admiration for the values of the ancient world, made the decision to reconstruct a long-buried ancient building a consistent expression of the Getty personality; it was a radical decision in the service of a conservative artistic taste.

Getty was perfectly conscious of the long tradition of the house-as-museum, the house-turned-into-a-museum, the museum-posing-as-a-house. His adopted England was full of venerable houses with highly individual art collections that were open to the public, sometimes only a few afternoons a year. Among American models, there were the house-museums of Isabella Stewart Gardner in Boston, Henry Clay Frick in New York, Hearst at San Simeon, and Henry E. Huntington nearby in Pasadena. These were built in Italian, French, Spanish, and Beaux-Arts neoclassical styles, respectively. In New York City, his fellow oilman John D. Rockefeller, Jr. had built The Cloisters above the Hudson River, a pastiche of real and imitation medieval buildings to house medieval art. Why not a Roman villa overlooking the Pacific?

Getty would build what he liked, and he would like what he built: "It will simply be what I feel a good museum should be, and it will have the character of a building that I would like to visit myself. . . . Why not show Californians what an especially attractive Roman building would have looked like, with its gardens, fountains—even details such as the lamps and appropriate flowers? Many contemporary museum buildings have failed while attempting less than that."

The choice of the Villa dei Papiri in Herculaneum as his model also reflected Getty's long-standing fascination with that buried Roman town and the great house outside its walls. They were one of the settings for a novella Getty had published in 1955, *A Journey from Corinth*. Along with neighboring Pompeii and Stabiae, Herculaneum was buried when Vesuvius erupted on August 24, A.D. 79. One day, it was a fishing village on the Bay of Naples and a posh seaside retreat for wealthy Romans; a few days later, it had disappeared under a river of hot volcanic mud that filled every cranny and covered every roof. Over the centuries there were more volcanic flows, burying the town to a depth of 90 feet.

As Getty knew from his readings, the villa in question, the grandest of them all in Herculaneum, was in all likelihood the retreat of the wealthy consul Lucius Calpurnius Piso. (In *A Journey from Corinth*, the protagonist, a Greek landscape architect from Corinth, goes to work for Piso at the villa in Herculaneum. Piso is portrayed as the Roman counterpart of Getty himself— powerful, bluff but kindly, knowing what he wanted—and

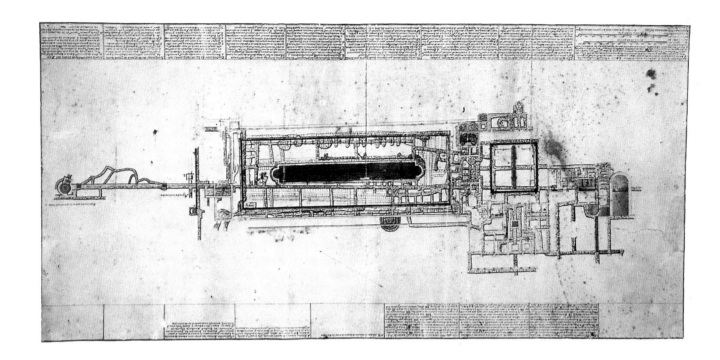

Ultimately, Getty decided in favor of a reconstruction of a classical building, the Villa dei Papiri, excavated at Herculaneum by means of tunnels beginning in about 1750. The Swiss engineer Karl Weber oversaw the initial excavation and made meticulous drawings of the tunnels and floor plan, three of which are shown here. These, in turn, formed the basis for the layout of the Getty Museum.

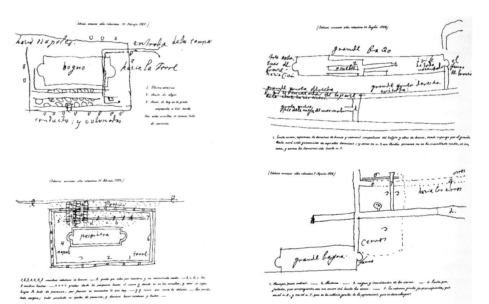

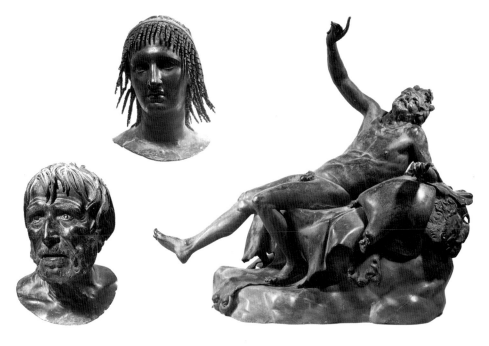

The Villa dei Papiri was both a major architectural discovery and a source of a huge number of Roman bronzes, now in the National Museum of Archaeology in Naples, three of which are pictured here; [top left] *Bust of Thespis* (bronze and copper, H: 40.5 cm [16 in.]); [bottom left] *Bust said to be of Seneca* (bronze, H: 33 cm [13 in.]); [far right] *Statue of a Drunken Satyr* (bronze, H: 137 cm [54 in.]). [Bottom] Nearly 1,800 papyrus scrolls with Greek and Latin texts gave the villa its name.

eventually the possessor of the *Lansdowne Herakles*, which Getty describes fancifully as coming from the plundered agora of Corinth.) This house was widely known for its extensive collection of Greek and Roman sculpture. It was also a seat of serious learning, stimulated by the philosopher Philodemus, who enjoyed Piso's patronage. It had perhaps the only private library in the Roman world that has been recovered—almost 1,800 papyrus rolls, which, badly scorched, were the inspiration for the name given the villa by subsequent archaeologists: Villa dei Papiri.

Within days after the catastrophe, looters descended on Herculaneum and its famous villas, but the volcanic mud hardened before much theft had been accomplished. Slowly the town receded from collective memory. Then, sixteen centuries later, in 1709, workmen digging a well in the village of Resina struck something hard. This was bad news for that job but a marvelous discovery for the world: the obstacle was the upper tier of marble seats in an ancient theater. Excavation proceeded fitfully under the auspices of several sponsors, most notably Charles III, the Bourbon King of Naples. Because the tufa was so hard and so deep in most places, the only feasible means to proceed was to sink vertical access shafts and then to tunnel horizontally from these entryways. This method of reconnoitering was not very precise, to say the least, and it was thirty years before the ruin was conclusively identified as Herculaneum.

In 1750, forty years after the initial discovery, one of the vertical entry shafts struck an inlaid marble floor of great beauty. This turned out to be the belvedere in the garden outside Piso's villa. For the next fifteen years, the king's miners dug a growing network of tunnels and galleries at the villa, yielding a treasure of tile and marble floors, papyri from the library, and the splendid collection of ancient bronze and marble sculpture that fills many galleries in the archaeological museum in Naples today. When the law of diminishing

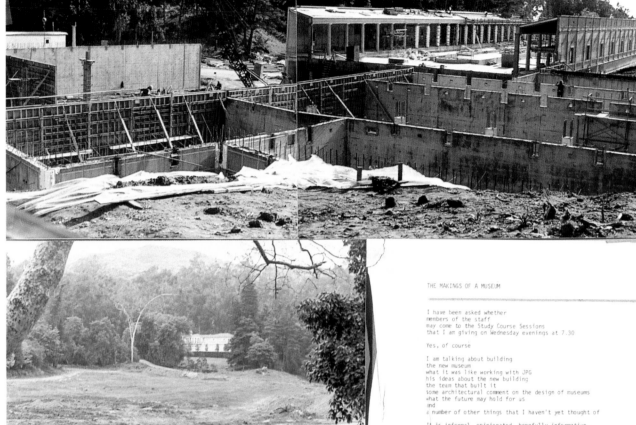

THE MAKINGS OF A MUSEUM

I have been asked whether
members of the staff
may come to the Study Course Sessions
that I am giving on Wednesday evenings at 7.30

Yes, of course

I am talking about building
the new museum
what it was like working with JPG
his ideas about the new building
the team that built it
some architectural comment on the design of museums
what the future may hold for us
and
a number of other things that I haven't yet thought of

It is informal, opinionated, hopefully informative,
popular rather than scholarly
and intended to stimulate ideas about museums

Terry Longyear and Andy Blakley and Luanne Pfeifer
were there last night - they could tell you
what it is like

I am not asking (let alone encouraging)
you to come.
But you are welcome if you want to

S

3 March 1977

Construction of the new Museum
began in December 1970 and pro-
ceeded at a fast pace. Getty, who
never returned to the United States
from England, was kept up to date
on the progress of construction
by being shown large boards with
color snapshots of the building
as it grew. In some cases, such as
the one shown here, photographs
were combined to achieve dramatic
wide-angle perspectives of the
construction.

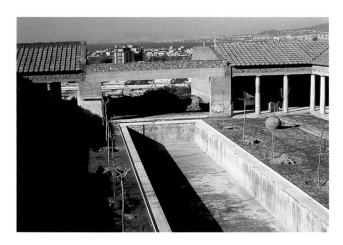

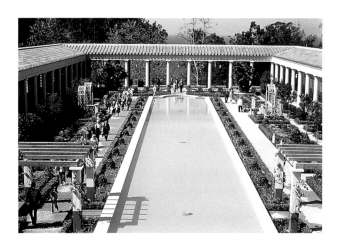

Norman Neuerburg, an archaeologist and leading authority on Roman domestic architecture, supplied an intimate knowledge of classical precedents. Here in a series of comparisons, one can see how closely the new Villa, shown in the right-hand column, was based on ancient examples, in the left-hand column: [first row] the masonry of the semicircular grilles of the archways in the lower walls was modeled after that in the necropolis of the Porto Romano in Ostia; [second row] the long pool in the Outer Peristyle Garden resembles the pool in the Villa San Marco in Stabiae; [third row] the colorful wall decorations on the long wall of the Main Peristyle, in the so-called the "second style" of Pompeian painting, are taken from those in the peristyle of a villa at Boscoreale; [fourth row] the columns of the Main Peristyle, like the long pool, are modeled after columns in Villa San Marco in Stabiae.

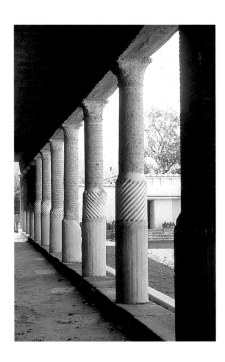

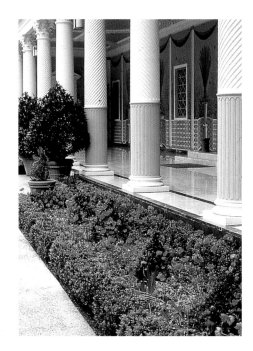

returns set in, the Bourbon diggers filled in their shafts and tunnels. (Pompeii was rediscovered later than Herculaneum, in 1748. The initial destruction there had been greater, but the soft pumice was so much easier to dig that Pompeii became the first and most famous of the rediscovered towns.) The discoveries brought to light from the towns and villas beneath Vesuvius created a tremendous vogue for Roman architecture, decor, painting, and furniture and gave impetus to the development of neoclassical styles.

One of the fortunate happenstances in the annals of archaeology was the appointment of the Swiss engineer Karl Weber to oversee the excavations at the villa in Herculaneum. Weber's meticulous records are our main source of information on the floor plan and details of the Villa dei Papiri. A related piece of good fortune two centuries later was the presence in Los Angeles of the archaeologist Norman Neuerburg, who had studied the ruins of Herculaneum, Pompeii, and Stabiae for twenty years and was a leading authority on Roman domestic architecture. Getty engaged Neuerburg as his historical consultant for the re-creation in Malibu.

The firm of Langdon and Wilson was hired as architect, contracts were let, and, on December 21, 1970, ground was broken for the new Getty Museum several hundred yards down the canyon slope from the ranch house museum. Getty was in a hurry, so research, design, and construction proceeded together on a "fast track," in construction parlance. Craftsmen came to the job from all over America and Europe, including crews recruited from Hollywood studios, particularly the one that built the sets for *Cleopatra*. To oversee the job, Getty hired an English architect, Stephen Garrett, who had been his consultant for remodeling the Getty house in Posillipo beside the Bay of Naples. He was a busy man.

The Getty Museum in Malibu was not a replica of the Villa dei Papiri, but a reconstruction based partly on fact, partly on scholarly imagination. No architectural elevations of the original building are preserved, and until recently it was not certain whether there was a second floor around the inner peristyle. (The reopening of the shafts in the late 1980s allowed archaeologists to observe upstairs water pipes that Weber had missed and to verify that there was, indeed, a second floor.) Otherwise, the layout of the museum building was substantially the same as the buried original: a large two-story main block, including an atrium and the usual rooms adjoining it; an inner peristyle with garden; a dining room *triclinium* and a vast 350-foot-long peristyle with colonnades, frescoed loggias, fish pond, and garden. The axis of the building was turned 90 degrees, however; the original villa was laid out with its long axis parallel to the coastline, while the direction of the canyon site at Malibu required a perpendicular axis. The original peristyle would have been enclosed on all sides, while the end wall of the museum was left open, and for good reason—it had beautiful vistas of the Pacific Ocean beyond.

The traditional Roman peristyle was constructed on a massive artificial terrace, and so it was in Malibu, although for thoroughly modern purposes: beneath the peristyle was an underground parking garage. The garden in the Getty peristyle was designed in the geometrical Roman manner, and although no one knows precisely what a Roman garden looked like or whether it had more than a mile of boxwood hedges, as this one did, it must have been a reasonable approximation. Replicas of the bronze sculptures recovered from Piso's villa were placed in what are known, or thought to be, the locations in which they were discovered. The five famous bronze so-called *Dancing Maidens* in the inner peristyle were placed as though they were fetching water at the edges of a long, narrow pool. (When the Museum opened in 1974, reproductions of pieces of wooden furniture unearthed at Herculaneum were also shown. The originals had been preserved in a carbonized state. In fact, all manner of organic matter survived the centuries: eggshells were found in cupboards.)

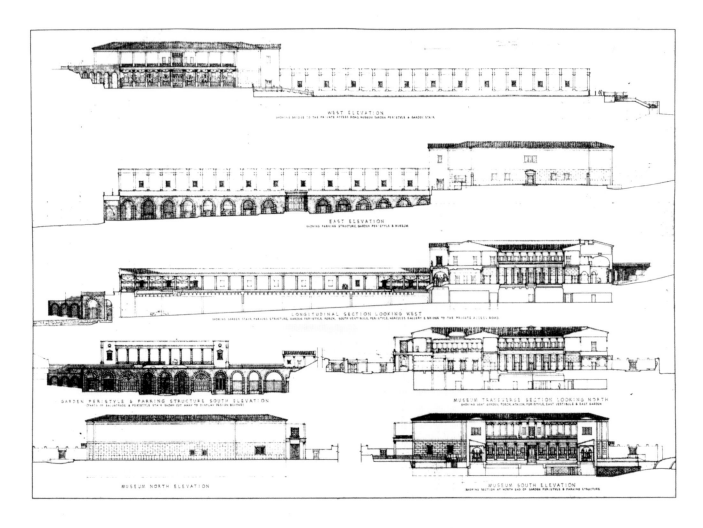

Langdon and Wilson's elevation
drawings for the Villa building

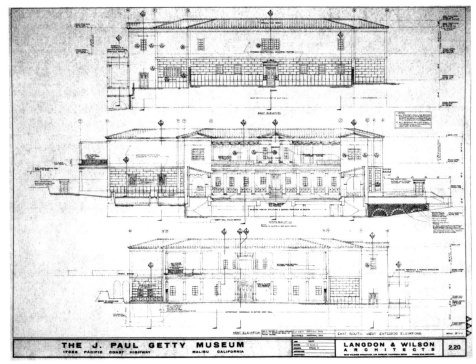

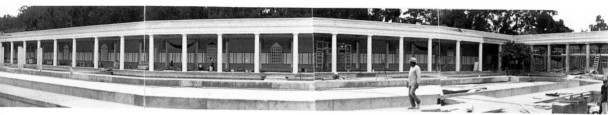

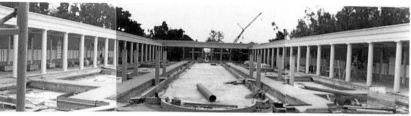

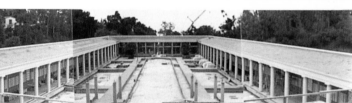

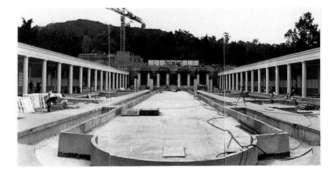

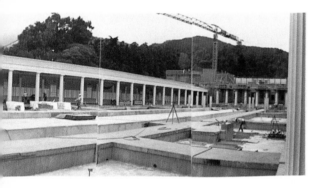

Wide-angle photomontages made for
Getty's review give an impression of
the massive and intricate reinforced
concrete construction required to
realize the design.

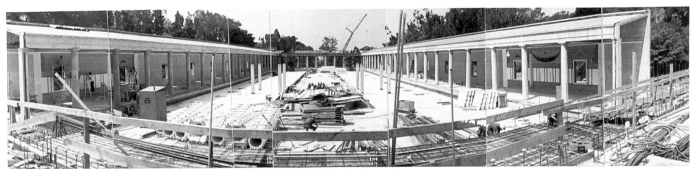
looking south down Peristyle Garden [view from entrance to Museum]

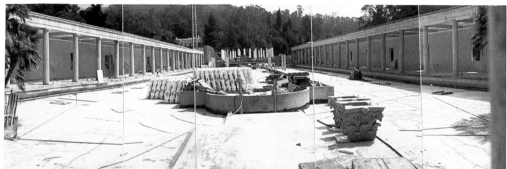

Capital to column on south elevation

looking north up Peristyle Garden

Coffered ceiling (in fibrous plaster panels) to ceiling of Peristyle Garden collonade

looking west across south end of Peristyle Garden

↖ Mediterranean Palm Tree

Column to south collonade

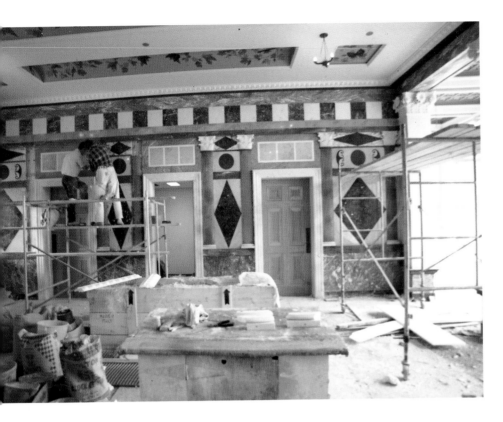

Workmen for the firm of Carnevale and Lohr are shown at the painstaking task of creating the marble mosaics [top left and bottom]; [top right] Garth Benton at work on the wall painting; [opposite page] a photograph of a sketch for a bay that was sent for Getty's review.

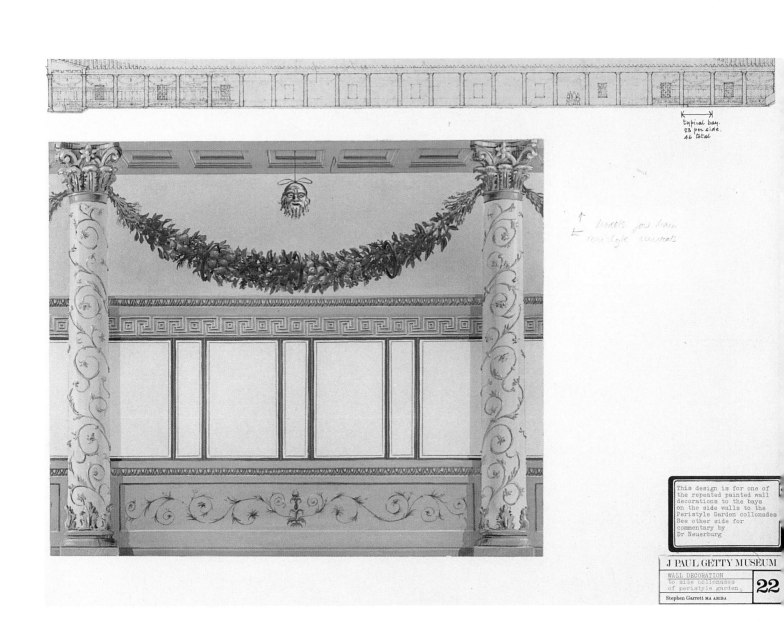

typical bay.
23 per side.
46 total

↑ models for drawn
└ peristyle murals

This design is for one of
the repeated painted wall
decorations to the bays
on the side walls to the
Peristyle Garden collonades
See other side for
commentary by
Dr Neuerburg

J PAUL GETTY MUSEUM

WALL DECORATION
to side collonades
of peristyle garden

22

Stephen Garrett MA ARIBA

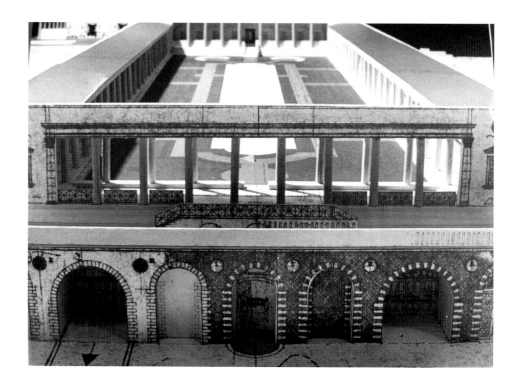

The gardens were designed by the Los Angeles landscape architect Emmett Wemple. The selection of the plantings was based on wall paintings, root tracings from the mud at Herculaneum, and the letters of Pliny the Elder. (This important figure from history lived across the Bay of Naples from Vesuvius; his nephew Pliny the Younger told the story of how, in his capacity as commander of the Roman fleet, his uncle sailed across on a rescue mission during the eruption and died with many others on the beach at Stabiae.) Only plants known to have been used by the Roman *topiarii*, or master gardeners, were used in Malibu: dozens of varieties, including pomegranate, oleander, bay laurel, acanthus, holly, rhododendron, myrtle, roses, iris, narcissus, and olive, fig, apple, and pear trees. Many of them were imported from Italy; others were bought in Californian nurseries (conditions in the Bay of Naples are so similar to those in Malibu that nurseries often had exactly what was needed). This meant that many familiar flowering plants of Southern California, such as bougainvillea, were missing from the garden. The concern for authenticity at the Villa sometimes went to extremes. When the architects sought advice on how to make a tile roof look 2,000 years old, or just 200, a reply from the London firm of Widnell and Trollope reported the success they had had with the roof of Getty's other Italian house at Palo, also near the sea. Their secret was a "fairly liberal application of salt and cow dung in a fairly liquid form." In the end, nature was allowed to take its course on the roofs at Malibu.

Two deviations from Roman precedent were required in the Peristyle Garden. Because the garden was the roof of the underground garage, the 220-foot pool is only 18 inches deep, while the original would have been perhaps a dozen feet deep and used as a fish tank. (In Los Angeles, codes would have required a fish tank of the original depth to have a lifeguard!) The garden topiaries in Malibu were simple geometric ones, while Roman *topiarii* produced extravagant designs, sometimes re-creating battle scenes and chariot races, or spelling out their employer's name. It was decided that the maintenance expense for extensive topiary sculpture would be prohibitive. The Romans with their technological genius would have admired a twentieth-century device used in the garden: an underground liquid fertilizer-injection system.

The marble floors and polychrome marble walls, the wall and ceiling paintings, and the ornamentation in plaster imitate the Roman styles popular in the first century A.D.

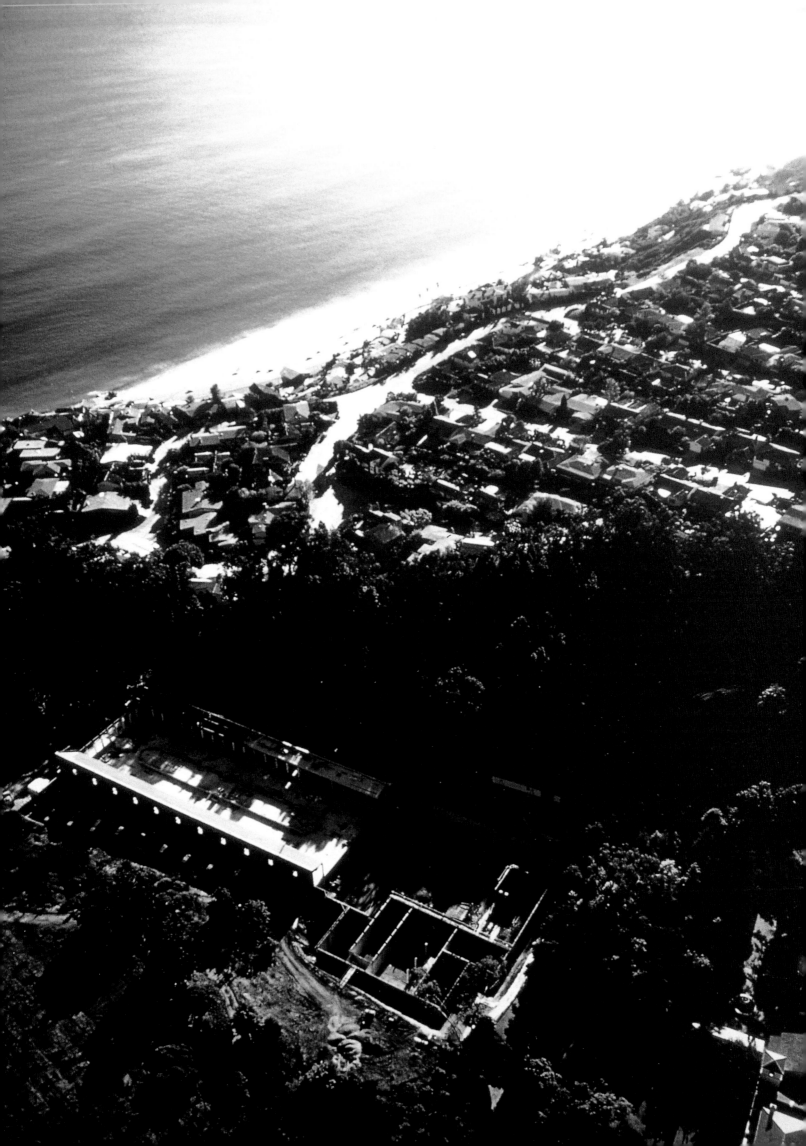

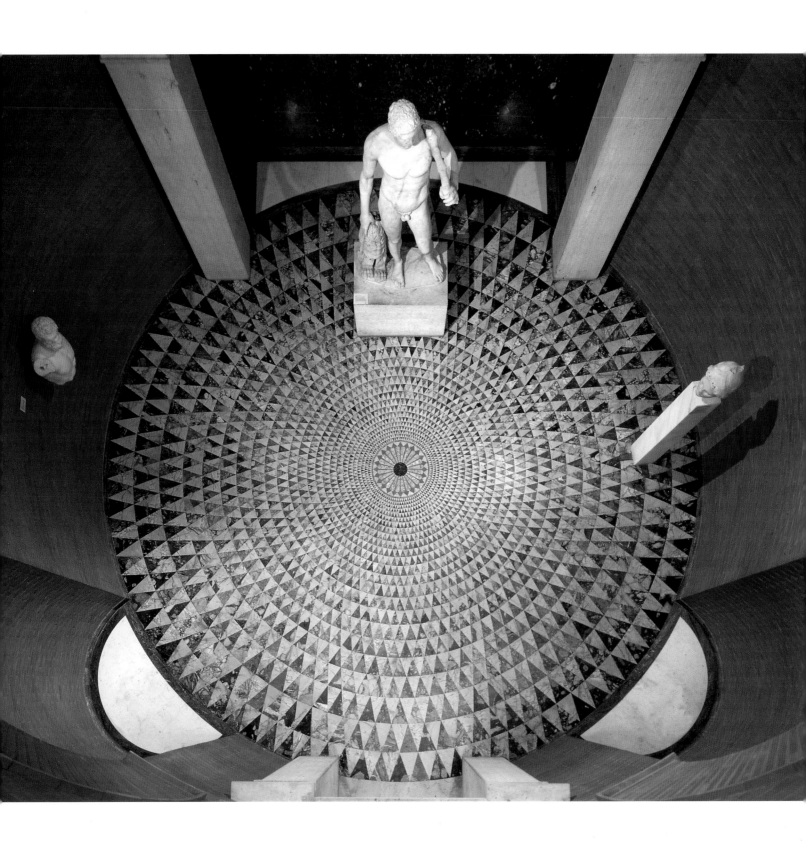

Sculptor working on the
model for the capital
for 128. BN photo of
original in background

Full-size plaster model
of capital for 128.
To be executed in
coloured marbles.

Special care was taken in designing the installation of the *Lansdowne Herakles*, which stands on a simple base in a green and red marble niche. The elaborate pavement is based on the first floor found at the Villa dei Papiri, which may have belonged to a belvedere overlooking the sea. Like others throughout the Museum, it was meticulously planned. After the architects had established the size of a given room, the design of the ancient floor chosen for reproduction in it was adapted to fit, and drawings were sent to Italy. Marble was selected, pieces were cut to match those of the original floor, the pieces were attached to backings and shipped in sections to Malibu, and the floor was installed.

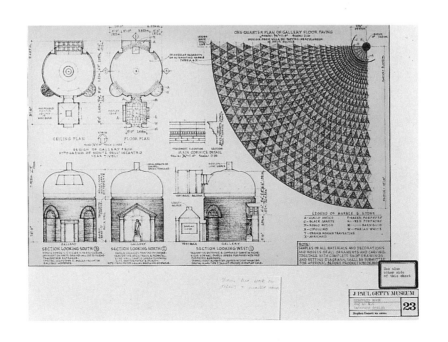

The gardens in both [this page] the Inner and [opposite page] Outer Peristyle have elaborate symmetrical plantings as they would have had in the ancient villa, geometric in layout but softened by the low, gentle curves of the topiary plantings. Oleander, ivy, and box hedges are the dominant forms; vine-covered trellises have focal positions in the Main Peristyle Garden. The statues and busts are casts of sculptures discovered during explorations of the Villa dei Papiri.

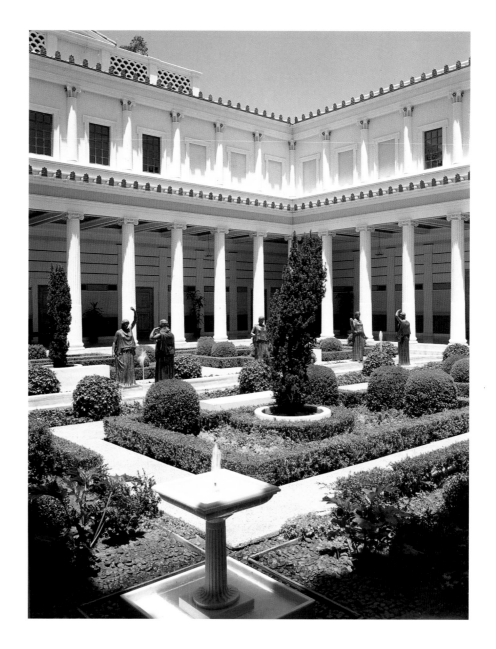

Much was based on examples excavated in the three towns buried by Vesuvius—Pompeii, Herculaneum, and Stabiae—and many of the mosaics are actually made of salvaged ancient marbles or new pieces obtained from reopened ancient quarries. In the small room off the Inner Peristyle that was designed to display one of Getty's favorite sculptures, the *Lansdowne Herakles*, which became known as the Temple of Herakles, the beautiful inlaid floor with a wedge pattern reproduced the floor of the circular belvedere, the hard surface struck by diggers when they first found the Villa dei Papiri.

One change from traditional Roman design in the Villa was the choice of colors for some of the wall decorations. Although the pinks and yellows looked too garish to some early visitors and critics, the original Roman walls would actually have been even more boldly colored, with much more red and with much less white. The Villa represented a compromise between the full-blown color scheme of sumptuous Roman houses and the pale colors, or white, of the neoclassical buildings of the nineteenth century (which were influenced by Greek and Roman ruins that had been bleached of their color). This compromise was approved by Getty himself, as were all major and most minor decisions at the new Museum.

There were other modifications. A *nymphaeum* (a garden decorated with plantings and statuary) in the original Roman building gave way to the West Garden at the Museum,

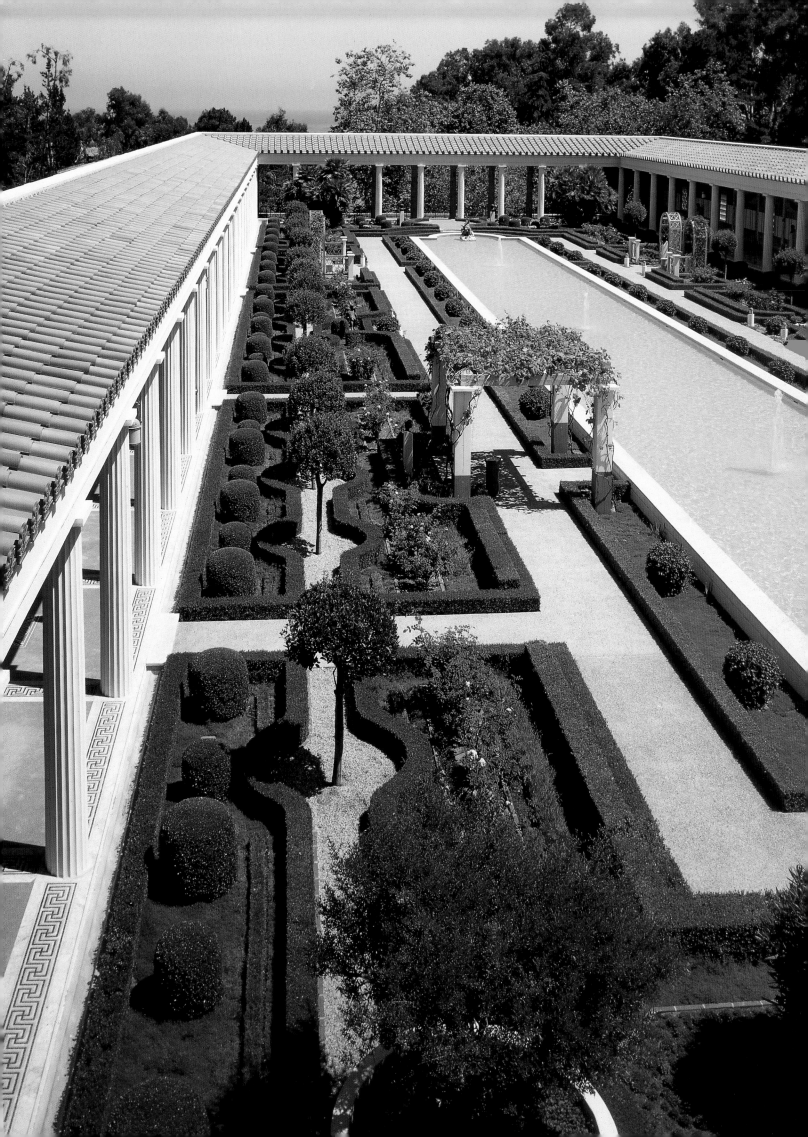

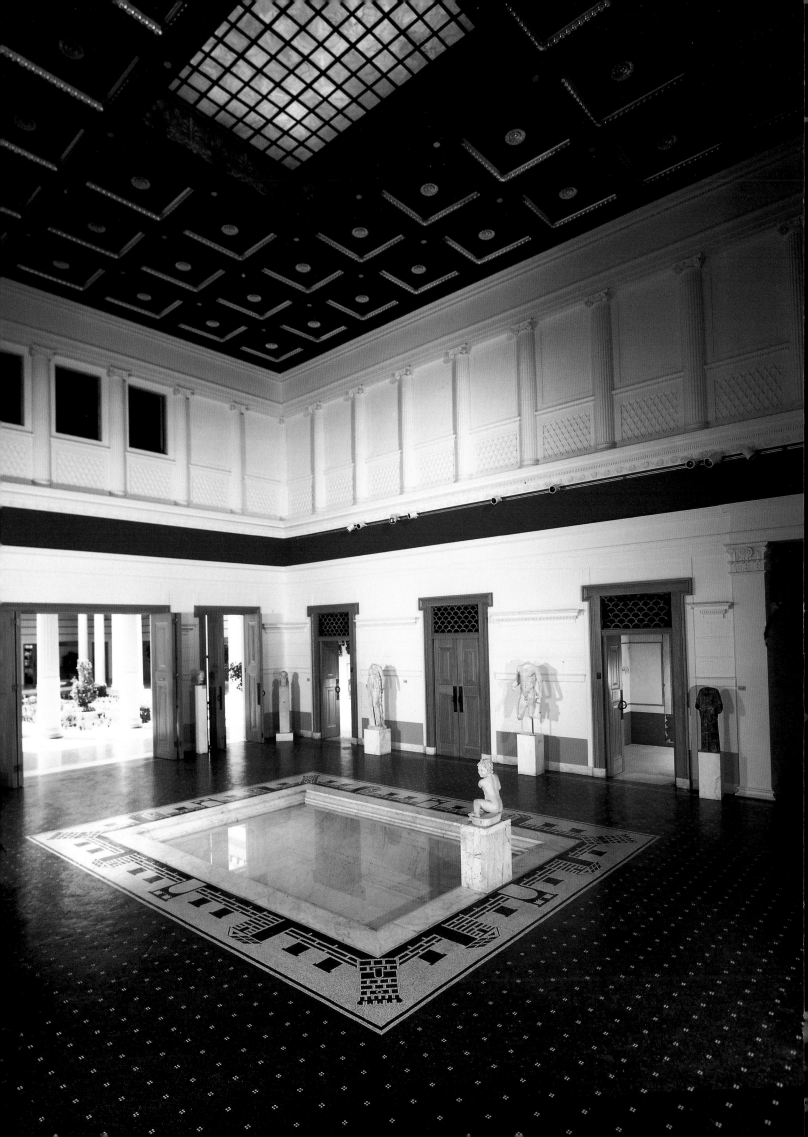

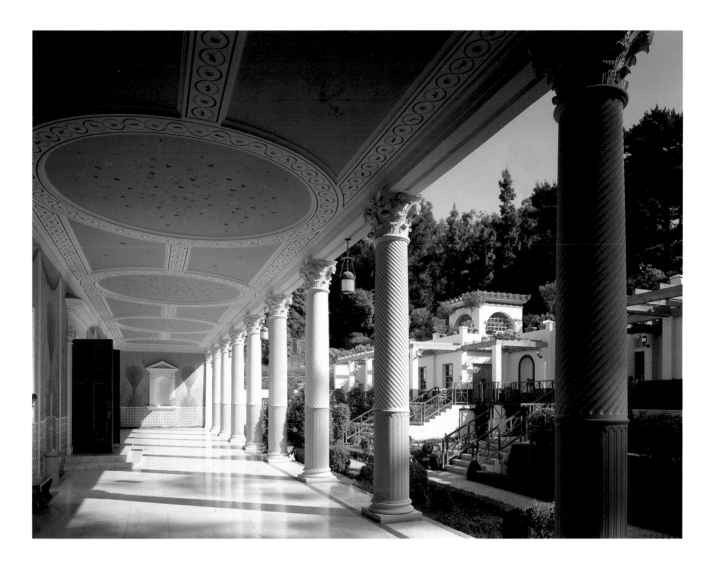

Some modifications to the original villa were made to accommodate the needs of a modern museum. [Opposite page] In the Atrium the hole in the ceiling, which in Roman times would have been open to allow rainwater to collect in the pool below, is closed in the Museum for practical reasons. [This page] The patio of the Tea Room of the Museum, at the right, would have been a *nymphaeum* at the Villa dei Papiri, an enclosure with plants and fountains.

which was soon preempted by the architect to become the patio of the Tea Room. The *compluvium* in the roof above the water basin in the Atrium would have been open in the original villa, in order to catch rainwater, while for security reasons it was closed at the Museum.

Taken all in all, the Villa was a thoroughly informed but still imaginative reconstruction of a great patrician building. It had a historical place of its own: it carried on an old tradition of reconstructing classical buildings, which dates from the Renaissance and became a particular preoccupation of nineteenth-century architects and their wealthy patrons, especially after the discoveries of Pompeii and Herculaneum. Young French architects sent to Rome from the Académie des Beaux-Arts were required to invent reconstructions of Roman buildings, starting with measured ruins and proceeding through colored renderings. Not all reconstructions remained on paper. King Ludwig of Bavaria had a Pompeiian house built for him at Aschaffenburg. The Villa in Malibu was part of an American tradition as well: it was another in a long series of architectural dreams made real by wealthy Americans for their own pleasure and for the benefit of the public. The Villa dei Papiri remains buried today, and may remain so forever. The Getty Villa halfway around the world has given us the best re-creation we are likely ever to have of a sumptuous Roman residence and some of its pleasures.

The new Getty Museum opened on January 16, 1974, at a cost of a little more than $18 million. The eighty-one-year-old founder retained the title of director; Stephen Garrett was deputy director. The collection, which had required almost twenty years to grow into nine galleries in the Ranch House, expanded almost overnight into twenty-seven galleries—twelve on the ground floor housing the antiquities collection, fifteen upstairs with the decorative arts and paintings. The Ranch House Museum had about 6,000 square feet of gallery space, including the sculpture court; the new building, 48,000 square feet.

Getty put a $40-million endowment in place and approved a $2-million operating budget. He also bought works of art for the Museum at a quick pace in the early seventies in order to fill the new galleries. Getty and his museum staff were more active in the higher reaches of the art market than any collectors in the world. Ten years after he had refused to bid on Rembrandt's *Aristotle*, he bought Lord Harewood's *Death of Actaeon* by Titian for $4 million, a world auction record at the time. (As it turned out, the Museum never got the painting. Operating under a law giving British museums the right to keep important works in the country by matching the purchase price, the National Gallery in London made a successful appeal for contributions and nullified Getty's purchase.)

While a concerted effort was required to fill the galleries with first-rate works of art, no effort at all was required to fill them with people. Getty made it clear from the beginning that he would endow the new museum so that it could remain free of charge. Curiosity, publicity, and free admission made it a hit from opening day. The crowds created an immediate and pressing problem. Cars lined up on the Pacific Coast Highway and clogged the adjacent residential streets. The neighbors were unhappy, and since they owned the narrow strip of land at the exit from the Museum grounds to the Pacific Coast Highway (Getty had passed up an opportunity to buy it outright), they could have shut down the Museum if the situation had not improved. But it did improve, from their point of view. The Museum was required to be closed on weekends and remained so until 1983. A reservations system for parking was instituted, and visitors were prohibited from walking onto the museum grounds except with bus passes. These strictures, misunderstood as elitist in some quarters, in fact were mandatory in view of the political and practical realities.

And the traffic was not the half of it. Neither Getty nor anyone associated with the new museum anticipated its immediate, immense popularity. Nor had they provided all the necessities for a growing operation: the building had no loading dock or freight elevator, and far too little space for many functions and tasks performed by up-to-date museums. More important, there was no provision at all for educational services.

Getty had written: "There are replicas and imitations of ancient public buildings, but none of a private structure—so this one should provide a unique experience. . . . I would like every visitor at Malibu to feel as if I invited him to come and look about and feel at home." Among the peristyles, gardens, arbors, and porches on the ground floor, the effect of the Villa was just as Getty had hoped. Unlike most museums, which look and feel like the civic monuments that they are, the Villa felt more like a home, albeit a grand one. Despite being too small now, inconveniently located, and poorly laid out for accommodating 400,000 people a year, the Villa has given visitors an unforgettable experience of architectural surprise, historical allusion, and hospitality.

The Museum was greeted by many critics as a folly, a new tourist attraction for Southern California; see Gettyland, then drive 60 miles to Disneyland. Some critics said the whole project was too learned, others that it was kitsch. Before long, however, the postmodern classicism of the 1970s and 1980s made the notion of historical re-creation more respectable among the architecturally sophisticated, and Getty's Roman villa looked to be

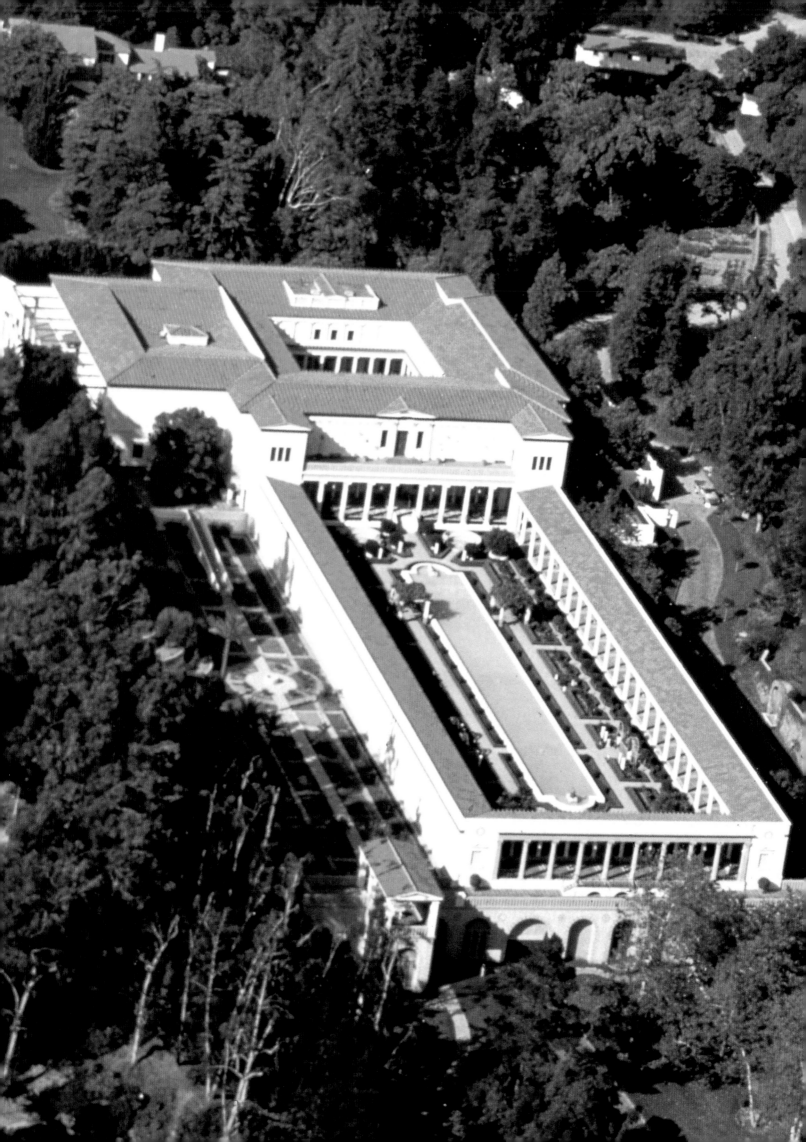

a harbinger of things to come. Today there remains a great difference in attitude toward the Villa between people who have actually been there and those who have not. Those who have may not love the idea of an imitation Roman villa in a Los Angeles suburb, but they seldom deny its seductive powers.

Getty imagined that the new museum would be harshly reviewed in some quarters, but according to friends, he was wounded by remarks that attributed the folly of the Villa to the vanity of the man. At the same time, he was reassured by the fact that the public loved the place. It was clear that many of the thousands who had been attracted by sheer curiosity were encountering works of art often for the first time, and doing so in a receptive frame of mind; to their surprise and delight, they were enjoying the experience. Getty had shown that a museum was not something to be feared. Word of mouth was keeping the reservations line busy, and school groups were pressing to come.

For several years before the Museum opened, Getty had listened quietly as visiting emissaries to Sutton Place showed him pictures of the work in progress and gave him vicarious walks through the newly installed galleries. In those last few years of his life, he would sometimes rise abruptly from a business meeting and walk into one of the great rooms for a conversation about the paintings with any curator or knowledgeable guest who happened to be on hand. He often kept people up late talking about art. Just days before he died, on June 6, 1976, Getty asked one of his curators to show him pictures of his favorite works and to read to him from the catalogues of the collection.

There is no doubt that Getty died with his art on his mind, but there was every reason at the time to doubt that this would mean much in terms of his bequest to the Museum. In fact, he had told his curators any number of times to expect nothing more from him except his private collection at Sutton Place. Otherwise, the Museum would be on its own in the post-Getty era, with an endowment sufficient for operating expenses but little more. That was the understanding in Malibu.

This posture must have been something of a ruse on Getty's part. His original will, drafted in 1958, four years after the establishment of the Museum in the Ranch House, left the bulk of his estate to the Museum. Subsequent codicils modified the details of this bequest, not its basic intent. This was not public knowledge, however, and the staff was as stunned as everyone else in the art world when they read in the newspaper that Getty had left the Museum four million shares of Getty Oil stock worth $700 million. The newspapers quickly ran stories declaring that the Getty Museum was now the richest in the world, with an endowment vastly larger than the Metropolitan Museum's $130 million—larger even than the combined endowments of all the other major museums in America—and sufficient to support an annual acquisitions budget of at least $50 million, maybe $100 million.

The bequest was taken to court, however, and more than once. The first time, the issue was not that the Getty family had been ignored—for they had been generously provided for by the trust established by Getty's mother, Sarah, thirty years earlier, now worth about $1.3 billion—but, rather, that the last codicil to the will put the assets of the Museum under the direct control of its trustees, not the family. After several years in the courts, the codicil was confirmed, but the funds were not immediately forthcoming. Instead, the courts allotted the Museum a large advance representing interest and dividends against the presumed inheritance. But then these disbursements were halted in 1979 by another complicated lawsuit, and the following year the IRS moved to collect $628.63 million in taxes on the grounds, in effect, that the Museum did not qualify as a charity under the letter of the law. A further complication during this period was an offer by

the consortium from Kuwait to buy the estate's shares of Getty Oil. These legal tangles induced the Board of Trustees to suspend acquisitions until the bequest was actually in hand.

The IRS lost its case, the Kuwaiti offer was rejected, and an out-of-court settlement was reached on the final pending lawsuit. In the spring of 1982, six years after Getty's death, the legal issues were finally resolved and the bequest became official. Newspapers carried another round of stories when the money was wired into the Museum's bank account in Los Angeles. Duly noted was the fact that the market value had risen from $700 million to $1.2 billion. (Two years later, after Harold M. Williams became president, the value of the bequest almost doubled as the result of the sale of Getty Oil to Texaco, at that time the largest corporate acquisition ever.)

The years 1982 to 1984 were ones of rapid growth and change. A decision was made by the Trustees not only to strengthen the Museum but also to create five new organizations devoted to worldwide conservation, art scholarship, and public education in the arts (see Introduction and Appendix 1). What was originally the Museum trust became the J. Paul Getty Trust. Directors were appointed for the Trust's new programs, staffs were recruited, and operations began.

V.

The Getty Museum in a New Era

Growth and change were occurring at the Getty Museum, too. Stephen Garrett, who as deputy director since 1973 and director since 1977 had overseen the construction of the Villa building, gotten the Museum running, and created educational services and publishing programs, had retired in 1982. For a time the Museum was run by Stephen Rountree, deputy director, and by Otto Wittmann, the trustee who served as acting chief curator.

The first question in 1983 for a brand-new director and his senior staff was: what kind of art collection should the Getty Museum try to form? There were no restrictions in the will; theoretically the Museum could buy anything, go in any direction the Trustees would approve. Indeed, Getty's will was one of the most remarkable ever made by an art collector, especially such a strong-willed man with such clear preferences: not only did he leave a huge amount of money, but also he made a bold act of faith, entrusting virtually every decision about its use to his Trustees and Trustees to come. Nevertheless, there were some important factors to take into account. To begin with, the collection already had a distinct character—specialized and narrowly focused on a few areas of European art— and this distinctness had virtue. Moreover, the expanding Los Angeles County Museum of Art was providing the city with works representing the whole world, from the earliest times to the present. Why try to create another large general art museum? It would have been possible for the Getty Museum to broaden the geography to include art of Asia, Africa, and the Americas, and to extend the chronology to include the twentieth century. However, specialized art museums elsewhere in the vicinity covered these fields: English art at the Huntington, Asian art at the Pacific Asia Museum, contemporary art at the new Museum of Contemporary Art—why compete? Instead, why not see the Museum's limits as a potential benefit, and develop deeper, richer holdings within the existing boundaries? Prices had already risen enough by 1983 to suggest that, despite its buying power, the Getty would find it impossible, after such a late start, to create a collection that was both broad-based and distinguished. It would be a challenge just to build up the existing collections and make them truly significant. It was going to cost a fortune simply to buy great paintings, since Getty had left behind a very uneven and generally disappointing collection, much inferior to that of the Norton Simon Museum. On top of that, to acquire Greek and Roman antiquities that would be worthy of a great museum would be an expensive and uncertain business.

It was decided in 1983 to remain a museum mainly of European art. The three existing collections would be strengthened and a few new ones added. There was already a precedent for expansion. In 1981, the Museum had begun putting together a small group of drawings at the urging of George Goldner, the head of the photo archive, who spotted the great Rembrandt chalk drawing of a nude (then thought to represent Cleopatra) coming up in a London auction and persuaded Otto Wittmann, Harold Williams, and the Trustees to buy it. More acquisitions followed. By 1983, it was obvious that, since the market looked promising and the material had a logical relation to the other Getty collections, drawings should be a new department and the museum staff should create as fine a collection as could be formed.

A remarkable opportunity arose in 1983, when the Museum was offered the finest private collection of illuminated manuscripts in the world. Assembled by the German chocolate manufacturer Peter Ludwig and his wife, Irene, it contained 144 examples—a survey of medieval and early Renaissance manuscripts containing a staggering wealth of illumination by the greatest masters. No such collection existed outside the East Coast. Panel paintings of comparable importance from the same periods, if they existed at all, had practically disappeared from the market; for the Getty Museum's audience, manu-

Drawings had not been among the works of art Getty himself collected. In 1981, the Trustees were convinced to buy a superb Rembrandt drawing of a nude (thought then to be Cleopatra), thus beginning what eventually became a drawings collection of international importance.

Rembrandt van Rijn
Dutch, 1606–1669
Nude Woman with a Snake, ca. 1637
Red chalk and white chalk,
24.7 x 13.7 cm (9¹¹⁄₁₆ x 5⁷⁄₁₆ in.)
81.GB.27

The arrival from Germany of the Ludwig collection of illuminated manuscripts was a major event for the Getty Museum and for collecting in America: here the two rare book dealers involved in the sale, (left) the late Hans P. Kraus and (center) the late Jake Zeitlin, pose with (right) Thomas Kren, who was then Associate Curator of Paintings at the Getty Museum and is now Curator of Manuscripts.

[Opposite page] Examples of the quality and breadth of the Ludwig collection:

[Top left]
Simon Bening
Christ before Caiaphas
Prayer Book of Albrecht of Brandenburg
Belgium (Bruges), ca. 1525–30
16.8 x 11.5 cm (6⅝ x 4½ in.)
Ms. Ludwig IX 19 (83.ML.115),
fol. 128v

[Top right]
Master of Gerona
Initial *A* with *Christ in Majesty*
Antiphonal
Italy (Bologna), late thirteenth century
58.2 x 40.2 cm (22¹⁵⁄₁₆ x 15¹³⁄₁₆ in.)
Ms. Ludwig VI 6 (83.MH.89),
fol. 2 (detail)

[Bottom left]
The Women at the Tomb
Sacramentary
Germany (Mainz or Fulda), second quarter of the eleventh century
26.6 x 19.1 cm (10½ x 7⁷⁄₁₆ in.)
Ms. Ludwig V 2 (83.MF.77), fol. 19v

[Bottom right]
Initial *N* with *A King as Judge*
Vidal Mayor
Northeastern Spain,
ca. 1290–1310
36.5 x 24 cm (14⅜ x 9⁷⁄₁₆ in.)
Ms. Ludwig XIV 6 (83.MQ.165),
fol. 72v

script illumination could represent this period. The purchase was made by the trustees, and within a year Thomas Kren was appointed curator and the Department of Manuscripts was formed.

Getty had bought only a few bronzes of the seventeenth and eighteenth centuries to complement his pieces of furniture, but he had no great interest in sculpture after antiquity. This was a logical area for the Museum to expand, given the close connections with its paintings and decorative arts, not to mention antiquities. And there seemed a reasonable chance of putting together an excellent group of sculptures within a decade or so. In 1982, the Trustees had bought the first sculpture, Giambologna's marble *Female Figure*, an excellent start. A curator of sculpture, Peter Fusco, was recruited in 1983 to start a new department for the Getty Museum.

Chance played a role in the creation of the fourth and last new Getty collection—photographs. The new director was approached in 1983 by a New York dealer, who showed how it might be possible to buy, more or less simultaneously, three of the world's most important collections of photographs covering the entire history of the art from its invention in 1839 to the present. A dozen other smaller holdings could be added at the same time. All in all, the Museum would immediately have about 26,000 examples, each chosen by connoisseurs—picture for picture perhaps the best collection in the world, and the only comprehensive West Coast collection. Where better to assemble it than Los Angeles, the city made famous by film? In 1984, the trustees approved, and a curator, Weston Naef, was hired to create and staff a new department.

Building a great collection led the list of the Museum's goals, but there were others. A first-rate staff of conservators was needed to examine and treat new acquisitions as well as care for the existing collection. A distinguished private restorer in Florence, Andrea Rothe, came to head the paintings conservation studio. New conservators were recruited for decorative arts and sculpture: Barbara Roberts, then Brian Considine. Jerry Podany was put in charge of antiquities conservation. Each of these added skilled people to their staffs. A small complex of laboratories and studios was built around the original museum courtyard next to the Ranch House (which after 1974 had become an office annex), and an analytical lab for museum objects was established as part of the newborn Getty Conservation Institute—the first of many collaborations among Getty organizations.

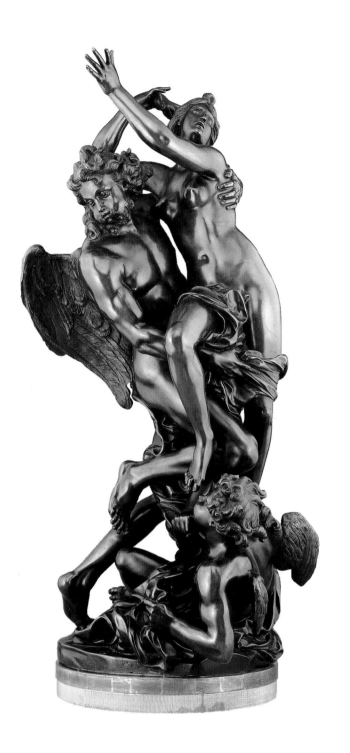

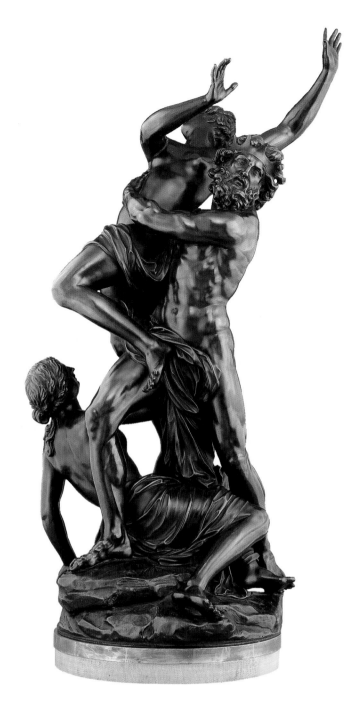

[Left]
After a model by Gaspard Marsy
French, 1624–1681
Boreas Abducting Orithyia, cast
ca. 1693–1710
Bronze, 105 cm (41 5/16 in.)
88.SB.74

[Right]
François Girardon
French, 1628–1715
Pluto Abducting Proserpine, cast
ca. 1693–1710
Bronze, 105 cm (41 5/16 in.)
88.SB.73

Other goals were educational. Getty's attitude about educational services had been to consider them unnecessary expenses. In the later 1970s, however, an education department was created, then a guest scholar program, which, over a period of fifteen years, has brought 171 museum and university colleagues to Los Angeles for periods of two to eight months to work on their own projects. These scholars not only have done important work, they also have made the Getty Museum much better known throughout the world. Programs for guest conservators and interns, as well as a lecture series, were added, and after 1983 such specialized services to scholarship as seminars, symposia, and an expanded program for guest scholars became part of the general growth.

Beginning in 1983, it became a basic objective that visitors get ample opportunities to learn about the works of art they are seeing. Experience and common sense had shown

Nearly life-size, this marble nude is an early work by the great Flemish-Italian sculptor Giambologna. It was the first major work of Renaissance sculpture bought by the Getty Museum.

Giambologna (Jean Boulogna or Giovanni Bologna)
Italo-Flemish (born Douai, active mainly in Florence), 1529–1608
Female Figure (possibly Venus, formerly called *Bathsheba*), 1571–73
Marble, H: 115 cm (45¼ in.)
82.SA.37

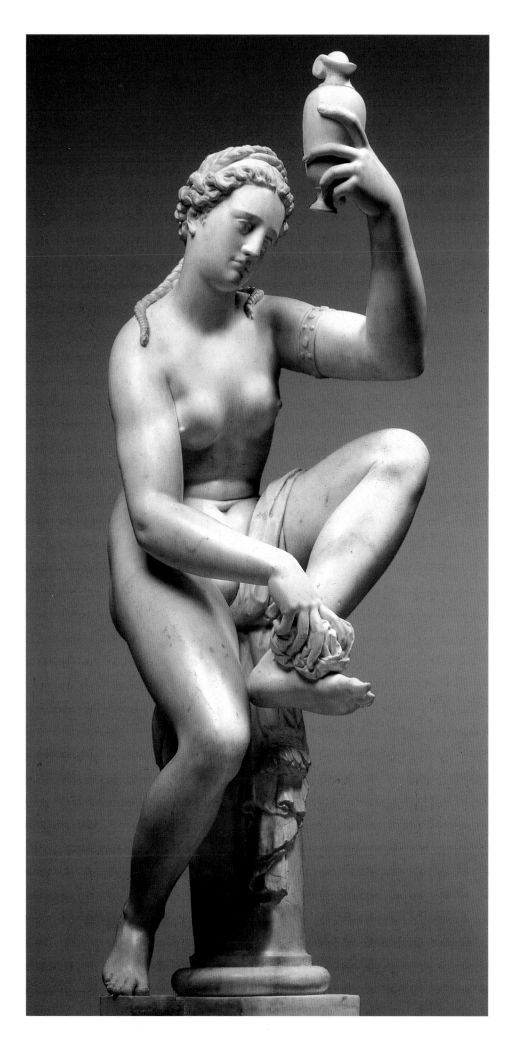

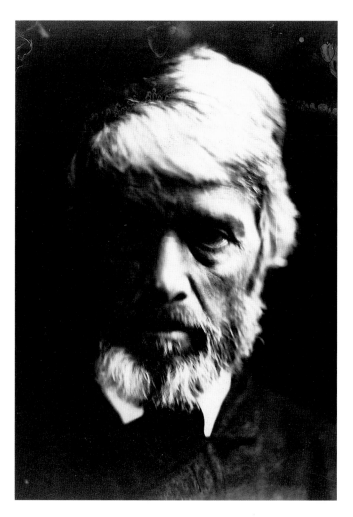

In 1984 a group of private holdings of photographs were bought *en bloc* to form an entire new Museum collection. In the top row are photographs by Edgar Degas and Julia Margaret Cameron that belonged to the influential collector Samuel Wagstaff; below them is a Man Ray abstraction from the large and important collection of Arnold Crane.

[Top left]
Edgar Degas
French, 1834–1917
After the Bath, Woman Drying Her Back, 1896
Gelatin silver print, 16.5 x 12 cm
(6¹¹⁄₁₆ x 4¾ in.)
84.XM.495.2

[Top right]
Julia Margaret Cameron
British, 1815–1879
Thomas Carlyle, 1867
Albumen print, 36.4 x 25.8 cm
(14⁷⁄₁₆ x 10³⁄₁₆ in.)
84.XM.443.23

[Bottom]
Man Ray
American, 1890–1976
Gun with Alphabet Squares, 1924;
Gelatin silver print, 29.5 x 23.5 cm
(11⁵⁄₈ x 9¼ in.)
84.XM.1000.171

Conservation departments were strengthened to study potential acquisitions and care for the collection. Andrea Rothe came from Florence to head the new team of paintings conservators. Here he is pictured working on the restoration of Mantegna's *Adoration of the Magi*.

that they are more apt to enjoy and remember works of art if they learn something about them. Moreover, studies have demonstrated that different people learn in quite different ways—some by reading, some by listening, some by making visual connections. The ideal is to provide the means for a thoroughly enriching experience for every visitor, young or old, novice or experienced. This led the Museum to recruit more and better professional educators and commit money and attention to their work. It also led to studies of the audience, in order to know better who was attending and who was not and to get help from the visitors themselves in learning what services needed improvement. Soon there was a professional evaluator on the staff whose work helped shape our approach to the audience.

Studies in 1984 and 1988 of the visitor population put its demographic peculiarities in sharp relief. Although the Museum was full every day, the audience was 90 percent white and well educated, with 75 percent visiting for the first time. The local population of Latino, African-American, and Asian descent was simply not coming to the Getty, and regular repeat visitors were in small proportion to tourists. These statistics did not differ radically from those of other local art museums, they were just more extreme. The Museum clearly was not taking advantage of its most obvious opportunity, of providing a large part of the Los Angeles population with a pleasant and possibly life-changing experience. The

Conservation studios and laboratories were built in and next to the Ranch House, which itself became an office annex to the Museum. [This page] Antiquities conservators are seen working on the *Lansdowne Herakles.* [Opposite page] Decorative arts conservators protect a German giltwood console table (upside down) from pest infestation using a system developed at the Museum.

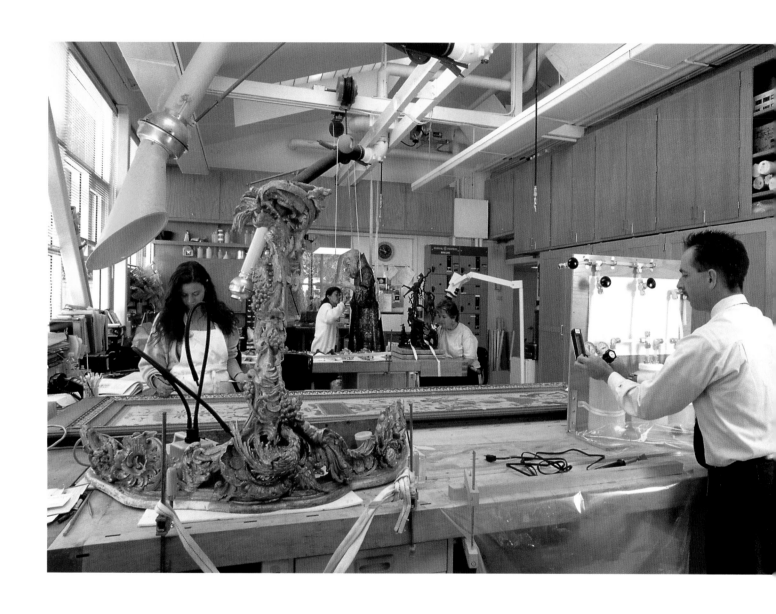

staff began to put concerted effort into making the Museum better known and more attractive to sectors of the Los Angeles public that weren't attending, and studying the results. Latino audiences were a particular target. Spanish-speaking volunteers and staff, including reservations agents, were added. More bilingual materials and activities were developed. Community organizations, churches, schools, and the Spanish-language media were contacted, particularly when an exhibition was held that might be of special interest to Latino audiences. The result has been encouraging: nearly ten years of effort have made a solid increase in attendance by Latinos from Los Angeles and surrounding areas.

In 1991, the results were published of a study involving eleven art museums that explored the usefulness of focus groups for understanding the needs of museum audiences. Sponsored jointly with the Getty Center for Education in the Arts (now the Getty Education Institute for the Arts), it showed how illuminating this technique can be. First-time museumgoers reported that they were surprised at the pleasant and valuable time they had but were blunt about where museums fail. In the Getty's case, ironically, this included not making ourselves well enough known to the public—thus not seeming to offer an invitation—and having confusing (or absent) signs and illegible labels. (Teams of staff members listening to these candid observations come away more apt to see the quality of the visitor's experience as the responsibility of the entire staff.)

A statement of the Museum's mission written in 1984 gave precedence to the traditional activities of art museums—collecting, conserving, exhibiting, and interpreting the collection. As the collection grew year after year, however, the Museum's educational role gradually took on greater de facto prominence, and four years ago the first sentence of the mission statement was changed to read: "The mission of the J. Paul Getty Museum is to encourage the appreciation and understanding of art, its history, context, and meanings."

Building up the Museum's publications program was also a goal. At a time when other museums across the country were struggling to produce catalogues of their permanent collections, the Getty was in the lucky position of being able not only to publish specialized books and catalogues but to maintain a high standard of design and production. The Museum also began to produce popular books for its large general audience.

As the new collections of works on paper and parchment—drawings, illuminated manuscripts, photographs—grew in the first years after 1983, galleries were renovated upstairs for regular temporary exhibitions drawn from the new holdings. There have been more than 140 of these shows. A glance at the list of titles gives the flavor: "*Vie à Mon Désir*: Illuminated Manuscripts and their Patrons," "The Decorated Letter," "Fouquet's Century: Transformations in French Painting, 1415–1530," "Drawings of the Nude, 16th–19th Centuries," "Alexander Rodchenko: Modern Photography in Soviet Russia," "Fame and Photography," "Hidden Witness: African-Americans in Early Photography." These shows have changed the life of the Museum. A constantly changing menu of events has attracted many more repeat visitors. Some shows have been the focus of special activities to involve new, more diverse audiences with the Getty Museum.

Most museums work hard to get the attention of the media. The Getty Museum can say without arrogance that it had no need to, for it was covered all too avidly by the American and foreign press. In the early years of the post-bequest period, however, almost every story concerned sudden wealth. One misconception that would not go away was that the Museum was required by law to spend the Trust's income on acquisitions. This was never true. The Trust was and is a private operating foundation, whose purpose is to operate its own programs; it must simply spend 4.25 percent of its average endowment for qualifying

This fourth-century Greek bronze sculpture, one of the few discovered in modern times, was found in international waters in the Adriatic Sea. It is one of the key pieces in the Museum's antiquities collection.

[Right]
Statue of a Victorious Youth
Greek, 325–300 B.C.
Bronze with copper inlays,
H: 151.5 cm (59⅝ in.)
77.AB.30

[Above]
The statue before cleaning, as it appeared after being recovered from the sea.

Nicolas Poussin
French, 1594–1665
The Holy Family, ca. 1651
Oil on canvas, 100 × 132 cm
(39¾ × 53 in.)
81.PA.43
Owned jointly with the Norton
Simon Art Foundation, Pasadena

purposes—a wide variety—in three out of four years. A great deal of the new income flowing into the Trust was, in fact, used to set up and run its five new operations (Appendix 1).

In the years following the bequest, critics prophesied that the newly rich Getty Museum would simply buy everything in sight, running up prices and despoiling the artistic heritage of Europe. A precedent they often cited was Paul Mellon's aggressive purchases of British art in the 1960s and 1970s. Pictures by Constable, Turner, Stubbs, and other English painters were underpriced when Mellon began, and he was so avid that prices did, indeed, go up dramatically. (Mellon later created a museum and study center at Yale University that have done more for the worldwide appreciation of British art than anything else in modern times.) Perhaps some persistent myths in Europe—of Getty the oilfield wildcatter, of the American West as a frontier where anything goes, of Californians as upstarts with more money than taste—supported the idea that the Getty Museum would ruin the market for everyone else. Although the Museum's behavior over the dozen years that followed proved to be quite moderate, the worldwide publicity given to the Museum's purchase in 1977 of a fourth-century Greek bronze sculpture of a young athlete had helped to raise these fears.

Encrusted with barnacles, this piece had been inadvertently fished off the bottom of the Adriatic Sea off Fano in 1964 and sold to middlemen. Eventually it was offered to the Getty Museum not long before Getty's death. Cleaned of the barnacles, the sculpture was obviously one of the most beautiful Greek bronzes ever to appear, but Getty thought the price was too high. In 1977, the year following Getty's death, the Museum bought the

bronze for considerably less than the previous price. Even though the purchase came thirteen years after the piece was discovered, there were accusations that the Museum somehow had been a partner to a ring that had smuggled it out of Italy. Italian courts later ruled that the sculpture had been found in international waters and therefore had never been subject to Italian patrimony laws, but an impression had been made in the press that lingered for years afterward.

British newspapers were especially hard on the Getty Museum when it bought a fourteenth-century Sienese *Crucifixion* attributed to Duccio, and matching funds were raised within Britain to retain the work (including $500,000 from Getty's oldest son, J. Paul Getty II, a philanthropist long resident in London); the Sunday *Times* of London gloated that this would give the Getty Museum "a bloody nose."

In Los Angeles, a local paper wrote that the Getty might buy outright the former Pasadena Museum of Modern Art, now the Norton Simon Museum, which was alleged to be having financial difficulties despite an infusion of several million dollars from Simon. This story was triggered in part by the joint purchase by the two museums of Poussin's *The Holy Family*. In fact, the decision to buy it together was simply a means of avoiding an expensive contest between two museums 40 miles apart that would not have been in either's best interest. (The Poussin and a Degas pastel that was later bought jointly travel back and forth every two years.)

In actual fact, the Getty Museum could never have had such a dramatic effect on the world art market, or even the market in European art—this is, after all, an estimated $5- to $10-billion enterprise worldwide, and the Getty Museum was buying in only a few sectors of the market. In one area in which prices soared in the 1980s, twentieth-century paintings, the Getty Museum was not involved at all. Rather, its buying was judicious. Voluntary restraint in cases involving national patrimony would be a valuable policy in the long run.

In the areas in which the Getty Museum did collect, it was just one of several inflationary factors. Most of the very high prices for paintings sold in the 1980s were paid not by museums but by private collectors, many of them new to art, who saw these as attractive and safe investments—maybe even profitable—and who were not averse to the publicity cranked up by auction houses and savored by the press. Institutions can rarely compete with such buyers, who often come to the saleroom without a fixed limit and, when they want something badly enough, will bid whatever it takes. In every area of the Museum's collection, there have been times when private buyers have outbid us. To tell of two instances: a real estate magnate paid $4.4 million for eleven Renaissance drawings mounted on one page of a notebook assembled by Vasari, and a pharmaceutical heiress paid $4.8 million for a drawing by Raphael. This list could go on.

The scarcity of great works, hot competition from private buyers, and restrictive export laws in Europe have been facts of life for the Getty curators in the past dozen years. Their talent and a great deal of money have nevertheless brought about a profound change in the Museum's collection, which, though it still shows every sign of immaturity, is far larger and more important than it was. It has come to deserve a bigger home.

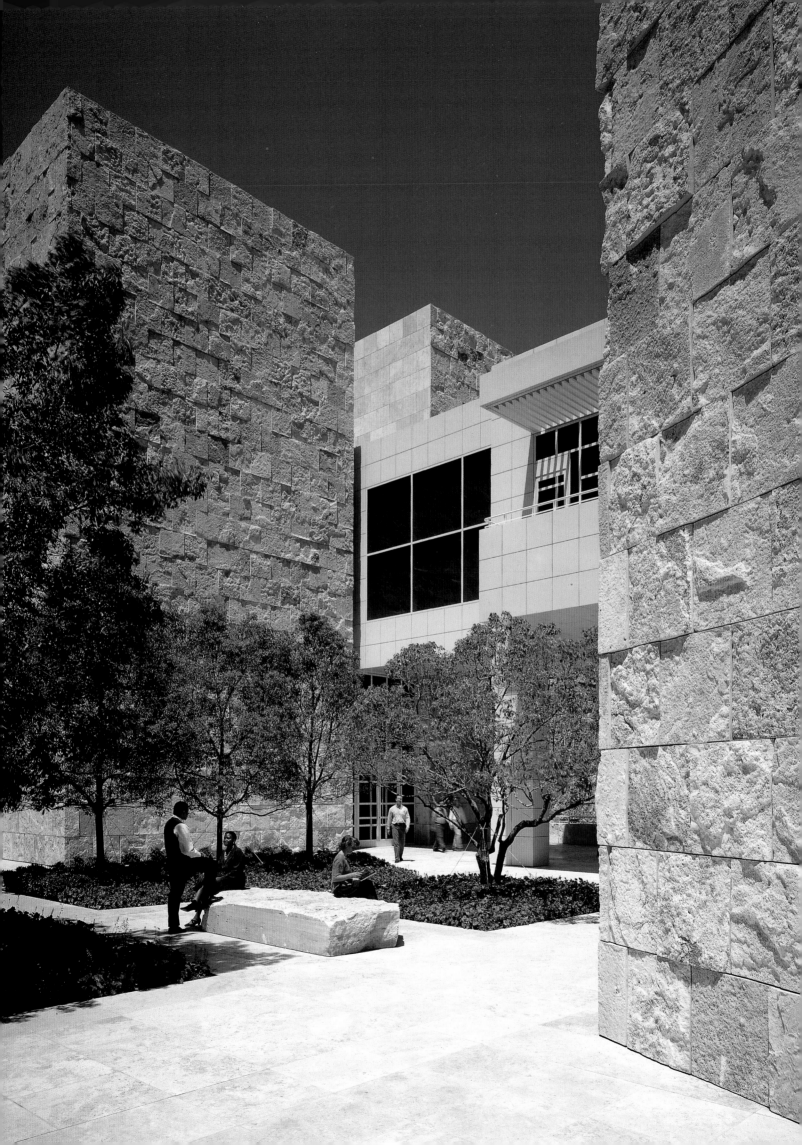

VI.

The Getty Museum at the Getty Center

By the time the Getty bequest became final in 1982, the collection had already become too large for the Villa building. The trustees could see that expansion in the secluded canyon in Malibu was out of the question. There was no space, and even if there had been, it was clear that the logical use of the Villa in the future would be to show Greek and Roman art. For the collections of later art, which were going to grow dramatically, it was evident that a larger building was required. And for the convenience of the much bigger audience that would want to come, a more central location was desirable. Everything pointed to a new museum somewhere else.

Furthermore, the Trust already had established five more organizations under the Getty aegis, and a single new location for all of them would offer the chance to realize another great hope: that a visual arts organization of diverse parts would be strengthened by the daily presence of the others and by the interaction that would inevitably come. This was not likely to happen with the Museum tucked away in Malibu and the other Getty operations housed miles apart, as they now were, in various buildings in Century City, Santa Monica, and Marina del Rey. From the beginning, the plan was to bring together in one place the principal site of the Getty Museum as well as the five new organizations, now known as the Research Institute, Conservation Institute, Information Institute, Education Institute, and the Grant Program.

Even from the earliest days, these Getty programs showed potential for collaboration. To illustrate just one instance: since 1983, the Conservation Institute has been supplying the Museum conservators with the most up-to-date scientific analysis, and the Museum has been providing the Institute scientists with real-life puzzles for technical study; the Institute has given Museum conservators a chance to participate in training courses in such remote places as Cyprus and Brazil, and the Museum has provided experienced instructors. At a single location in Los Angeles, the two staffs could see one another more often, trade information, perhaps form partnerships more readily. For the Conservation Institute, moreover, a highly visible location next door to a popular museum would help it reach a wider audience with its own message about the need to conserve works of art and architecture worldwide. There were many opportunities for innovative work in scholarship and arts education, too, that would likely come from daily contact between professionals in the presence of major collections of art, books, and documents.

In 1982 and 1983, every large piece of land for sale in the Los Angeles basin was considered for the Getty's new campus. Harold Williams and his staff set requirements for the site that were simple but difficult: it had to be central (or as central as any one place can be in sprawling Los Angeles), easily reached by both private and public transportation, and have some distinctive quality of visibility or beauty. The ideal was to find a place as memorable as the Malibu site but better located and more accessible.

A large tract of the Veterans Administration Medical Center in Westwood was seriously considered. So was the Ambassador Hotel grounds downtown. But when a plot of land in the foothills of the Santa Monica Mountains became available, it was instantly the frontrunner. Four hundred feet above the surrounding plain, 900 feet above the ocean to the west, the spectacular hilltop afforded a vast panorama of the city and surrounding mountains and ocean. Like the Malibu canyon, it would be an extraordinary place for the visitors, but for opposite reasons: the site in Malibu was concave, surrounded by hills, and out of sight, while the new site was convex, open, and visible from every direction. It was attached to a much larger tract—742 acres in all, mostly steep chaparral-covered slopes—that could be bought at the same time to ensure that the environs would never be developed. The trustees bought the land in September, 1983. It would not be easy to build on, and it lacked any kind of city services such as paved roads, water, or utilities, but there

[Left] Richard Meier (far left) on the site in 1985 with (left to right) John Walsh; Barbara Chiavelli of the Getty Trust; Kurt Forster, then director of the Getty Center for the History of Art and the Humanities; Luis Monreal, then director of the Getty Conservation Institute; and Ralph Schwarz of Richard Meier & Partners.

[Right] Meier's partner, Michael Palladino (center), on the site showing the first drawings to the Museum's associate directors [left to right] Bret Waller, Deborah Gribbon, and Barbara Whitney.

[Opposite page] The site of the Getty Center before groundbreaking.

would certainly be no place like it in Los Angeles. And hundreds of thousands of people would see it and be reminded of it each day.

Next, an architect was needed. A design competition, one of the common methods for choosing an architect, was not feasible for the Trust at this stage, for the newer Getty organizations were not yet ready to write the specific description of their needs that could be the basis for a program, thus a design. Instead, an interview process was devised, and with the help of a professional advisor and a committee of experienced outsiders, invitations went out to thirty-three architects to submit their qualifications for the job. From this group, seven semifinalists were selected. They received visits from the Getty staff members and advisors, who went to see their buildings in the United States, Europe, and Japan, interviewed them and their clients, debated their qualifications, and finally submitted to the trustees three finalists: James Stirling of London, the most influential postmodern classicist; Fumihiko Maki, a leading Japanese architect; and Richard Meier, the New York modernist.

In October, 1984, a year after the selection process began, Meier was chosen as project architect. His strength as a designer and his proven ability to work on a large scale were decisive. This was an unusual job, and not merely for its sheer size. In most instances, an architect designs in the context of surrounding buildings and thus responds to existing forms and scale, but this spectacular hilltop was a raw site, a blank canvas. The trustees felt confident that Meier could adapt his cool, urbane forms, which have many links with the tradition of California modernism established by Rudolph Schindler and Richard Neutra, to the requirements of this challenging site. An experienced architect of museums, he had designed the High Museum of Art in Atlanta, the Museum of Decorative Arts in Frankfurt, and an addition to the Des Moines Art Center. His office had the capacity for handling a very large project. It would have to work with a complex client group, for each of the six Getty organizations that would move to this campus would have its own representatives and its own idiosyncratic set of requirements. Moreover, the Meier office would have to help produce a program, since of the six Getty organizations, only one, the Museum, had been functioning long enough to be prepared on its own to generate a program in fairly short order. The newer organizations would be determining what kind of space they would need at the same time as preliminary design work was going forward.

The project would become the largest single-phase construction job in the history of Los Angeles, with well over a thousand people working on the site. Inevitably, such a major proposed change to the residential neighborhood was bound to get the close attention of the neighbors themselves, as well as the scrutiny of the various municipal authori-

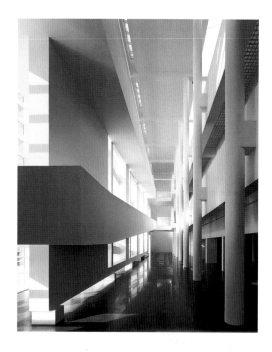

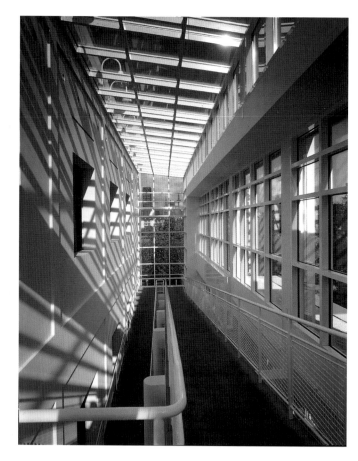

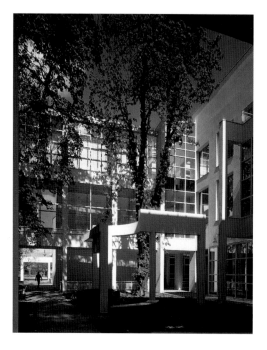

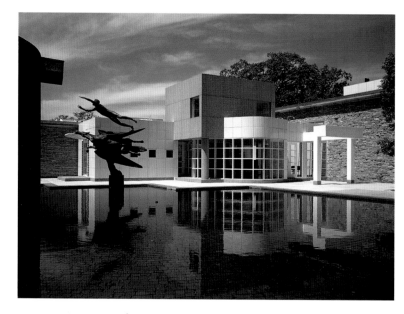

A factor in the choice of Richard Meier for the Getty Center project was his experience in designing other museums: [clockwise from top left] the Museum of Contemporary Art, Barcelona (1987–1995); the Museum of Decorative Arts, Frankfurt (1979–1985); the Des Moines Art Center addition (1982–1985); the Museum of Decorative Arts, Frankfurt.

ties. After many meetings and much negotiation, 107 restrictions were appended to the construction permit, covering pollution, noise, traffic, and the environment and including the stipulation that not one load of dirt could be hauled off the site. Another restriction was a strict cap on the height of the buildings, which imposed pronounced horizontality on any possible design.

The Getty job was billed in the press as the architectural commission of the century. That probably went too far, but it was arguably the best commission in America since Rockefeller Center, and certainly the most conspicuous. When Meier was selected, he said to a reporter, "This is put up or shut up time for me." As it turned out, neither he nor anyone else had any idea just how arduous the planning and design stages would be. More

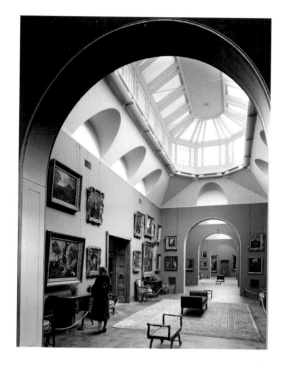

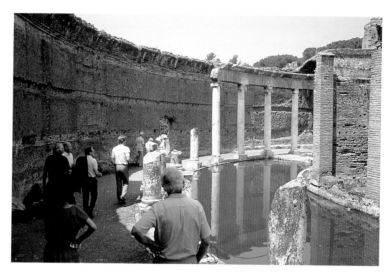

In the first year of the project, Meier traveled with Getty staff members to study museums, libraries, and other sites that had something valuable to teach. The Dulwich College Picture Gallery [left] is a model of harmonious proportions and effective use of daylight. The ruins of Hadrian's Villa [right] suggest how a complex of buildings can be organized on an irregular site.

than seven years passed between the selection of Meier in 1984 and the finishing of his designs in 1991. That year, the Trust published a book about the story thus far, *The Getty Center: Design Process*; a sequel is being published in 1997, the year of the opening.

A 24-acre plot in the southernmost part of the site had been chosen for the buildings even before Meier was hired. It was decided that the remaining acreage would remain in its natural state. For visitors to reach the building plot from the only feasible entry to the site, an underpass of the San Diego Freeway, they would have to drive three-quarters of a mile up the road unless an alternative were provided. To avoid a parade of cars up and down, it was decided to build near the entrance a parking structure big enough for a maximum of 4,000 visitors a day, plus ample space for school and tour groups—1,200 cars and 12 buses—and some form of transportation up and back. Buses were considered, but then a tram was specified: a quiet, nonpolluting conveyance capable of making the trip in less than five minutes.

Among other challenges imposed by the site was the absence of water. For safety reasons alone, it would be necessary to build a private reservoir holding a million gallons. And to build anywhere in Southern California involves study of the geology of the site, in particular its location in relation to known earthquake faults. Fortunately, seismic engineers found that the Getty site had been highly stable for many millennia. Although buildings would have to be strongly constructed and the collections well protected, this was a relatively safe place to build. An earthquake in 1994 gave this proposition a successful test. (There was minor damage to steel joints, as there was all over Los Angeles; the contractor strengthened these, and code requirements were revised on the basis of this experience.)

Meier's site plan, which he presented in 1986 and has altered very little subsequently, had to deal with several geometrical and practical factors. The 24-acre plot was divided naturally by a canyon into a "Y," with two ridges diverging to the south. The grid of the city streets and the north-south axis of the San Diego Freeway were ever-present elements. And the placement of the Getty organizations on the site had to accommodate their distinctly different functions and characters, especially the Museum, a public institution that wanted to be relatively visible, and the Research Institute, a private, contemplative operation that did not need or want to be conspicuous. Meier's ingenious layout took advantage of all the givens.

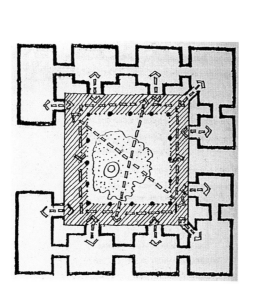

Meier's pavilions around a courtyard spring from an idea in the Museum's program. [Left] A schematization by the programming consultant Peter Kamnitzer. [Right] Meier's earliest block diagram of spaces and adjacencies required by the program. [Opposite page] Meier's study of May, 1987, for the plan of the Museum.

The "Y" shape of the site led Meier to position the Museum on the eastern ridge, where it would be more visible to its potential audience than anywhere else, and to locate the Research Institute on the western ridge facing the sea, only a short distance away from the other buildings, but with a degree of seclusion. In between the ridges, the former canyon was reserved for an enchanting garden for the public. Where the ridges meet, Meier located the main public services: tram plaza, auditorium, restaurant. The Conservation Institute and Education Institute, which have many connections with the Museum's activities, were located next door, together with the Grant Program. Meier seized on the acute angle formed by the axes of the San Diego Freeway and the city grid and imbedded it in the geometry of the whole plan, so that it would reappear in many guises, giving logic and energy to the relations between buildings. Symbolically, it weaves the Getty complex into the fabric of the surrounding city.

Meier approached the design of the Museum buildings knowing what the staff wanted. We had traveled together, for one thing, looking at buildings in Europe and America that we felt could teach or inspire us. A little group of the Trust clients, Meier, and a few key members of his team went far afield on several trips to study not only museum and library buildings, but various kinds of architectural complexes (hill towns, monasteries) and gardens as well—all of which had suggestive power for our project. Among the museums were the Dulwich College Picture Gallery outside London, the National Gallery of Scotland in Edinburgh, the Alte Pinakothek in Munich—the best models of the nineteenth century—and of the twentieth century, the Freer Gallery in Washington, the Louisiana outside Copenhagen, and the Yale Center for British Art in New Haven. These travels began to establish a common frame of reference between Meier and ourselves.

It is common wisdom that you can't get a good building without a good program. The client has the burden of specifying not only the requirements for space but also—just as important—describing the goals and character of the place. Writing a program was an absorbing experience for everyone involved, a chance to shape a museum that could realize our dreams. We had all experienced the frustrations of trudging through museums that were poorly laid out. We had felt claustrophobic and exhausted in buildings that failed to take the visitor's comfort into account. We had seen too many recently built

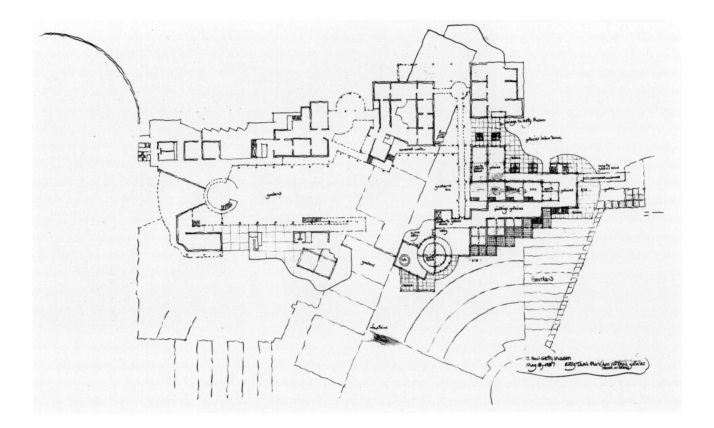

museums where the light was bad and the surroundings were distracting. We thought we could do better.

It took a year to draft and refine a program, then fit it together with the programs of the other Getty Trust organizations. There was guesswork involved, of course, since we had only an approximate idea of what the size and shape of the collections would eventually be when the new Museum opened. It was like designing a jacket for a fourteen-year-old that will have to fit when he is twenty. (As it turned out, our guess was not far off.)

Let us quote from the introductory parts of the program, which try to express in broad terms what kind of museum we wanted:

> *The character of the new Getty Museum ought to be markedly different from that of a large general art museum. Its size and scale will be relatively modest. The collections will be specialized, the emphasis will be on the permanent collections rather than loan exhibitions, and the spirit will be contemplative rather than frenetic. The new Museum will be an elevated place, literally because it will sit on a hill above the surroundings and figuratively because visitors will feel that they have withdrawn for a while from the anxieties of daily life. They should be put in a receptive frame of mind by the atmosphere of a beautiful, comfortable building. In the galleries, they ought to be seduced by the beauty of individual works of art, a seduction that will be more complete if the works of art are not only especially fine but are seen in beautiful light and harmonious settings.*
>
> *The Museum is to be a place where art is respected, where the public gets uncondescending guidance, and where integrity reigns. The seriousness of its purpose will be reinforced by the presence nearby of two other Getty institutions devoted to scholarship and conservation. Visitors will understand that the Museum is far more than a public showplace. Their receptivity should not be diminished by overcrowded galleries.*
>
> *In the new Museum we have a remarkable chance to deepen the visitor's experience by a variety of means, including a lucid organization of the collections, helpful labeling*

Nearly a decade was necessary for the design to be translated into concrete and steel. [This page] The first schematic model, displayed at the still-undeveloped site in October, 1987. [Opposite page] The new Getty Center, as seen in a photograph taken in December, 1995.

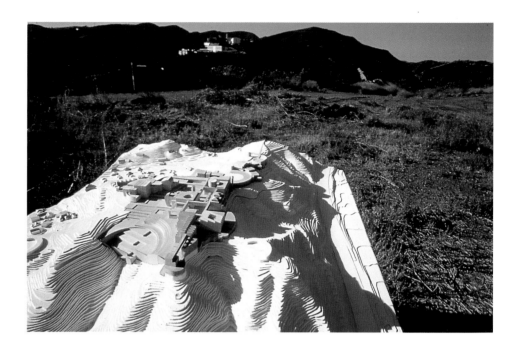

and educational adjuncts in the vicinity of the collections that provide information and interpretation.

The Museum's form and layout ought to express the special character of the Getty collections. The physical plan should organize the collections logically and include routes of travel that reward the visitor with variety, surprise, and beauty.

The large general museum is typically housed in one or several large building masses whose interiors are subdivided for the various collections; these are presented synoptically, like chapters in a text on the history of art. The Getty collections, however, are less a text than an anthology, chosen somewhat arbitrarily and edited rigorously. We have elected to build subcollections of strength and depth, such as eighteenth-century French art and European paintings, and to sacrifice broad or uniform coverage of the history of art. As a result, the various Getty collections may logically be housed, singly or in combinations, in discrete but connected clusters.

The setting is of great importance to an optimal experience. For this, we need a museum building that plays skillful accompanist to the collection. The building should subordinate itself to the works of art in the galleries, assert itself with dignity and grace in the public spaces, and contribute logic as well as pleasure to the visitor's progress. We hope that the building can give modern form to the well-proven virtues, aesthetic and functional, of the great museums of the past. We require settings for the works of art that bear some relation to their original context, with lighting, scale, decor, and materials chosen to make works of art look at home—albeit in a home of the 1990s. Visual competition needs to be kept to a minimum. We need to provide many intervals for visual relief, rest, and reflection, for it defeats our purpose to tax the visitor's body and overload his senses. Looking at art should be an intense experience. After a while recovery is necessary, for which we need to provide appropriate spaces.

We gave Meier other requirements. The galleries should use daylight as much as practicable, we said, and the paintings galleries should use it exclusively whenever possible. For the exterior, we wanted materials that would not deteriorate but improve with time, and would relate visually to the colors and textures of the natural landscape of the site. And we wanted the architecture to express some spiritual links between the new museum and the Villa in Malibu.

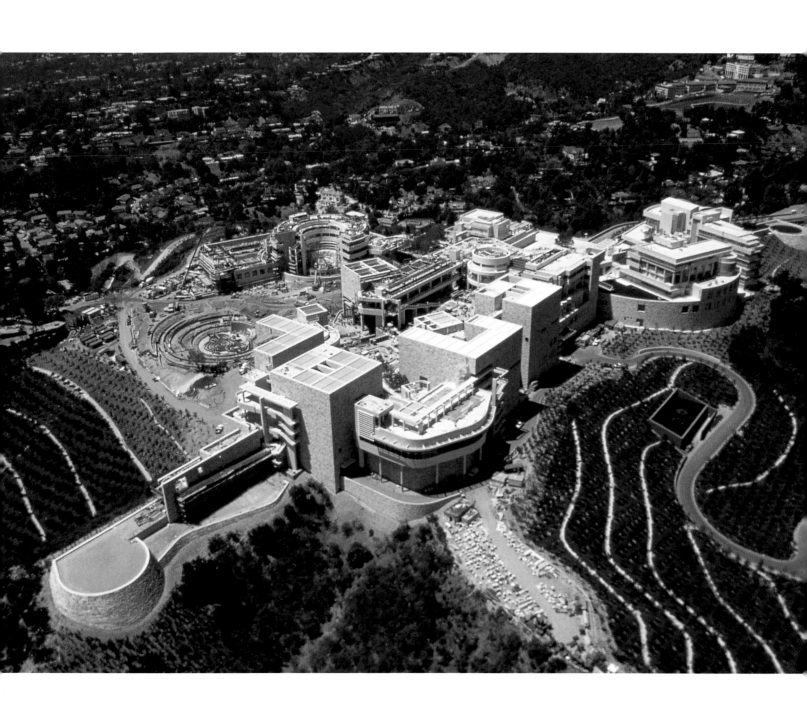

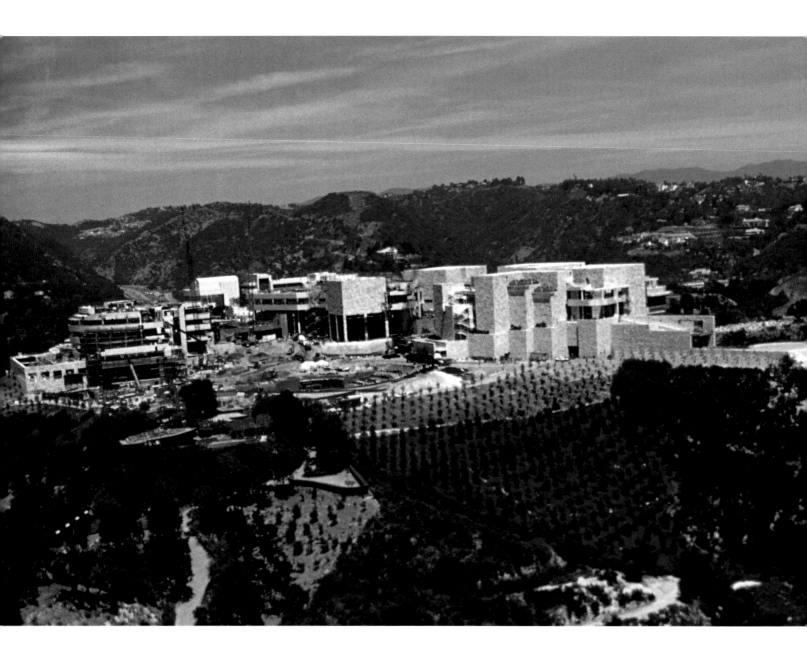

The immensity of the construction task can be seen in photographs [this page] looking north at the Museum and [opposite page] looking through the window mullions of the West Pavilion lobby toward the North and East Pavilions

Meier immersed himself in the Museum's program. If his buildings succeed, this is in good part because they carry out the program so well.

Meier's first functional diagram for the Museum already contained the solution he would adopt for the ground plan, a grouping of two-story pavilions around a central courtyard. There are also three floors *below* the courtyard level on the east and south sides, mostly for nonpublic functions—offices, workspaces, and storerooms. The first of the pavilions is a lobby for orientation and various visitor services, and the other five are for galleries. They are connected by walkways—some open but covered, others enclosed— that give a constantly changing visual experience. This layout lets visitors plan their own itinerary. By going clockwise they can follow a chronological sequence—from the Middle Ages and Renaissance (manuscripts, sculptures, ceramics) all the way to the twentieth century (photographs). They can choose any other sequence they want, however, by passing through wide-open doors from the lobby to the courtyard and from there to any of the pavilions. The program specified "routes of travel that reward the visitor with variety, surprise and beauty," and these routes became a theme. The walkways and terraces look into the courtyard and out to the gardens, and they open up spectacular panoramas of the surrounding city, eastward past the skyscrapers of downtown to the San Bernardino Mountains, southward to San Pedro, Palos Verdes, and Catalina, westward and northward

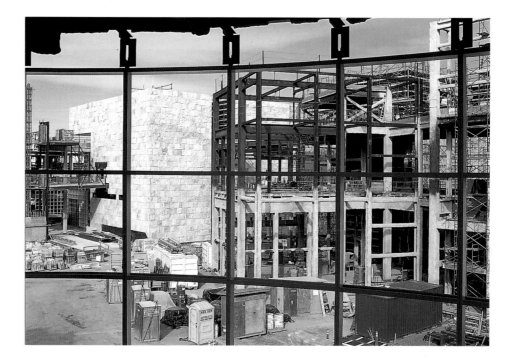

to the Santa Monica Mountains. A broad terrace between the East and South Pavilions is a kind of public balcony for viewing Los Angeles. Only the Griffith Park Observatory offers such a sweeping panorama.

On the terraces and in the courtyard are all kinds of opportunities to relax: coffee kiosks, chairs and tables, arbors and shade trees, fountains. This is not runaway California hedonism, but a means of making visitors more receptive to works of art. These are the "intervals for visual relief, rest, and reflection" the program called for, interspersed among the galleries.

It was the galleries that received the greatest amount of attention from Meier and ourselves in the ten years it took to bring them from first design to finished interiors. Having the right kind of light for each collection was so important that it dictated the decision to put the paintings upstairs, where skylit galleries could be built, and the other collections downstairs, where daylight from high windows could be provided for sculpture, and where daylight could be excluded altogether for reasons of preservation (decorative arts, manuscripts, drawings, and photographs). This meant we could not permanently integrate works of art of many media from the same period—for example, paintings, drawings, and upholstered furniture of eighteenth-century Venice— but the sacrifice was made consciously in order to get optimum light for individual objects. We provided four temporary exhibition galleries dispersed in the pavilions where we could combine and recombine works of different media at will.

The twenty paintings galleries have skylights with louvers that exclude direct sun and high coved ceilings that diffuse the light and keep its source out of the visitor's field of view—a system adapted from the great nineteenth-century galleries of Great Britain and Germany. The scale of the galleries varies from intimate, for early Netherlandish panels, to fairly grand, for Italian baroque and rococo pictures. The wood floors, door frames, and baseboards, as well as the fabrics that cover most walls, are modernist adaptations and simplifications of the décor of earlier picture galleries.

Downstairs, large, high-ceilinged rooms with clerestory windows have been provided for sculpture. These have floors and moldings of brown travertine, darker and richer than the pavements in public spaces, and walls of tinted plaster. Manuscripts, drawings, and photographs have their own exhibition galleries, each scaled and furnished differently.

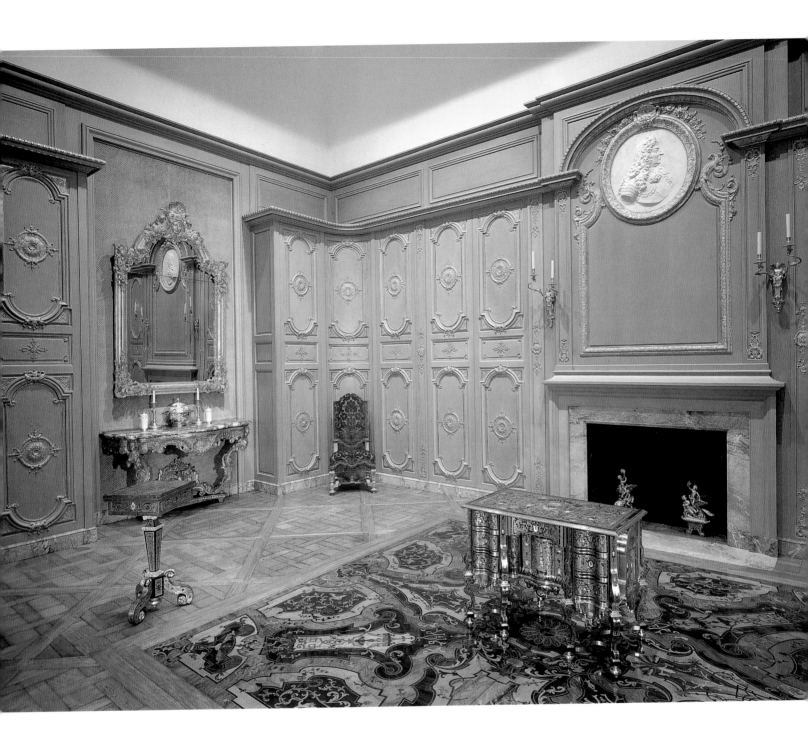

Reconstructing an eighteenth-
century paneled room is a pains-
taking task both of craftsmanship
and scholarship. Pictured on these
two pages is a room with paneling
dated about 1719 from the library
of a house on the Place Vendôme in
Paris. On this page is the completed
room.

Two proposals for the installation of the paneling: [top] an early rendering, proposing wainscoting, by the Office of Thierry Despont, made before it was determined that the paneling was actually a series of cupboard doors that originally opened to reveal bookshelves; and [middle] a drawing by Elisabeth Le Roy Ladurie of the proposed reconstruction of the room by Bruno Pons, who discovered the original function of the panels. [bottom] A workman installing one of the curved corner panels that, because of its unusual shape, was stored in an attic while the rest of the paneling was stripped of its paint and reinstalled in another house. Since this curved panel retains its original paint and gilding, the rest of the paneling could be restored to what was almost certainly its original appearance.

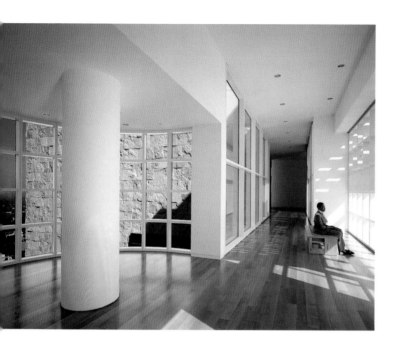

[Top left] The upstairs passage between the North and East Pavilions in the Museum. [Top right] Looking toward the Pacific Ocean from one of the terraces. [Bottom] The early Renaissance paintings gallery with (from left to right) Cenni di Francesco di Ser Cenni's *Polyptych with the Coronation of the Virgin and Saints,* Luca di Tommè's *Saint John the Baptist,* Bernardo Daddi's *Arrival of Saint Ursula in Basle* and his altarpiece *The Virgin Mary with Saints Thomas Aquinas and Paul.*

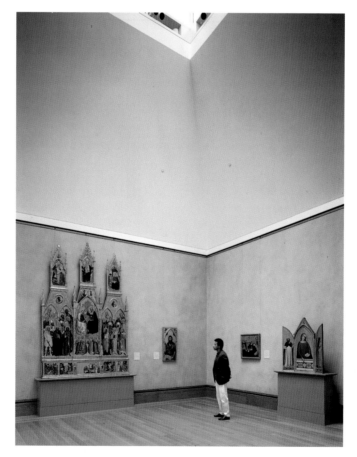

One of the information centers located in each pavilion, sketched by Reid Hoffman, Getty Museum Exhibition Design Department.

The design of all these gallery interiors had the participation of the New York architect and interior designer Thierry Despont, working in association with the Meier office.

The most elaborate of all the installations of the permanent collection is devoted to French decorative arts and furniture. It is an enclave within the Museum, running from the east pavilion through the south and filling a one-story terrace building in between, fourteen galleries in all. Designed by Despont in association with Meier, the rooms adopt the styles of succeeding eras, from the late seventeenth-century baroque (for tapestries and Boulle furniture) through the late eighteenth-century neoclassical. Despont has used the full architectural vocabulary of French interiors—parquet floors, wainscoting, wall fabrics, cornices, and elaborate plaster ceilings. In the Great Hall, some 80 feet in length, the end bays are set off from the main space by pairs of massive Doric columns. Interspersed among these invented halls are four original paneled rooms, newly reconstructed, two of which could never be installed at Malibu for lack of space.

On the west side of the courtyard is a temporary-exhibitions wing. It is intentionally removed from, and subordinated to, the permanent collection. It is designed to accommodate medium-size loan exhibitions of serious (but we hope lively) content—not the very large touring spectaculars organized by large public museums, but shows of a kind that make a distinctive contribution and might not otherwise be held in Los Angeles, or held at all. Some of these shows will include material outside the scope of our own collections. These galleries all have skylights, but daylight can be excluded when necessary.

There is a great deal of space dedicated to education, based on the well-proven principle that most visitors enjoy works of art more if they know something about them and can relate the works to their own experience. In the lobby, visitors can see an orientation film in one of two little theaters. As they proceed through the galleries, there are information centers nearby where they can get answers to questions, see didactic displays, or use an interactive computer system to get information about objects in the collection. A flexible audioguide system provides another means for visitors, including families and those who are Spanish-speaking, to learn about objects while looking at them. Print information of various kinds is available in the galleries. Parents with children can go to a family room in a conspicuous spot off the central courtyard to see displays tailored to their interests and get advice on activities and materials to use together in the galleries.

Teachers and schoolchildren have the exclusive use of much time and space. The Museum is open exclusively for groups on weekday mornings before eleven. There are several multipurpose rooms for school classes just below the lobby level, and parking for twelve buses has been provided. These education spaces—and, indeed, the whole Museum—will get heavy use in the morning before the Museum opens to the public.

We had called for buildings made of materials that would seem at home on the site and would age gracefully. After many experiments, Meier responded with a bold solution: Italian travertine, split to reveal its astonishing richness. These blocks are the cladding for lower walls everywhere at the Getty Center, and at the Museum they are the main material, covering the gallery pavilions as well. Lighter, more transparent parts of the buildings are carried out in Meier's familiar combination of glass and metal panels, which in this case are not white but light tan. Carrying associations of permanence, Meier's rough cleft travertine blocks are warm in color and endlessly varied in their relief surfaces, whose patterns seem to change all day long as the sun slants across them.

In size and architectural style, the new Getty Museum was fated to be very different from the Villa in Malibu. Yet we wanted the new place to be as hospitable as the old and to provide an experience for the visitor that would be just as pleasurable and memorable. The Meier buildings are designed to make this possible, and they carry a few reminders of

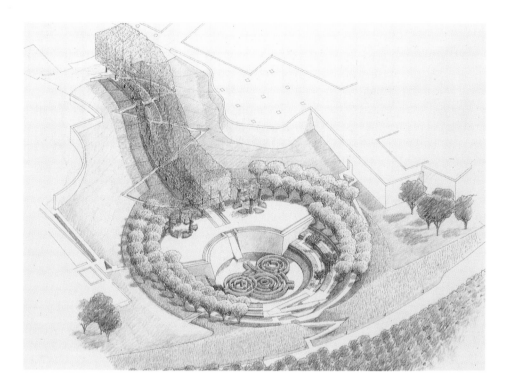

Malibu as well: the long courtyard recalls the Outer Peristyle, the gallery buildings have square central voids that echo the Inner Peristyle, and the plan encourages people to move easily between indoors and outdoors.

Another pleasure for visitors, added to the Getty Center in the later stages of its design, is a central garden in the former canyon between the Museum and the Research Institute. It is the work of Robert Irwin, a Southern Californian long considered among America's leading artists, whose work has moved in thirty-five years from immaterial "light and space" gallery installations to outdoor projects that use the familiar materials of garden design in unfamiliar combinations. Irwin has designed the Getty's central garden to include a watercourse that descends in a serpentine bed under an allée of sycamores. It crosses a terrace with "trees" of bougainvillea trained on metal frames, then spills down a wall of granite into a large pool. Seeming to float on the pool is a maze of azalea bushes, and surrounding the pool are terraced beds of flowering shrubs under crape myrtle trees. It is a place designed to play off shapes and colors against the buildings and to enchant the visitor.

VII. The Villa in the Twenty- First Century

Plans for the Getty Center have taken a long time to gestate. So have plans for the Getty Villa. Ever since the idea of a new Getty Center was conceived, in the early 1980s, the decision of what to do with the Malibu site has been a topic for exploration. The initial assumption was that it would become a museum of Greek and Roman art, a branch of the Getty Museum like the Metropolitan Museum's branch in upper Manhattan for medieval art, The Cloisters. During the past half-dozen years, however, the plan for the Villa has evolved into something more ambitious.

By 2001, when it will reopen to the public, the Villa site will have become a center for comparative archaeology, containing a branch of the Getty Museum—with its collections of Greek and Roman art, exhibitions, and a wide range of educational services—as well as operations of the Research Institute and the Conservation Institute. Studies in archaeology and related fields, not limited to European antiquity but ranging across many cultures, will be conducted in the renovated Ranch House building. The collection will be treated in conservation laboratories, and training will be given to conservators responsible for the care of archaeological sites as well as objects. At the core will be the Getty collections, beautifully reinstalled on both floors of the Villa building.

After an international search for architects to develop a master plan for the Villa site, the Boston firm of Machado and Silvetti was chosen. Meanwhile, a program was developed by a team of colleagues, representing all the Getty organizations, calling for remedying most of the failings of the present building, making it more efficient, and ensuring that it meets various city and federal codes. A better point of entry for visitors was needed: now they first encounter an underground parking garage, then enter the building via a cramped vestibule, which in the original Roman villa served as a dining room (the proper entry was the atrium). Visitors cannot find the stairs to the upper floor. There is no freight elevator. The auditorium is badly located. And the galleries need complete renovation in order to exhibit antiquities, especially upstairs, where these spaces have been used to show much different materials and where natural light can be introduced.

Machado and Silvetti's plans gracefully solve all these problems. Access by visitors will be easier and more pleasant. They will enter via an outdoor entry pavilion, near the northwest corner of the Outer Peristyle Garden, then approach on a walkway above the Herb Garden that provides views of the whole site. They will descend to a piazza in front of the present west facade, which will become the main entrance. The Tea Room and outbuildings, now outgrown and outmoded, will be replaced by a small outdoor theater for performances of Greek and Roman plays (with which the Museum has had great success in the past few years). Facing this piazza will be a new bookstore, and overlooking it a new café. The entrance to the Villa via the Atrium will allow visitors to enter as they would have in a Roman house. Across the Inner Peristyle, a staircase will be added, greatly improving circulation. The galleries will be remodeled, especially upstairs, where skylights and windows will at last introduce natural light. The décor of the galleries will carry on the nineteenth-century tradition of adapting classical forms and materials— plaster walls, terrazzo and mosaic floors—as a setting for the display of antiquities. The Ranch House and the laboratories next door will be renovated to create an enclave for scholars and conservators. A new auditorium in a more accessible location will be used for both public functions and specialized meetings.

Machado and Silvetti's plans call for a discreet reshaping of a site and building that have become a much-loved landmark in their first quarter century. The lovely canyon will be made more accessible to visitors. The collections will have a cogent and beautiful installation, and behind the scenes, many new activities will take place that are designed to make innovative contributions to archaeology.

Rendering of the outdoor theater and café from the terrace above the West Porch (new entrance), looking northwest, prepared by Machado and Silvetti Associates.

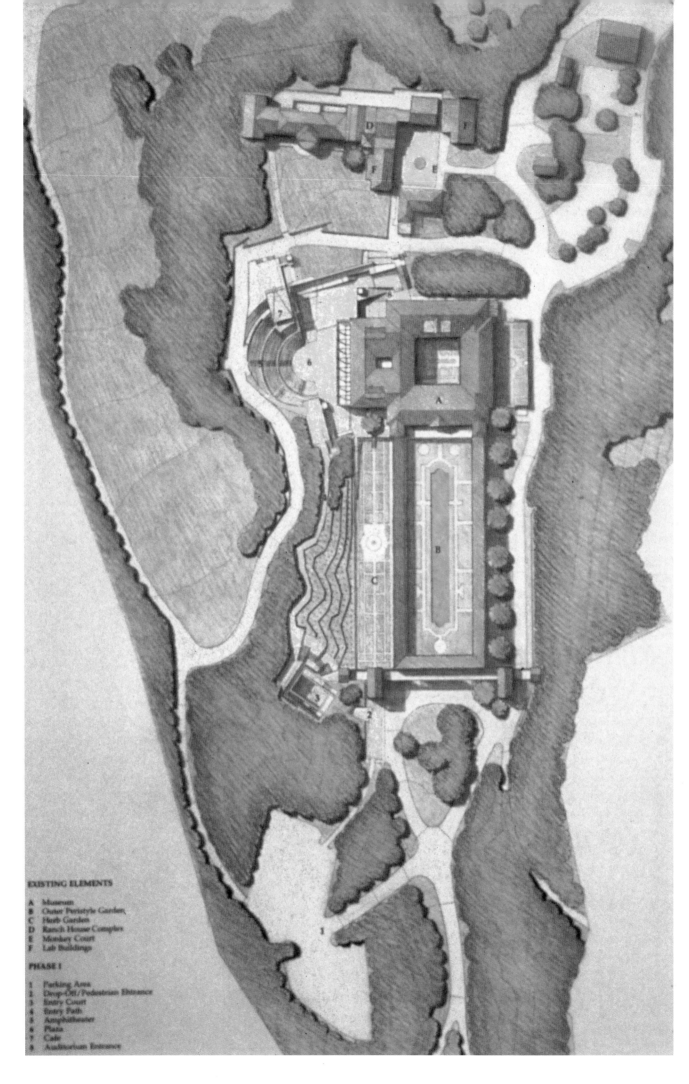

EXISTING ELEMENTS

A Museum
B Outer Peristyle Garden
C Herb Garden
D Ranch House Complex
E Monkey Court
F Lab Buildings

PHASE I

1 Parking Area
2 Drop-Off/Pedestrian Entrance
3 Entry Court
4 Entry Path
5 Amphitheater
6 Plaza
7 Cafe
8 Auditorium Entrance

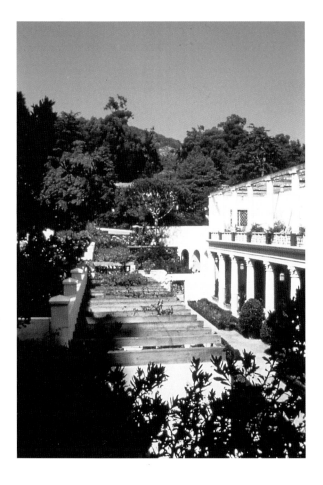

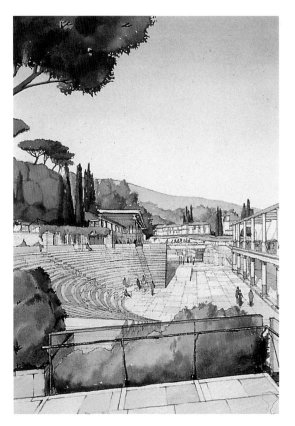

[Opposite page] An aerial view of the renovated Villa and ancillary buildings; [this page, clockwise from top left] the Herb Garden and west wall of the Outer Peristyle Garden as they look now, a rendering of the same area from the proposed walk toward the new entrance to the Villa, a rendering of the outdoor theater and café looking north, and the existing Tea Room, looking north. Renderings prepared by Machado and Silvetti Associates.

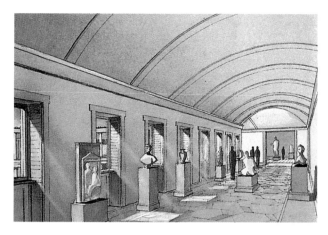

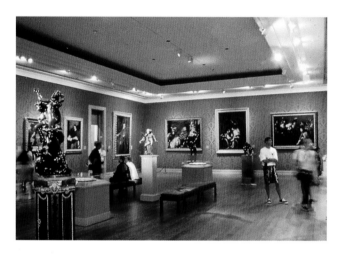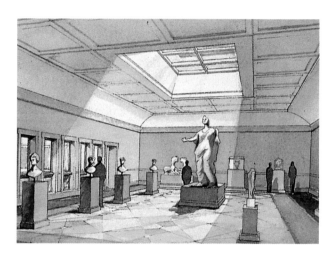

Machado and Silvetti has redesigned the Museum interiors to provide more of the light and air that were so prized by the builders of villas in Roman antiquity, and to make circulation easier. [Top left] A gallery for decorative arts at the Villa and [top right] the same space as renovated for antiquities, with a vaulted ceiling and windows giving views of the Inner Peristyle. [Middle left] A paintings gallery in the Villa and [middle right] the same gallery altered to suit Greek sculptures, with a skylight and windows overlooking the Atrium. [Bottom left] The present east side of the Inner Peristyle and [bottom right] the same area with a new stair to the upstairs galleries.

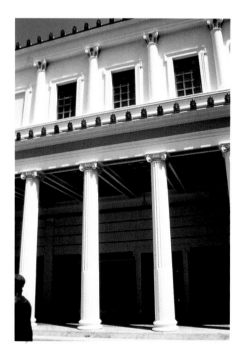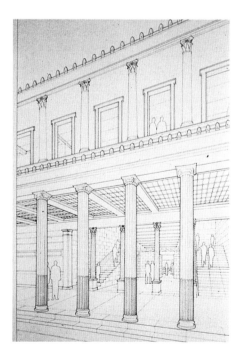

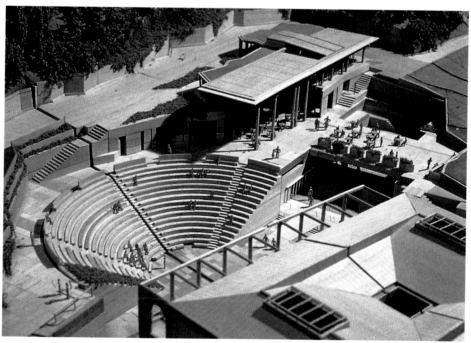

[Top] The ancient theater at Segesta, which served as a model for the proposed outdoor theater at the Villa. [Bottom] A model of the new theater, café, and entrance to the Museum. Model prepared by Machado and Silvetti Associates.

VIII.
The Getty Museum's Collections

In the fifteen years since it received the funds from J. Paul Getty's bequest, the Trust has given the Museum the chance to make a huge expansion and improvement of its collections. The change has been dramatic. The collections are now much more important, both in their concentration of great objects and in the rich interrelationships between works of different types. We have tried to acquire the best and the rarest works in each of our seven areas of collecting and, at the same time, to give the collection a distinctive profile—and the visitor pleasant surprises—by buying excellent lesser-known works.

We are often asked about the procedure the Museum uses to buy works of art. There is no mystery about this; the process is the same in most museums. Curators are constantly on the lookout for works important enough to take seriously. They receive offers from owners and agents and travel to see art dealers and auction houses. They meet with us individually at regular intervals to discuss what they have seen and recommend approval for works they believe most desirable. Often, these are shipped to the Museum for study. Condition reports, usually based on technical analyses, are prepared by the conservators on every work considered. The curators and senior staff meet as a group to review the recommendations. We reconcile these with the budget—which, though large, is not nearly enough for all the important works that we would like to buy—and present them with the curators' written proposals to the president and the board of trustees. It is a thorough process and has worked remarkably well.

Some guiding principles have been necessary. In a 1984 report to the trustees, we set these down in writing:

Get the greatest and rarest objects. If nothing is more important to a museum than its collection, nothing is more important to its collection than the great object that gives measure to the rest. There are not many such works left, but it should be our top priority to secure them.

Have principles, but seize the unexpected chance. The Getty has neither the ancient tradition nor the financial restrictions of America's older museums, such as the Metropolitan Museum or Boston MFA or the Frick Collection. Our youth and our resources give us the ability to respond imaginatively to opportunity that rigid preconceived notions may defeat.

Build on strength. We should not be afraid of specialization, but exploit its advantages. When we have a chance to form the best collection of a certain type, and it is logically connected to our mission, we should take it—at the expense, if necessary, of a well-rounded profile for our holdings. Better to do a limited number of things very well, be prepared to accept limits, and concentrate our resources on achieving greatness in a restricted number of fields.

Fill gaps, but only with superior examples. Once we are in a field, the desire to cover it more and more fully is inevitable. Here patience and discipline are in order, since the goal of quality is more important than the goal of art-historical coverage.

Collect collections. Our greatest advantage is that we can make great leaps in strengthening our collections, and even annex new territories from time to time. We need both energy and vision to locate these opportunities.

We have done well by sticking to these principles. As the market has become more and more depleted, however, and prices for the best objects have remained high—even today, nearly as high as the tremendously inflated levels of the later 1980s—the rate of the Museum's purchases has slowed. Rather than relax standards, we have maintained them.

Jan Steen
Dutch, 1626–1679
The Drawing Lesson, ca. 1665
Oil on panel, 49.3 x 41 cm
(19⅜ x 16¼ in.)
83.PB.388

Vincent van Gogh
Dutch, 1853–1890
Irises, 1889
Oil on canvas, 71 x 93 cm (28 x 36⅝ in.)
90.PA.20

Paintings

The most obvious transformation in the galleries has come in European paintings. Pictures were never a passion for Getty, and in the original Ranch House Museum they played only a supporting role. As more and more important examples displaced lesser ones to the storerooms over the past fifteen years, however, our paintings have become a major attraction for visitors. That said, the Getty Museum's representation of painting from the medieval to the Post-Impressionist era is naturally no rival for the comprehensive holdings of the greatest museums of America and Europe. It is too late for that. Nevertheless, the Getty has been fortunate to gather many remarkable pictures.

We had not been optimistic about finding many important works from the Italian Renaissance, which is practically a mined-out vein, but there have been surprising successes. To panels by Masaccio, Gentile da Fabriano, and Carpaccio, bought in the late seventies, we could add a rare fourteenth-century triptych of the Virgin Mary and saints by Bernardo Daddi, the principal painter in Florence after Giotto. Rarer still is its spectacular condition. The original gilding and its elaborate tooled decoration are preserved intact, as is the delicate modeling of the saints' costumes.

The *Adoration of the Magi* by Mantegna is a gravely moving meditation on worldly powers giving homage to the infant Savior. Painted on thin linen canvas, the picture long ago was mistakenly varnished, causing it to darken and giving it a shiny surface very different from the original matte effect. Before the auction sale at which we bought it (for a then-record price), it was not at all certain whether its disfigurement could be reversed. Our conservators believed that in good measure it could, and they proved to be right. Now, after painstaking treatment, the picture has regained most of the peculiar combination of weightiness and delicacy Mantegna intended us to see.

As we write, the British government has just given permission for the export of the great *Rest on the Flight into Egypt* by Fra Bartolommeo. This large panel with life-size figures is a major work of the High Renaissance, the most important in America outside the East Coast. It was painted in about 1509 in Florence by a talented contemporary of Raphael whose pictures have the serene balance and poignant expressiveness that embody the ideal of the time. It has a radiant landscape as well. It took the better part of a year for the export license process in Great Britain to play out, and we were surprised that we succeeded. This case typifies the problem for the Getty in the 1980s and 1990s: not only have the finest works been rare and expensive, but they have often been subject to the export controls of European countries. This effectively means no exports at all from Italy and Spain; great difficulty in France, Germany, and the Netherlands; and increasing trouble in Britain, where the usually reliable export review system has not always been consistently operated of late, and where a flood of new money from a national lottery now makes it much easier for British galleries to buy.

Great pictures are occasionally sold from American collections, however, and we can preserve for American audiences works of art that might otherwise go abroad. Such is Pontormo's *Portrait of a Halberdier*, a famous Renaissance picture that hung for many years as a loan to the Frick Collection in New York, then was sold to the Getty Museum at auction in 1989, becoming a cornerstone of the collection. Paintings by Fra Angelico, Dosso Dossi, Correggio, and other great painters of the fifteenth and sixteenth centuries have transformed the galleries.

It has been even more difficult to find paintings by the Netherlandish and German painters of the fifteenth and sixteenth centuries. The most important by far was *The Annunciation* by Dieric Bouts, dated from about fifty years earlier than the *Adoration of the Magi* by Mantegna, painted with the same technique on thin linen canvas but preserved in practically pristine condition. Bouts eliminated most of the conventional props

from his version of this common subject, and he composed a forcefully simple scene centered on the Virgin's modest hesitation when confronted with her duty. Most recently, we bought a marvelous panel by an anonymous Netherlandish painter active in Cologne, the so-called Master of the St. Bartholomew Altarpiece, that shows the Magi accompanied by extravagant cavalcades converging on Bethlehem, all witnessed by King David and the prophet Isaiah. It is full of the delightful observations and quirky energy typical of the best German painting around 1480.

Flemish and Dutch pictures of the seventeenth century have been more abundant in the market, and the Getty's collection has changed impressively in this area. Among a handful of fine pictures bought by J. Paul Getty is a marvelous late Rembrandt, *St. Bartholomew*, whose meditative expression is reinforced by complex light and rich brushwork. Almost everything else in the Dutch galleries, however, was bought more recently, including three early Rembrandt panels, of which *The Abduction of Europa* of 1632 is the best known. Painted in Rembrandt's refined early style, it retells the myth of the princess Europa, who was inveigled into taking a ride on the back of a white bull (the lecherous Jupiter in disguise) and abducted to the continent that was to be named for her. It has a fairytale exoticism in the costumes and an element of down-home familiarity in the setting, which suggests a Dutch river as much as it does the shores of the Mediterranean.

As the collection has grown, more and more historical and thematic connections between pictures have become obvious. The young Rembrandt's biblical stories enacted by lively small figures, for instance, continued the tradition of Jan Brueghel, among others. Brueghel's *The Entry of the Animals into Noah's Ark* of 1613 shows a fabulous menagerie being shaped up to go aboard the ark. It not only celebrates the wonder of God's creation—what we might today call biodiversity—but also implicitly boasts of the fact that Dutch and Flemish sailors had mastered the oceans and traveled to the four corners of the world to bring back living marvels as well as gold and silver.

Getty admired Rubens and bought a half-dozen pictures by the great Flemish master, but these, like so many others once attributed to him in more optimistic times, have since been regarded as studio work or old copies. They have been replaced in the galleries by newer pictures and a group of oil sketches. Among the latter is one of Rubens's most beautiful *modelli* (smaller preliminary versions of large compositions that were shown to patrons for approval)—*The Miracles of St. Francis of Paola*, which shows a swirl of courtiers, saints, and the afflicted being cured, all animated and made believable by Rubens's skill as composer and painter.

Among many Dutch paintings bought in the past fifteen years, few have the appeal of Jan Steen's *The Drawing Lesson*. Steen's technique is masterly, and the scene is not only an enjoyable tour of an artist's studio and a sympathetic portrayal of a master and pupils, but also a symbolic statement about the role of teaching in the noble profession of painter.

The Steen typifies the kind of work we are always trying to acquire: beautifully preserved, rich in content, showing a major artist at the top of his powers. These criteria are so important that when a painting meets them, we are often willing to buy it even though we already have other works by the same artist and none at all by others of equal importance. The result, since works of art come onto the market in an unpredictable way, is that we have surprising strengths and surprising weaknesses.

We had imagined it would be possible to buy major pictures by the greatest masters of eighteenth-century France—Watteau, Boucher, Fragonard, Greuze, Chardin—but to our surprise, very few of these have been available. The most spectacular purchase of all, however, was by an artist less well known to the public, the greatest painter in pastels of the era,

Maurice-Quentin de La Tour. This is a life-size, full-length portrait of a leading French jurist that sparkles with intelligence. It is also a miracle of preservation.

Tiepolo's *modello* for the now-destroyed ceiling painting in the church of the Scalzi in Venice is perhaps our most delightful Italian picture of the eighteenth century (although there are impressive pictures by Batoni, Bellotto, and other contemporaries). As spectators, we seem to look up through the ceiling of the church to the sky above, where the Virgin Mary and her little house are borne aloft by angels carrying them to safety. Like Rubens in the *modello* of *St. Francis of Paola*, Tiepolo tempts us to believe in levitation, and he brings the figures to life with his rapid, confident brushwork.

When the Museum's new era began in the early 1980s, there were only a few nineteenth-century paintings of any significance. Since then, the purchase of several dozen major pictures has changed the situation markedly. We are far from representing the major movements of Romanticism, Impressionism, and Post-Impressionism in the comprehensive way older museums do—having, instead, major works erratically distributed—and this situation will persist for a long time to come. Our nineteenth-century paintings are, nevertheless, thoroughly rewarding for the visitor.

Jacques-Louis David, the key French painter of the Revolutionary period and its aftermath, is represented by two superb pictures, one of them a portrait of unusual subtlety: the two daughters of Joseph Bonaparte are not only vividly painted, but also carefully differentiated by age and maturity, united in devotion to their absent father.

One by one, pictures by the leading Romantics have been added, notably a thrilling bullfight scene by the Spaniard Francisco Goya. Another picture shows how painters of the Romantic period used nature as a vehicle for meditation on the fate of humans. J. M. W. Turner's rousing seascape of 1844 presents nature as not only beautiful but also potentially dangerous, a challenge to the ambitions of shipbuilders and sailors.

We have been lucky that a handful of well-known masterpieces of Impressionist and Post-Impressionist paintings have been sold in recent years and that we were able to seize opportunity when it occurred. The biggest surprise came in 1987, when we had the chance to buy the famous *Christ's Entry into Brussels in 1889* by James Ensor, long recognized as the masterpiece of the artist and one of the key works of the fin de siècle in Europe. This huge painting still gives a shock. Its bitter political message is put across by thoroughly modern distortions and intentional crudity. The Ensor had been often exhibited and reproduced; much less well known was Cézanne's *Still Life with Apples*, recently acquired from a Swiss family trust. It is one of the most satisfying mature paintings by Cézanne, and like the Ensor, it anticipates artistic developments in the twentieth century. The story of Van Gogh's *Irises* is perhaps all too well known: at a famous auction sale preceded by much hoopla and a world tour, it was sold to an Australian, whose well-publicized financial failure later on made it possible for us to bring the wanderings of this deservedly famous painting to an end. Van Gogh's view of a flower bed in the asylum of St. Rémy, where the painter was struggling to regain his mental health, stands as one of the most memorable and personal images of the natural world in all of art. Added to a small core of brilliant Impressionist pictures by Monet, Pissarro, and Renoir, it justifies a trip to the Getty Museum for any lover of late nineteenth-century art.

Bernardo Daddi
Italian, ca. 1280–1348
*The Virgin Mary with Saints Thomas Aquinas and
Paul*, ca. 1330
Tempera and gold on panel,
Central panel: 120.7 x 55.9 cm (47½ x 22 in.)
Left panel: 105.5 x 28 cm (41½ x 11 in.)
Right panel: 105.5 x 27.6 cm (41½ x 10⅞ in.)
93.PB.16

Vittore Carpaccio
Italian, ca. 1460/65–1525/26
Hunting on the Lagoon (Recto) /
Letter Rack (Verso), ca. 1490–95
Oil on panel, 75.4 x 63.8 cm (29¾ x 25⅛ in.)
79.PB.72

Andrea Mantegna
Italian, ca. 1431–1506
Adoration of the Magi, ca. 1495–1505
Distemper on linen, 48.5 x 65.6 cm (19⅛ x 25⅞ in.)
85.PA.417

Fra Bartolommeo (Baccio della Porta)
Italian, 1472–1517
*The Rest on the Flight into Egypt with Saint John the
Baptist*, ca. 1509
Oil on panel, 129.5 x 106.6 cm (51 x 42 in.)
96.PB.15

Dosso Dossi (Giovanni di Niccolò de Lutero)
Italian, ca. 1490–1542
Mythological Scene, ca. 1524
Oil on canvas, 163.8 x 145.4 cm (64½ x 57¼ in.)
83.PA.15

Pontormo (Jacopo Carucci)
Italian, 1494–1557
Portrait of a Halberdier (Francesco Guardi?), 1528–30
Oil possibly mixed with tempera on panel
transferred to canvas, 92 x 72 cm (36¼ x 28⅜ in.)
89.PA.49

Master of the St. Bartholomew Altarpiece
Netherlandish, active Cologne ca. 1470–1510
The Meeting of the Three Kings, with David and Isaiah
(Recto) / *Assumption of the Virgin* (Verso), before 1480
Oil and gold leaf on panel, 62.8 x 71.2 cm
(24¾ x 28⅛ in.)
96.PB.16

Dieric Bouts
Flemish, ca. 1415–1475
The Annunciation, ca. 1450–55
Distemper on linen, 90 x 74.5 cm (35⁷⁄₁₆ x 29³⁄₈ in.)
85.PA.24

Peter Paul Rubens
Flemish, 1577–1640
The Miracles of Saint Francis of Paola, ca. 1627–28
Oil on panel, 97.5 x 77 cm (38⅜ x 30⅜ in.)
91.PB.50

Jan Brueghel the Elder
Flemish, 1568–1625
The Entry of the Animals into Noah's Ark, 1613
Oil on panel, 54.6 x 83.8 cm (21½ x 33 in.)
92.PB.82

Anthony van Dyck
Flemish, 1599–1641
Thomas Howard, 2nd Earl of Arundel, ca. 1620–21
Oil on canvas, 102.8 x 79.4 cm (40½ x 31¼ in.)
86.PA.532

Rembrandt van Rijn
Dutch, 1606–1669
St. Bartholomew, 1661
Oil on canvas, 86.5 x 75.5 cm (34⅛ x 29¾ in.)
71.PA.15

Rembrandt van Rijn
Dutch, 1606–1669
The Abduction of Europa, 1632
Oil on panel, 62.2 x 77 cm (24½ x 30⁵⁄₁₆ in.)
95.PB.7

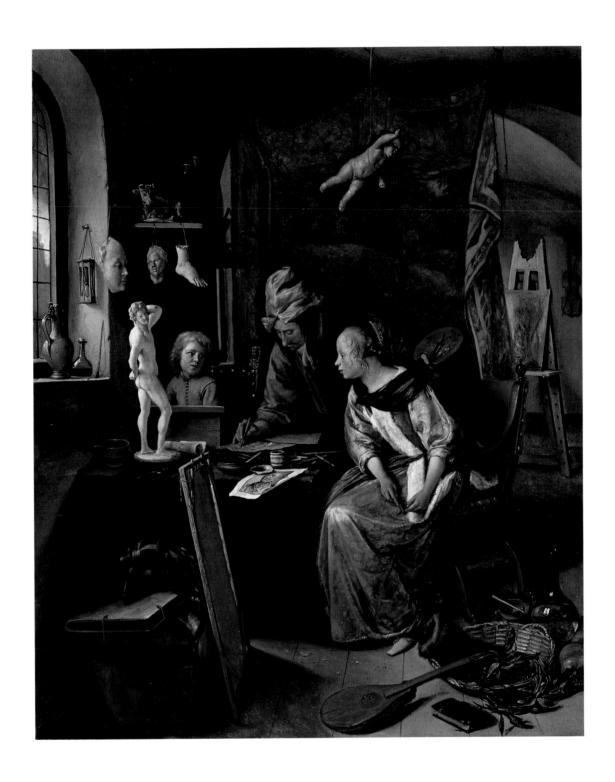

Jan Steen
Dutch, 1626–1679
The Drawing Lesson, ca. 1665
Oil on panel, 49.3 x 41 cm
(19⅜ x 16¼ in.)
83.PB.388

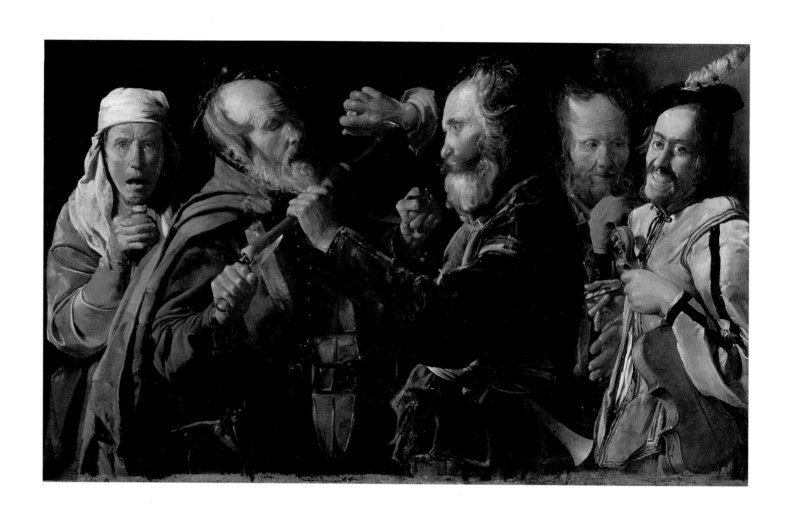

Georges de La Tour
French, 1593–1652
The Musicians' Brawl, ca. 1625
Oil on canvas, 85.7 x 141 cm (33¾ x 55½ in.)
72.PA.28

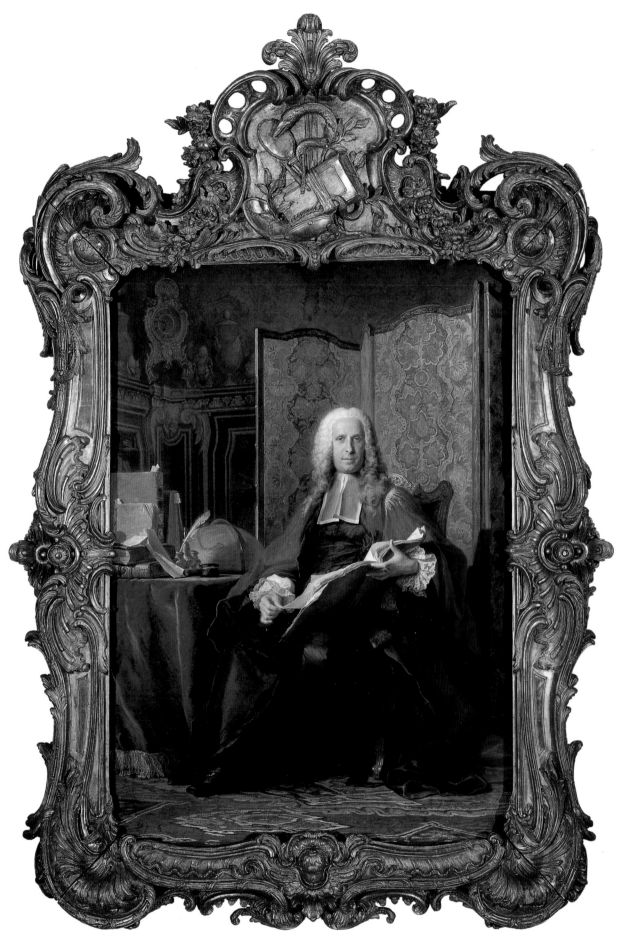

Maurice-Quentin de La Tour
French, 1704–1788
Gabriel Bernard de Rieux, président à la deuxième
chambre des enquêtes du Parlement de Paris, 1739–41
Pastel and gouache on paper mounted on canvas,
200 x 150 cm (79 x 59 in.)
94.PC.39

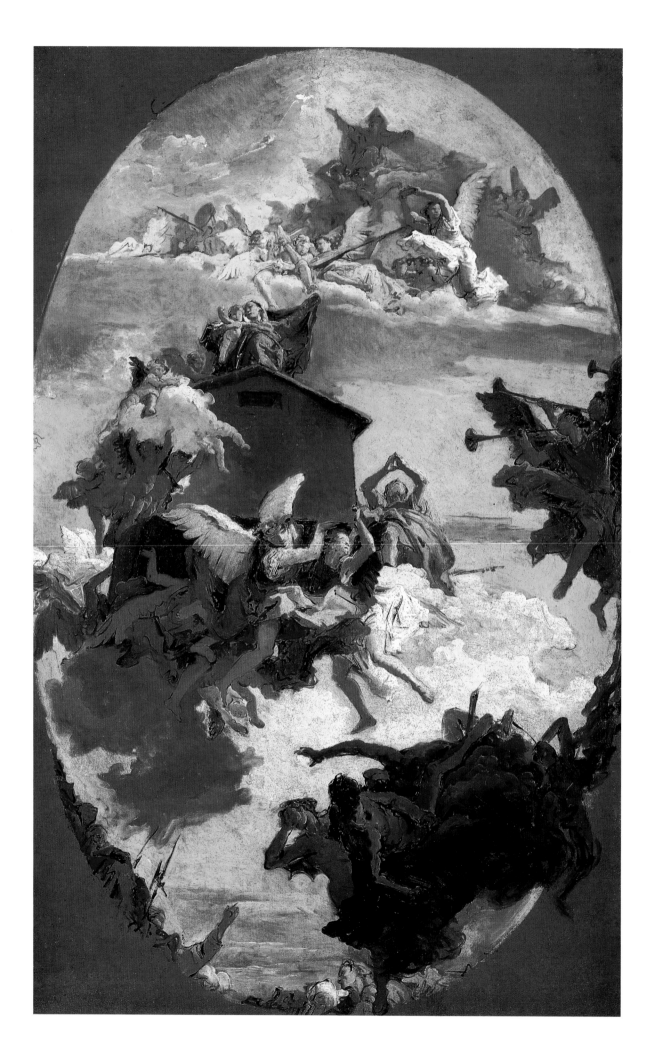

Jacques-Louis David
French, 1748–1825
The Sisters Zenaïde and Charlotte Bonaparte, 1821
Oil on canvas, 129.5 x 100 cm (51 x 39⅜ in.)
86.PA.740

[Opposite page]
Giambattista Tiepolo
Italian, 1696–1770
The Miracle of the Holy House of Loreto, ca. 1744
Oil on canvas, 123 x 77 cm (48⅜ x 30⅜ in.)
94.PA.20

Joseph Mallord William Turner
British, 1775–1851
Van Tromp, going about to please his Masters, Ships a Sea, getting a Good Wetting, 1844
Oil on canvas, 91.4 x 121.9 cm (36 x 48 in.)
93.PA.32

Francisco José de Goya y Lucientes
Spanish, 1746–1828
Bullfight, Suerte de Varas, 1824
Oil on canvas, 50 x 61 cm (19½ x 24 in.)
93.PA.1

Pierre-Auguste Renoir
French, 1841–1919
La Promenade, 1870
Oil on canvas, 81.3 x 65 cm (32 x 25½ in.)
89.PA.41

Édouard Manet
French, 1832–1883
The Rue Mosnier with Flags, 1878
Oil on canvas, 65.5 x 81 cm (25¾ x 31¾ in.)
89.PA.71

Claude Monet
French, 1840–1926
Wheatstacks, Snow Effect, Morning, 1891
Oil on canvas, 65 x 100 cm (25½ x 39¼ in.)
95.PA.63

Paul Cézanne
French, 1839–1906
Still Life with Apples, ca. 1893–94
Oil on canvas, 65.5 x 81.5 cm (25¾ x 32⅛ in.)
96.PA.8

James Ensor
Belgian, 1860–1949
Christ's Entry into Brussels in 1889, 1888
Oil on canvas, 252.5 x 430.5 cm (99½ x 169½ in.)
87.PA.96

Antefix in the Form of a Maenad and Silenos Dancing
South Etruscan, terra-cotta, early fifth century B.C.
H: 54.6 cm (21½ in.)
96.AD.33

Antiquities

In the late 1970s and early 1980s, while waiting for the use of the Getty legacy, the trustees realized that the Museum would quickly outgrow the villa building, and that an entirely new museum could be built somewhere else, allowing the Malibu site to become a place for antiquities. This idea became a plan by 1983, and it has guided our collecting ever since.

The antiquities collection had a long way to go before it would be large enough and good enough to justify a separate branch museum for Greek and Roman art. Getty's own sculptures were a start. His collection was strong on marble portraits and images of gods and heroes, but weak in bronzes, vases, goldsmiths' work, and terra-cotta. It was chronologically and geographically limited, lacking anything important from the prehistoric Mediterranean, Etruria, many Greek colonies, and the Roman hinterland. The first curator, Jiří Frel, added some major works such as the bronze *Victorious Youth* already mentioned (pp. 77–79) and, through purchases and gifts, secured a vast amount of archaeological material of minor interest for visitors but of value to scholars from the United States and abroad, who were drawn to the Getty in ever greater numbers to study the material.

Antiquities expanded dramatically through the acquisition of existing collections. The finest private holding of Greek vases in the world, that of Walter and Molly Bareiss, contained 479 complete and fragmentary examples. Purchased in 1985, these gave us a truly important collection. In the twelve intervening years, dozens more vases have been bought by an astute curator, Marion True, who is herself a vase specialist. The most recent purchase is a storage jar made in Rhegion (modern Reggio Calabria), one of the south Italian colonies of the Greek city-state Chalcis. The finest known vase of its type, it depicts a scene from the *Iliad*, in which the wily Greek heroes Diomedes and Odysseus sneak into the camp of the enemy Thracians while they are asleep and cut their throats so as to steal their immortal horses. The tale is told with brutal clarity, the horses are brilliantly drawn, and the whole vase has a robust vitality of shape and ornament.

A group of ten silver drinking vessels from the outer reaches of the empire of Alexander the Great, perhaps as far east as modern Afghanistan, includes a *rhyton* (a horn-shaped vessel with a spout) in the form of a stag, the noblest quarry of hunters. This and others of the group—a lion, two lynxes—are among the most vigorous representations of animals from all of antiquity. Silver like this, a token of wealth and imperial favor in antiquity, was melted down by captors and thieves on such a scale that very little has survived.

A group of ten pieces of Hellenistic gold jewelry came recently from an American collection, and following that came one of the most spectacular Macedonian gold wreaths ever found, a lavish miniature garden with leaves and several types of flowers, including myrtle, made of thin sheet gold and inlaid with blue and green glass paste. Spared from pillage by being buried in the tomb of its wealthy owner, it has survived beautifully.

Cycladic art—works made in the islands of the Aegean beginning around 2500 B.C.— had been neglected until the purchase of an especially fine marble *Harpist* in 1985. A group of eight pieces from the well-known Steiner collection, including one of the most subtly modeled and finely proportioned of all the female idols, raised the level of the collection. Visitors to the Getty Museum can now get a good idea of the achievement of this remarkable culture, which we know largely through the survival of such pieces as these.

The most important discovery of a Greek statue in the past decade was the over-life-size cult figure of Aphrodite acquired by the Museum in 1988. Undoubtedly made for a temple in the colonies of Magna Grecia, it is the centerpiece of an ensemble of pieces originally coming from Greek settlements in Italy that is among our greatest strengths. The only complete example of the most important type of sculpted figure to survive from antiquity, this one realizes the ideals of gravity, sensuousness, and mysterious animation

that are familiar from the Parthenon pediment sculptures by Phidias (the "Elgin Marbles"), a project the sculptor of the Getty *Aphrodite* may have participated in.

The *Aphrodite* is monumental; many of our greatest purchases have been very small. The bronze dead warrior is one of the most beautiful Greek works in the collection. The complex arched and twisting pose embodies the most advanced kind of bodily expressiveness in sculpture, ahead of any surviving contemporary figure in marble. No other Greek bronze of the fifth century embodies the ideal of *kalos thanatos*, beauty in death, so eloquently.

A previously unknown *kouros* figure, handsome and complete, proved to be our most troublesome acquisition. It is still not clear after a dozen years of study by experts, publication, and display, whether the piece is genuine or fake. Either it is one of the most important discoveries of recent years or a highly skilled modern forgery. Two years of studies before the piece was bought in 1985 determined that the stylistic evidence pointed, on the whole, toward its being authentic; the scientific evidence argued strongly for the same conclusion, since the weathering could not have been induced artificially, and the carving techniques were typical of ancient works, not fakes. In 1990, new suspicions were aroused about the piece after a fake with similarities to the *kouros* turned up, and technical studies were renewed. The *kouros* was the subject of an inconclusive international symposium in Athens we helped to organize, and later it returned to exhibition in Malibu together with comparative material and documentation—and an invitation to visitors to try to understand the puzzle, if not solve it. No new information has since been brought forward to argue against the *kouros*; indeed, the weight of evidence supports its authenticity.

For nearly a decade, the Museum's policy for acquiring antiquities required us to make inquiries about prospective purchases to governments, to announce and publish acquisitions promptly, and to return objects for which valid claims are made, even after the statute of limitations has run out and we are no longer legally obligated to do so. During the last few years, we came to believe that these self-imposed restrictions were not enough. In order to encourage better relationships with archaeological colleagues here and abroad, and to make for easier collaboration in future projects at the Getty Villa, we no longer collect unpublished material. We will sometimes buy works from documented old collections, or works published before the policy was instituted in 1995, but nothing else.

As we write, the Museum has made the most important acquisition of antiquities since Getty's gift of his personal holdings. Barbara and Lawrence Fleischman of New York have agreed that more than 300 objects from their collection, one of the finest in existence, would come to the Museum by a combination of gift and purchase, the donated portion being by far the larger. Any worry we had about the Getty collection of antiquities not fully justifying its own building is, thanks to the Fleischmans' generosity, a thing of the past. Not only are there major Greek and Roman statues that nicely complement ours, but concentrations of material in whole categories where the Getty has been thin. An Etruscan terra-cotta *antefix* (roof ornament) in the form of a Maenad and Silenos dancing, whose bright colors are unusually well preserved, is one of the fine group of Etruscan pieces that fills a large hole in the Getty collection. A large Greek wine vessel (*lebes*) of the Hellenistic period, unique in form, the finest bronze of its type known, is lavishly ornamented with silver grape vines and the twisting torso of a fleshy young satyr whose leer invites the spectator to drink. The satyr was a devotee of Dionysos; this god reappears more than once in the Fleischman collection, most memorably as a life-size bronze toddler wearing a wreath of immature grapes. Included in the Fleischman acquisition is a large group of works with theatrical subjects. Since performances of Greek and Roman plays will be part of the Villa's program after its reopening in 2001, these works of art should contribute particular pleasure to our visitors' experience.

Female Figure of the Late Spedos Type
Cycladic, island marble, 2500–2400 B.C.
H: 59.9 cm (23⅜ in.)
Attributed to the Steiner Master
88.AA.80

Harpist
Cycladic, island marble, ca. 2500 B.C.
H: 35.8 cm (14 in.)
W: 9.5 cm (3¹¹⁄₁₆ in.)
85.AA.103

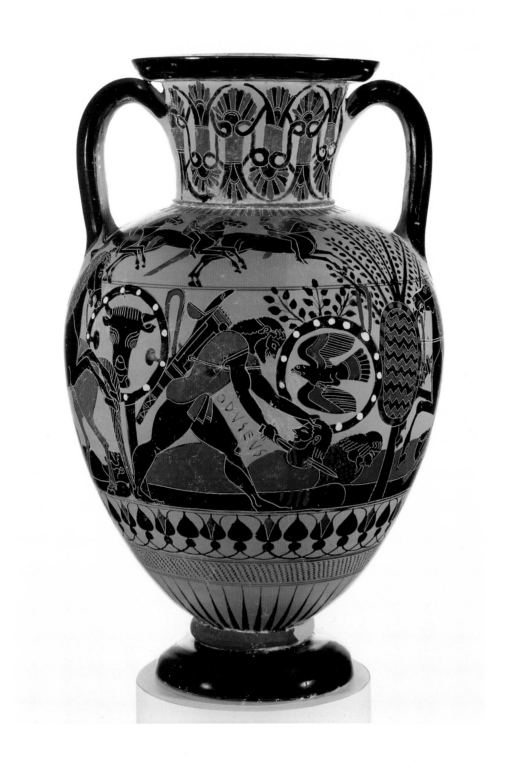

Black-Figured Neck Amphora
Showing Diomedes about to kill King Rhesos (side A);
Odysseus killing the last of the Thracian soldiers (side B)
Greek, "Chalcidian" (probably made in Rhegion, South
Italy), terra-cotta, ca. 540 B.C.
H: 39.6 cm (15⅝ in.)
DIAM: (body): 24.9 cm (9¹³⁄₁₆ in.)
Attributed to the Inscription Painter
96.AE.1

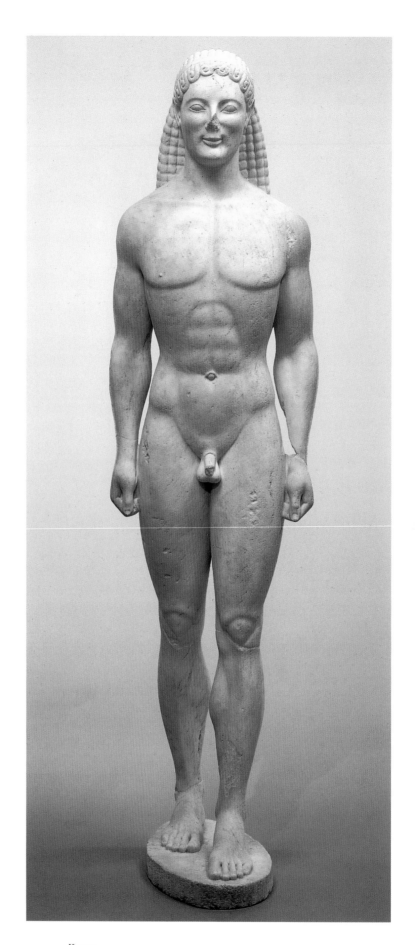

Kouros
Greek, Thasian (?) marble, ca. 530 B.C. or modern
forgery
H: 200 cm (80 in.)
85.AA.40

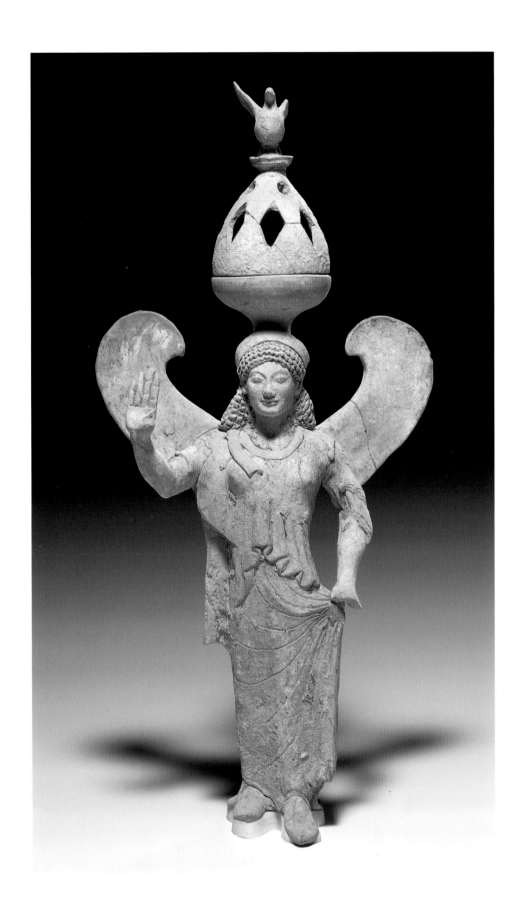

Thymiaterion Supported by a Statuette of Nike
Greek (Taranto, South Italy or Sicily), terra-cotta,
500–480 B.C.
H: 44.6 cm (17⅜ in.)
86.AD.681

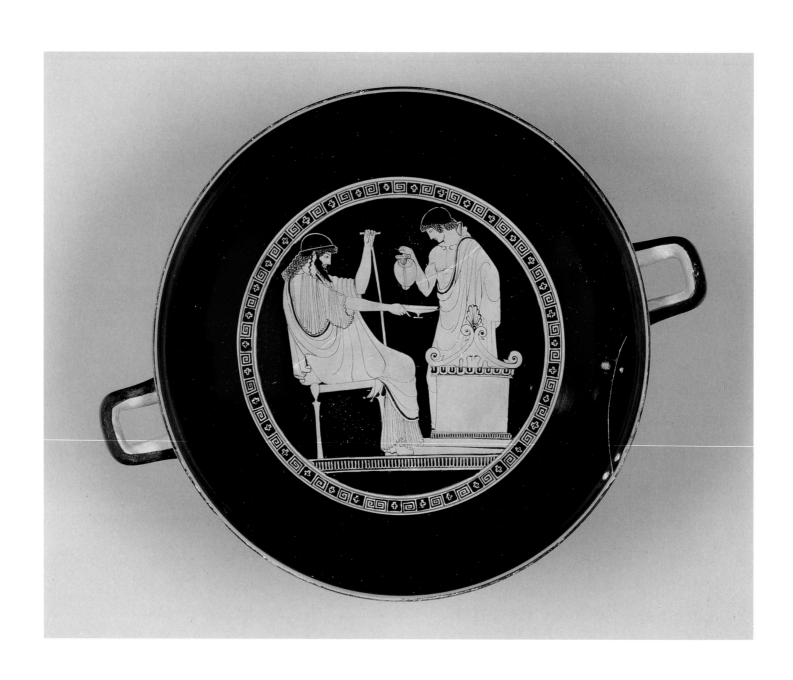

Red-Figured Cup Type B
Showing Zeus seated before an altar, served by
Ganymede (interior); Eos pursuing Kephalos, watched
by Pandion, Kekrops, and Erechtheus (side A); Zeus
pursuing Ganymede (side B)
Greek (Athens), terra-cotta, ca. 480 B.C.
H: 13.3 cm (5¼ in.)
DIAM: 32.4 cm (12¾ in.)
Signed by Douris (as painter) and attributed to Python
(as potter)
84.AE.569

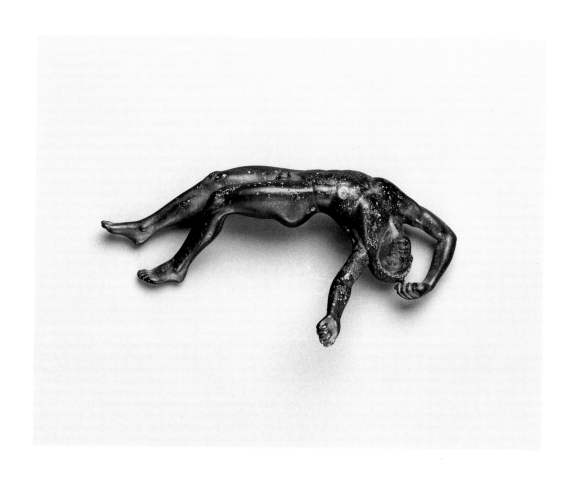

Statuette of a Fallen Youth
Greek, bronze with copper inlays, 480–460 B.C.
W: 7.3 cm (2⅞ in.)
L: 13.5 cm (5¼ in.)
86.AB.530

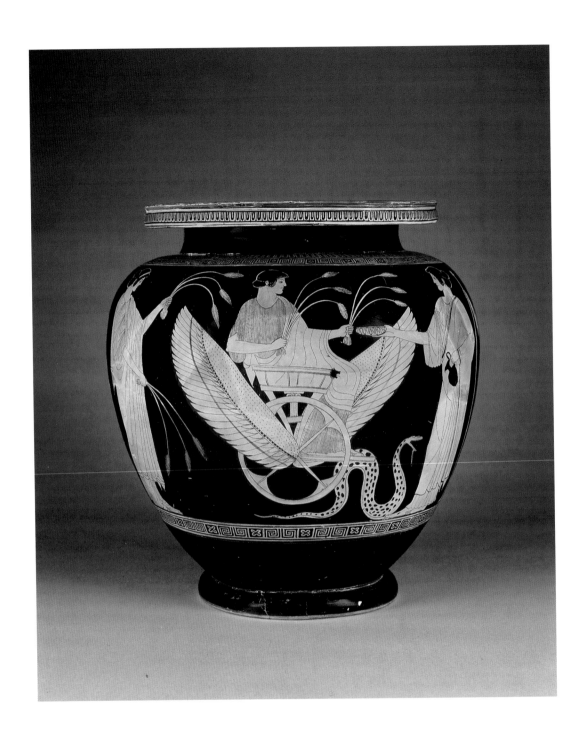

Red-Figured Dinos
Showing gods, goddesses, and heroes gathered for the
departure of Triptolemos
Greek (Athens), terra-cotta, ca. 470 B.C.
H: 36.8 cm (14⅜ in.)
DIAM: (body): 35.7 cm (14 in.)
Attributed to the Syleus Painter
89.AE.73

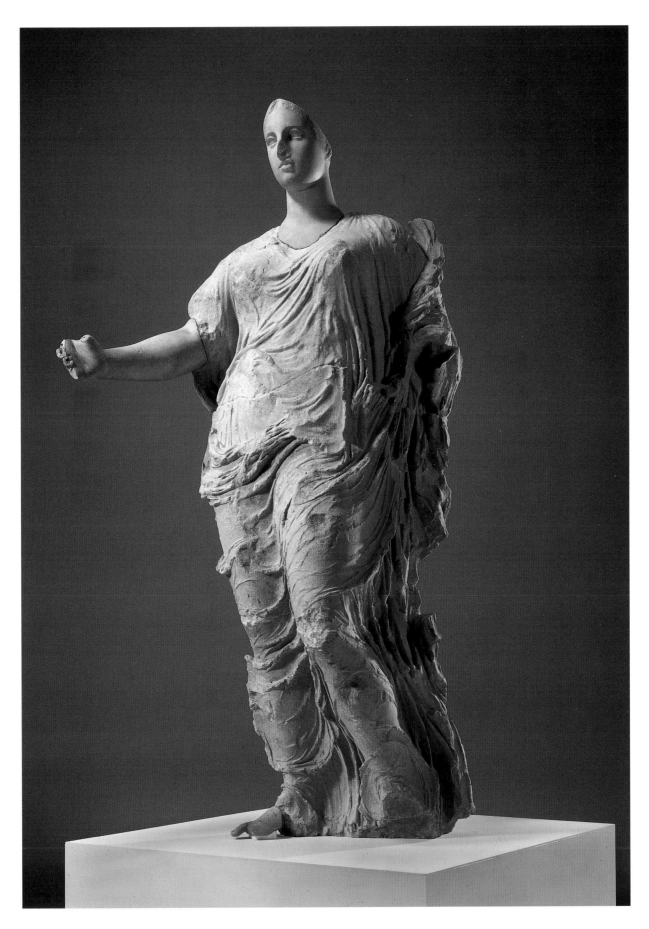

Cult Statue of a Goddess, perhaps Aphrodite
Greek (South Italy), limestone and Parian marble
with polychromy, 425–400 B.C.
H: 220 cm (85¹³⁄₁₆ in.)
88.AA.76

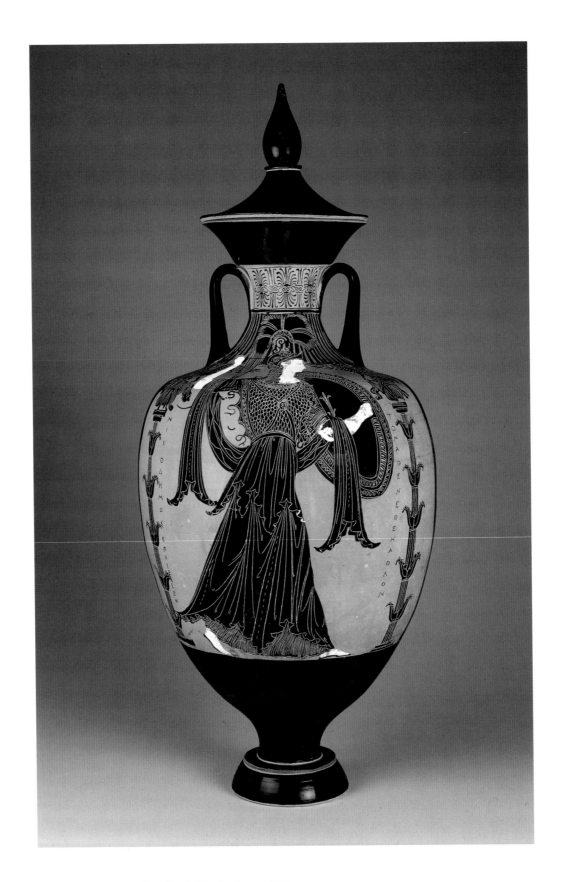

Panathenaic Prize Amphora and Lid
Showing Athena Promachos (side A); Nike crowning the
victor, with the judge on the right and the defeated
opponent on the left (side B)
Greek (Athens), terra-cotta, 363–362 B.C.
H: (with lid): 89.5 cm (35 in.)
CIRCUMFERENCE (shoulder): 115 cm (44⅞ in.)
Attributed to the Painter of the Wedding Procession
(as painter); signed by Nikodemos (as potter)
93.AE.55

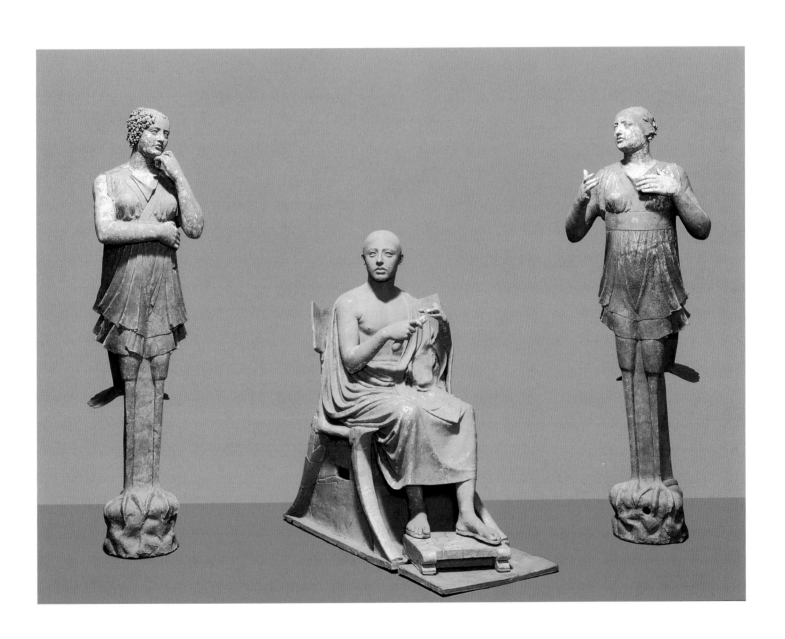

Seated Poet and Sirens
Greek (probably Taranto, South Italy), terra-cotta,
ca. 310 B.C.
H: (Poet): 104 cm (40⁹⁄₁₆ in.)
H: (Sirens): 140 cm (54⅝ in.)
76.AD.11

Head of Alexander
Greek, marble, ca. 320 B.C.
H: 28 cm (10¹⁵⁄₁₆ in.)
73.AA.27

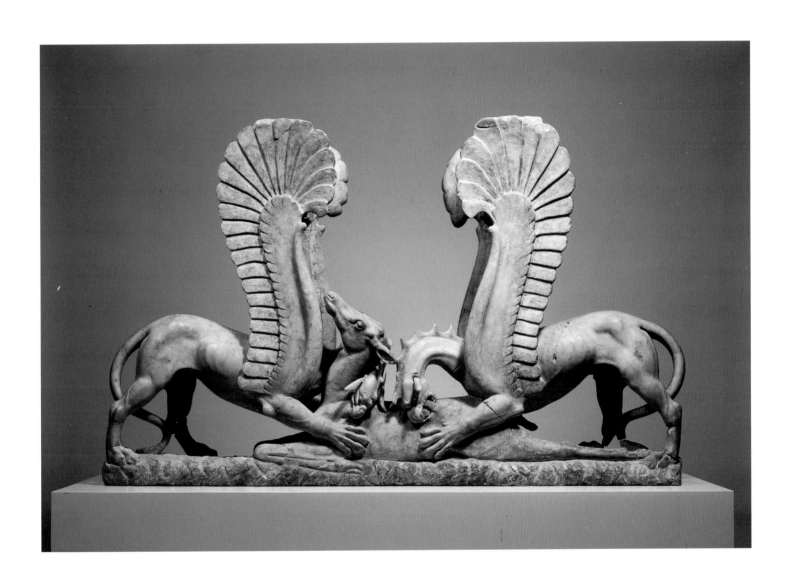

Sculptural Group of Two Griffins Attacking a Fallen Doe
Greek (South Italy), Asia Minor marble with
polychromy, late fourth century B.C.
H: 95 cm (37 1/16 in.)
L: (base): 148 cm (57 3/4 in.)
85.AA.106

Wreath
Greek, gold with blue and green glass-paste inlays
and glass beads, late fourth century B.C.
DIAM: 30 cm (11¹¹⁄₁₆ in.)
93.AM.30

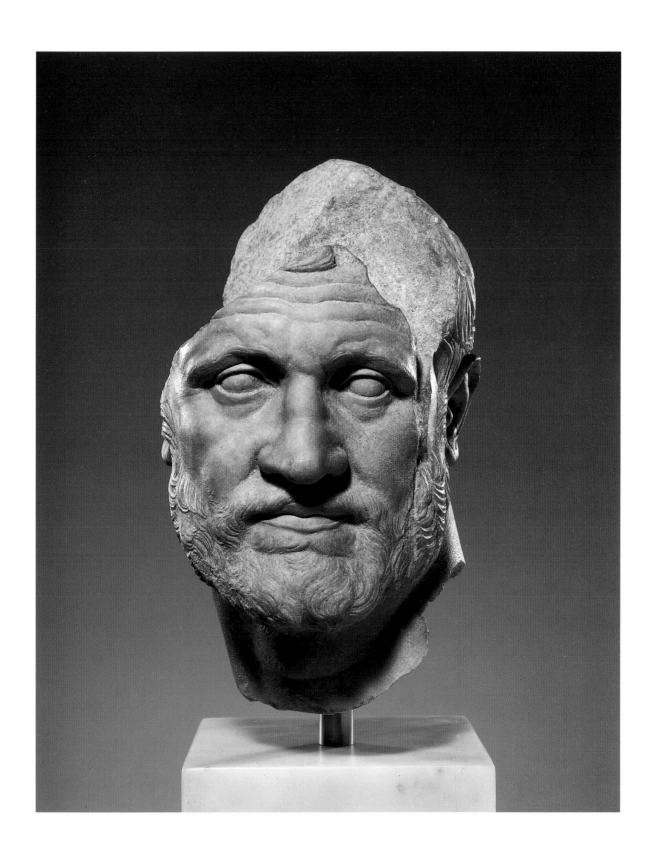

Portrait of a Bearded Man
Greek, marble, Hellenistic, 160–150 B.C.
H: 40.7 cm (16⅟₁₆ in.)
W: 25 cm (9⅞ in.)
91.AA.14

Hair Net with Aphrodite and Eros on the Medallion
Greek (possibly Alexandria), gold, garnets, and glass
paste, Hellenistic, 220–100 B.C.
H: 21.5 cm (8½ in.)
W: 8 cm (3⅛ in.)
92.AM.8.1

Lebes
Greek, bronze with silver inlays, Late Hellenistic,
50–1 B.C.
H: 58 cm (22¹³⁄₁₆ in.)
96.AC.51

Rhyton
Eastern Greek (Seleucid Empire), gilt silver with
glass paste and stone inlays, Late Hellenistic, late first
century B.C. or early first century A.D.
H: 26.5 cm (10⅜ in.)
DIAM: (rim): 12.7 cm (4¹⁵⁄₁₆ in.)
86.AM.753

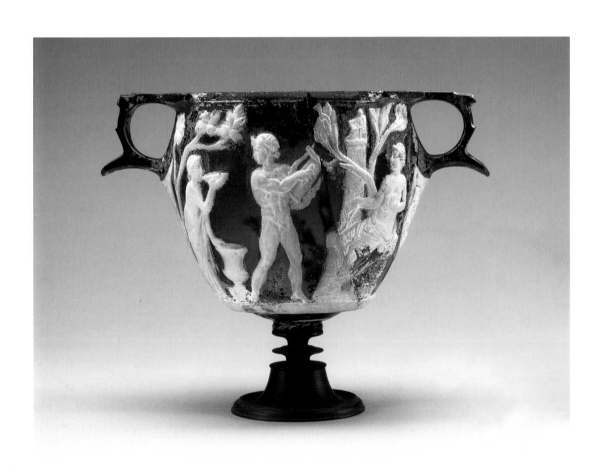

Skyphos
Showing a young satyr with a syrinx before a seated
woman (side A); young satyr with a lyre between
two women (side B)
Roman, cameo glass, 25 B.C.–A.D. 25
H: 10.5 cm (4⅛ in.)
W: 17.6 cm (6⅞ in.)
84.AF.85

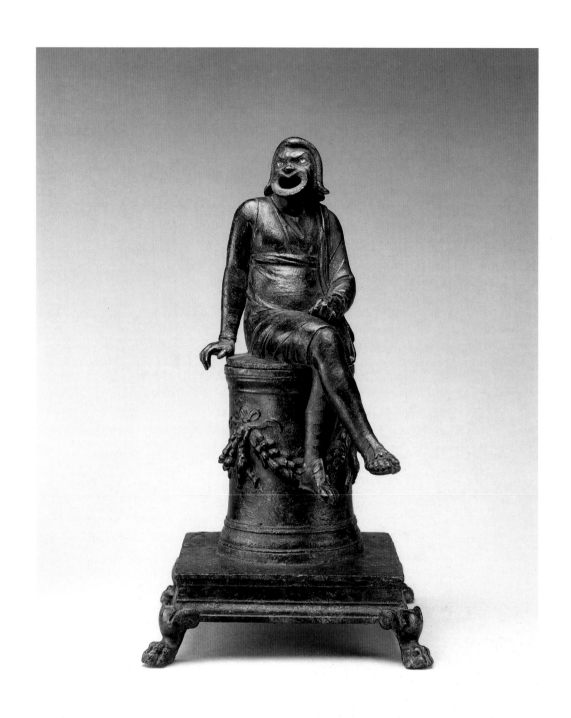

*Thymiaterion in the Form of a Comic Actor Seated
on an Altar*
Roman, bronze with silver inlays, first half of first
century A.D.
H: 23.3 cm (9⅛ in.)
W: (base with feet): 13.3 cm (6 in.)
87.AC.143

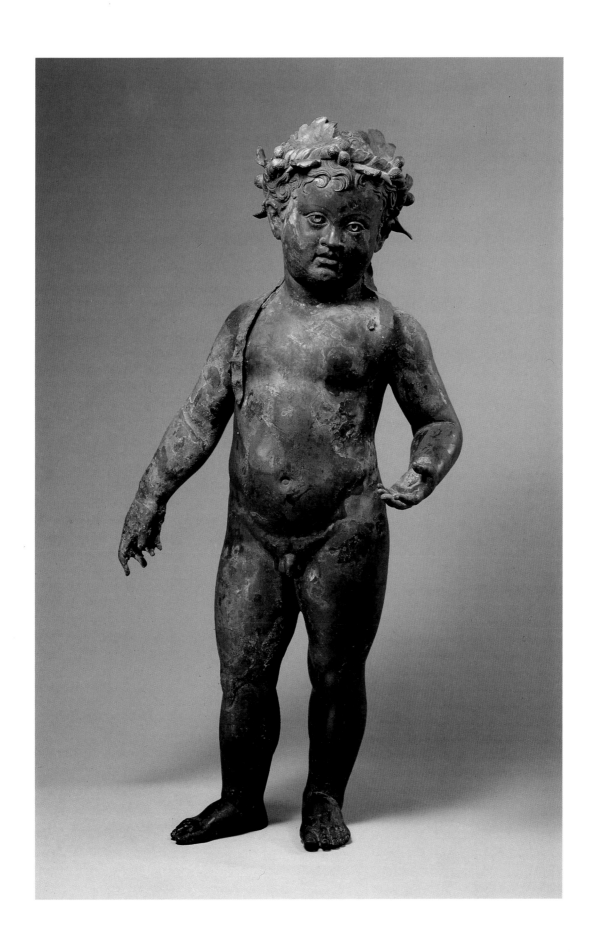

Statue of the Infant Dionysos (?)
Roman, bronze with silver and copper, first half of
first century A.D.
H: 64 cm (24¹⁵⁄₁₆ in.)
96.AB.53

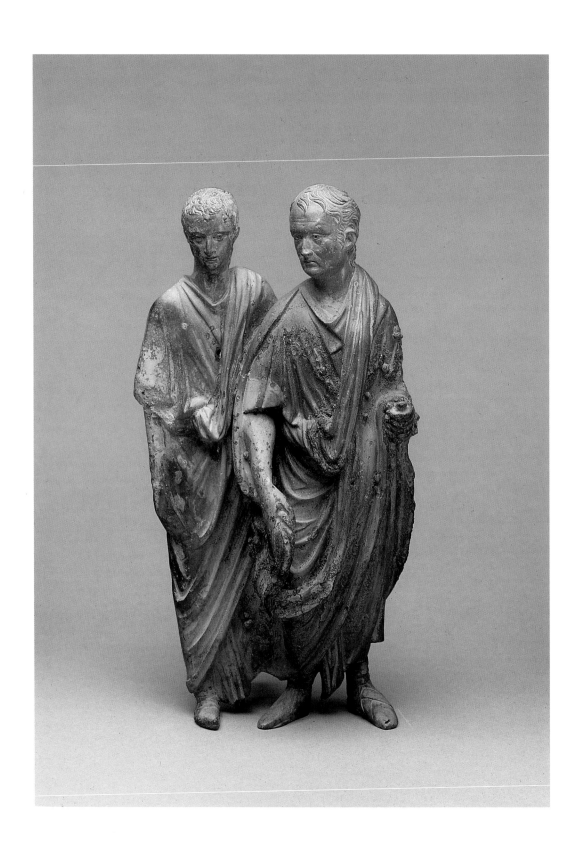

Relief with Two Togate Magistrates
Roman, bronze, A.D. 40–68
H: 26 cm (10⅛ in.)
W: 13.8 cm (5⅜ in.)
85.AB.109

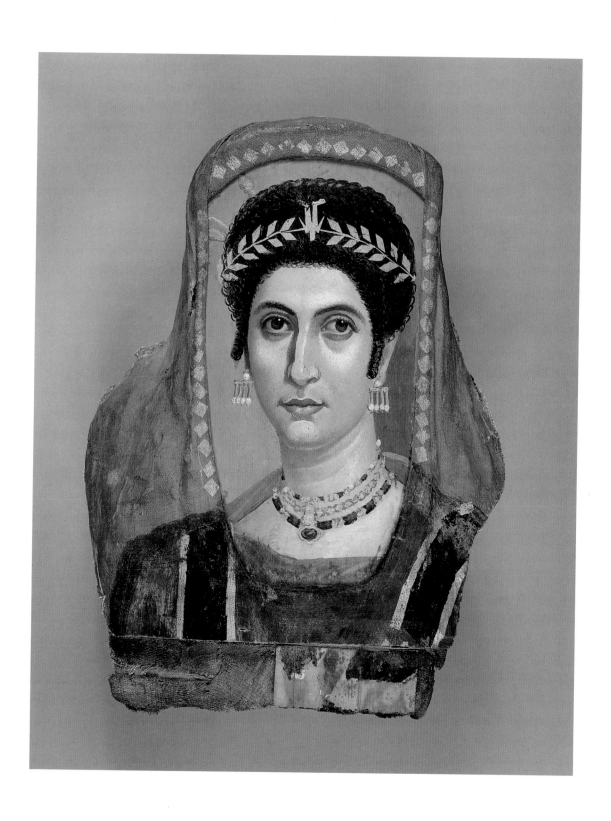

Mummy Portrait of a Woman
Romano-Egyptian (Fayum), encaustic and gilt on a
wooden panel wrapped in linen, A.D. 100–125
H: (panel): 33.6 cm (13⅛ in.)
W: (panel): 17.2 cm (6¾ in.)
Attributed to the Isidora Master
81.AP.42

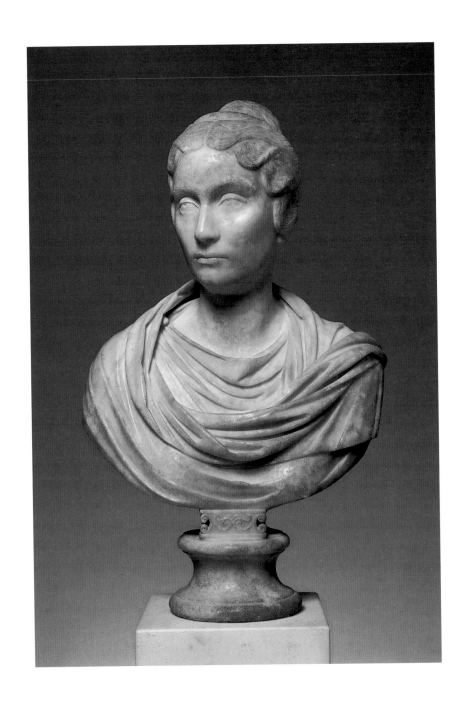

Portrait Bust of a Roman Lady
Roman, Carrara marble, A.D. 150–160
H: 67.5 cm (26⁵⁄₁₆ in.)
83.AA.44

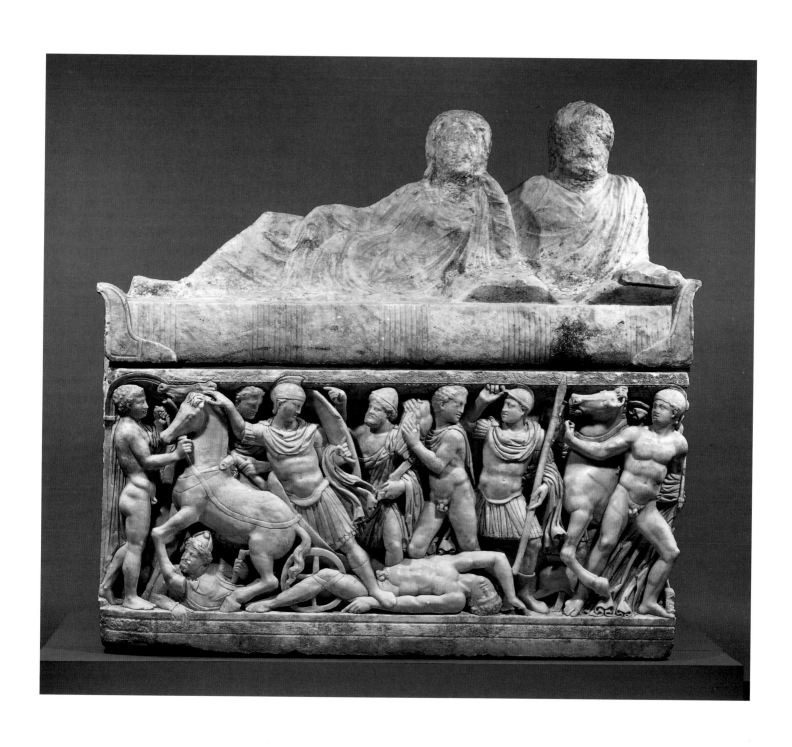

Sarcophagus with Lid
Showing Achilles dragging Hector's body (front);
the arming of Achilles (end); Centauromachy (back);
and the discovery of Achilles on Skyros (end)
Roman (made in Athens), marble, late second–
early third century A.D.
L: (box): 249 cm (98 in.)
H: (box): 134 cm (53 in.)
L: (lid): 218 cm (86 in.)
H: (lid): 100 cm (39 in.)
95.AA.80

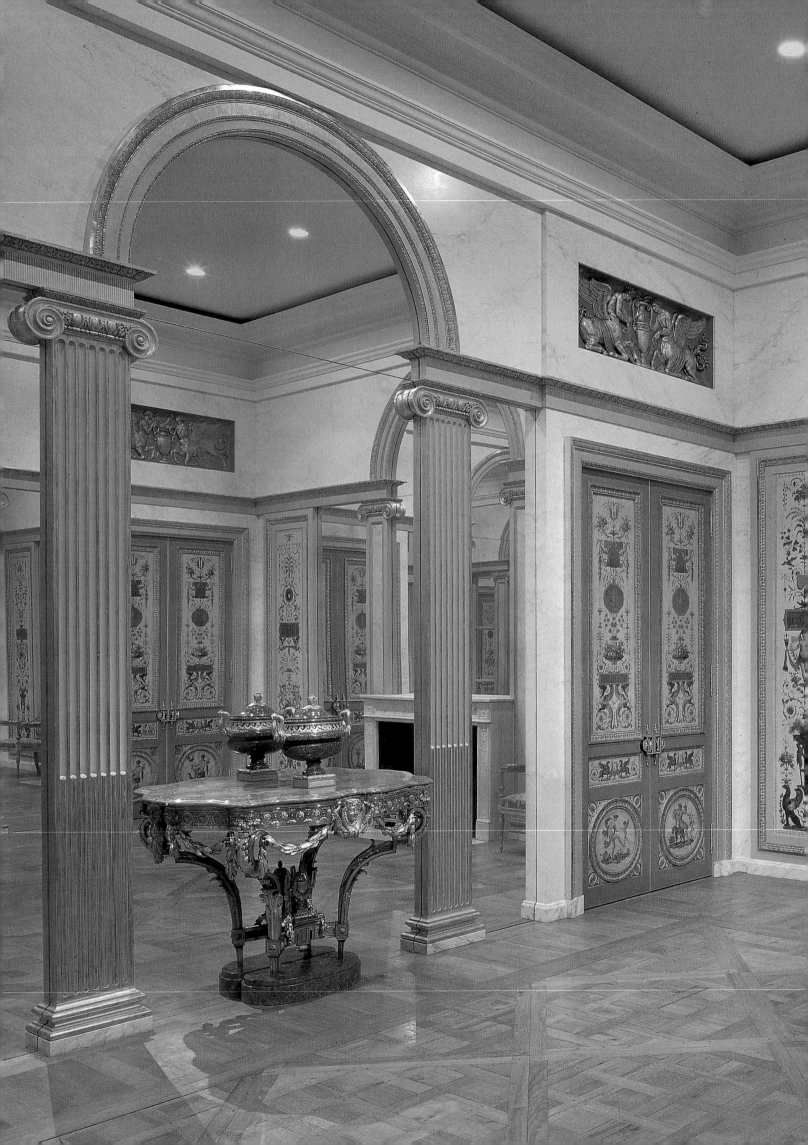

Decorative Arts

In 1954, when the Getty Museum opened in Malibu, there were about thirty fine pieces of French furniture. Small as it was, only three or four collections were better. Getty had been going after the work of the French cabinetmakers of the eighteenth century with a genuine passion. His diaries and letters are full of references to visits to private houses and dealers, including detailed notes on quality and worth. Of one table, the companion to a famous piece in the Louvre, Getty noted in 1949 that his piece was "more beautiful and important and the green lacquer is lovelier." Prepared to offer $30,000, he was quoted half that sum and bought it on the spot. (As it turned out, for half the expected price Getty actually got half the expected table: the Sèvres porcelain top is authentic and still on display, but the rest, including the green lacquer, is a twentieth-century copy that is now in storage.)

Three years later, in 1952, Getty purchased the famous double desk by Bernard II van Risenburgh, a Rococo masterpiece. Getty recounts in *The Joys of Collecting* that the owner, the Duke of Argyll, did not appreciate its excellence and value, nor did Getty, because he had turned down the duke's invitation to see the furniture at Inverary Castle. A few months later, the duke sold the desk to a New York dealer. Getty bought it a year later for $35,000, a price "much, much steeper" than he could have paid to the owner, he wrote ruefully, if he had bestirred himself to take the trip to Scotland in the dead of winter.

When the Museum opened, Getty considered the collection of French decorative arts complete and stopped buying; but when he decided to build the Roman villa and expand into it, he hired Gillian Wilson as curator and resumed collecting. Today, the Museum's collection of decorative arts reflects the taste and expertise of the curator in concert with Getty's own. It is more coherent than the others, partly because it covers the shortest period of time and does so in greater depth and with greater consistent excellence. There are many extravagances in the collection. Time and time again, Getty overcame his ambivalence about expense, and years after his death, the trustees would do the same. In 1979, the most expensive work of decorative art ever sold at that time was the elaborate corner cabinet by the cabinetmaker Jacques Dubois (dated 1744 but unfinished eight years later: Dubois's patron wrote a testy letter to his agent in Paris in 1752 demanding to know when it would be finished). Ten feet high and fabulously showy, the importance and high price of this cabinet set the tone and made part of the reputation of the Museum's collecting.

Over the years, the Museum has made something of a specialty of the work of André-Charles Boulle and his Parisian atelier, which originated in the late seventeenth century. Our eighteen pieces attributed to this genius—coffers, tables, cabinets, candle stands, and others—are extraordinary for their intricate marquetry, using veneers of ebony, brass, tortoiseshell, pewter, horn, and ivory, as well as many exotic woods. So naturalistic are the designs that individual flowers can be identified. A pair of robust coffers on stands are decorated with intricate patterns of pewter and brass inlay that mirror one another; the cabinetmaker used the material left over from the first coffer as the marquetry in the companion piece.

The decorative arts collection has entirely outgrown the space in Malibu. To remedy the situation, the new museum at the Getty Center has a suite of fourteen galleries designed by Thierry Despont, in association with Richard Meier, that form a kind of museum-within-a-museum inside the Meier building, incorporating original paneled rooms with other rooms designed in various period styles that suggest the contexts from which the pieces come.

Since Getty's death emphasis has been placed on furniture and objects of the neoclassical period. Beautiful in themselves, these pieces demonstrate the diffusion of the newer, more severe and architectural style, often with motifs derived from newly excavated

A room with painted and gilded oak paneling attributed to Rousseau de la Rottière after designs by Claude-Nicolas Ledoux, executed in 1788–89.

Roman houses at Pompeii and Herculaneum. One of the major examples is the rolltop desk of about 1785 by the German David Roentgen; another is from a group of pieces by the Parisian Martin Carlin decorated with porcelain plaques from the Sèvres manufactory that made this furniture almost as expensive in its day, relatively speaking, as it is now.

Getty himself preferred to collect large pieces. He would probably have been as anxious to buy the huge Dubois corner cabinet as his trustees were, but in general he was not keen for what he called "bric-à-brac." His definition was broad: bric-à-brac seemed to be anything less than four feet high or wide. He had to admit that the owners of the great houses for which this furniture was made were fond of decorative pieces, and Wilson showed him pictures from the Louvre to remind him that clocks, wall lights, candelabra, hardstone vases, and the like were integral to the arrangement of the rooms. Since Getty's time, the Museum has assembled a large array of these objects, accounting for the fact that decorative arts increased by a factor of ten in the seventies and eighties. Among the most intriguing are a few eighteenth-century scientific instruments, including a spectacular gilt-bronze compound microscope in working condition, complete with natural specimens on slides and a carrying case of tooled leather lined with velvet. Science was an adventure for rich amateurs at this period, and we can imagine the owner of this elegantly ornamented instrument showing his amazed visitors the veins of a leaf and the hairs on a flea.

Porcelain has been added as well. What began as the occasional purchase of important court pieces from Sèvres and Vincennes expanded in the late 1980s to a select group from other major manufactories. None of this had been of much interest to Getty himself. Perhaps the most beautiful and rarest are two Sèvres vases in the shape of eggs, their blue bodies strewn with gilded dots. (The finials are eggs on piles of straw. This sort of rustic whimsy recalls Marie Antoinette playing milkmaid at the hamlet created for her at Versailles.) Oriental ceramics with Parisian gilt-bronze mounts have been a specialty of the collection—Japanese and Chinese pieces commissioned in Asia and brought from Amsterdam by Paris dealers to be fitted with bronze and silver. The resulting hybrid objects are not only very beautiful, but also fascinating evidence of the cultural contacts between Asia and the West, in which admiration and appropriation play a part.

Part of the appeal of all this material, of course, lies not only in its astonishing craftsmanship but also in its ability to suggest to visitors how a class of cultivated and wealthy people lived in the past. This is especially true with our four paneled rooms. These include a neoclassical room of carved and painted decorations designed by Claude-Nicolas Ledoux, the leading architect in late eighteenth-century Paris; like one other, it was bought with a view to exhibition at the new Museum for the first time. Tapestries, a strong point of the collection, have two galleries designed especially for them, so the public can see a whole series of related works in one place as they were intended to be seen, such as the splendid Emperor of China series, which has been in storage in Malibu for many years.

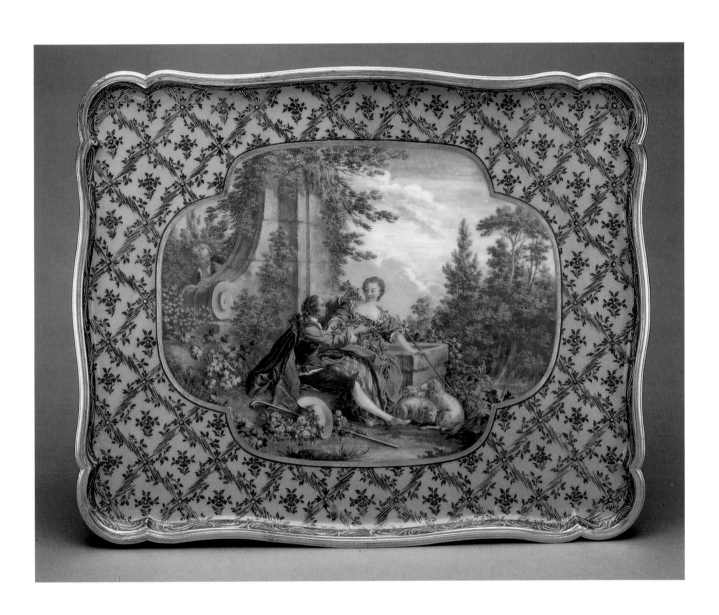

Porcelain Plaque (*Plateau Courteille ou de chiffonière*)
French (Sèvres), 1761
Sèvres manufactory with the reserve painted by
Charles-Nicolas Dodin (1734–1803) after a painting by
François Boucher (1703–1770)
Soft-paste porcelain with pink (*rose*) ground color,
polychrome enamel docoration, gilding
H: 2.5 cm (1 in.) W: 34.3 cm (13½ in.) D: 24.5 cm (10 in.)
70.DA.85

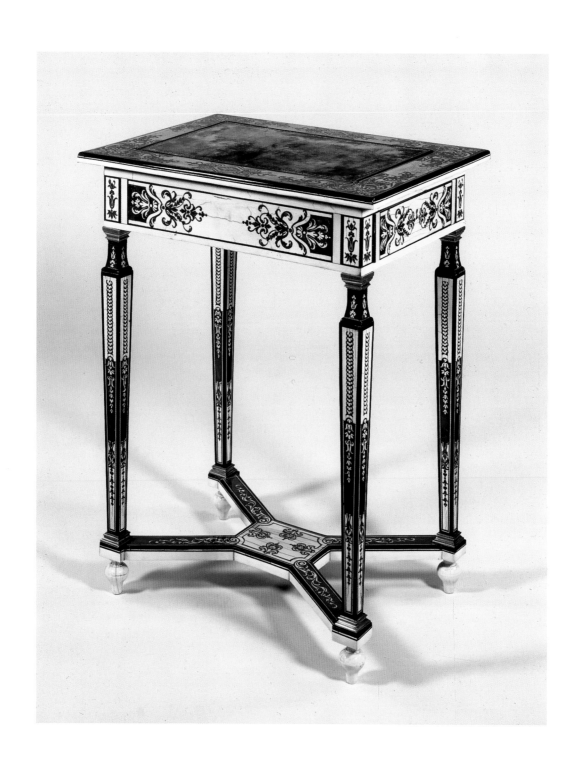

Reading and Writing Table
French (Paris), ca. 1670–75
Walnut and oak veneered with ivory, ebony, amaranth,
and blue painted horn; gilt-bronze moldings; steel; mod-
ern silk velvet
H: 63.5 cm (25 in.) W: 48.5 cm (19⅛ in.) D: 35.5 cm (14 in.)
83.DA.21

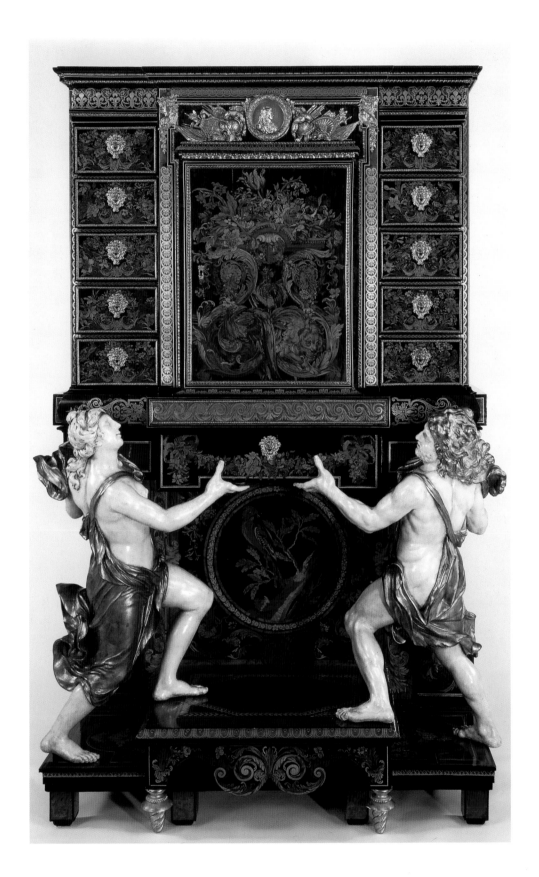

Cabinet on Stand
French (Paris), ca. 1680
Attributed to André-Charles Boulle (1642–1732)
Oak veneered with toroiseshell, brass, pewter, horn,
ebony, and ivory with marquetry of stained and
natural woods; drawers of snake wood; figures of
painted and gilded oak; gilt-bronze mounts
H: 229.9 cm (90½ in.) W: 151.2 cm (59½ in.)
D: 66.7 cm (26¼ in.)
77.DA.1

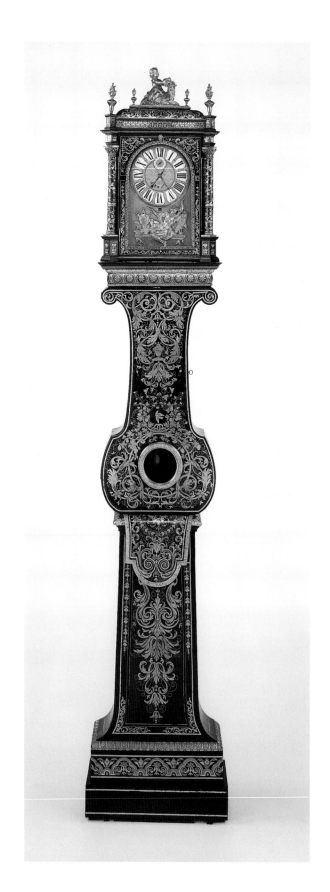

Long-Case Clock (*Régulateur*)
French (Paris), ca. 1680–90
Case attributed to André-Charles Boulle (1642–1732); clock
movement by Antoine I Gaudron (ca. 1640–1714)
Oak and walnut veneered with tortoiseshell, brass, pewter,
ebony, and ebonized wood; gilt-bronze mounts; glass;
enameled metal clock numerals
H: 246.5 cm (97½ in.) W: 48 cm (18½ in.) D: 19 cm (7½ in.)
88.DB.16

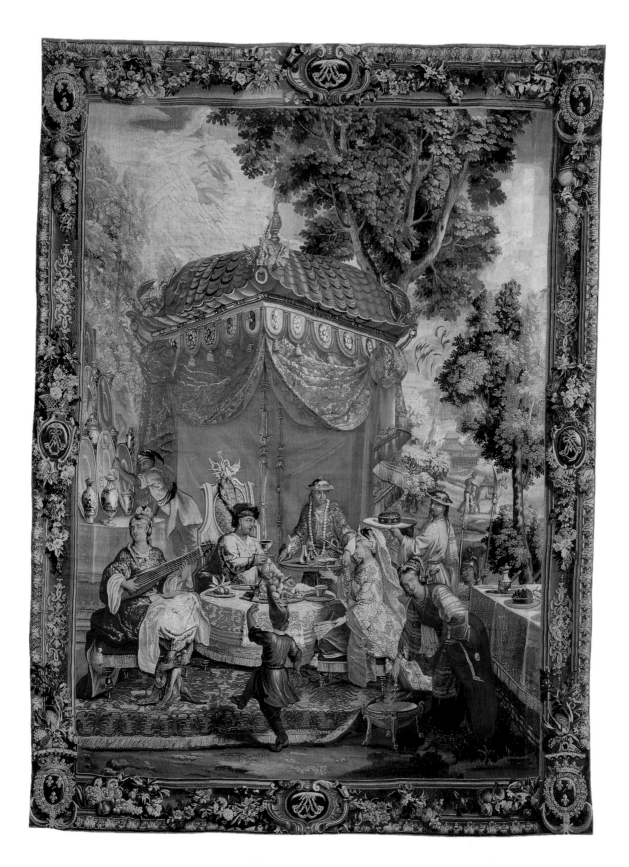

Tapestry
"The Collation" from the series *L'Histoire de l'empereur de la Chine*
French (Beauvais), ca. 1697–1705
Woven at the Beauvais manufactory under the direction of
Philippe Béhagle (1641–1705) after a design by
Guy-Louis Vernansal (1648–1729),
Jean-Baptiste Monnoyer (1636–1715) and
Jean-Baptiste Belin de Fontenay (1653–1715)
Wool and silk; modern cotton lining
H: 423 cm (166½ in.) W: 310 cm (122 in.)
83.DD.336

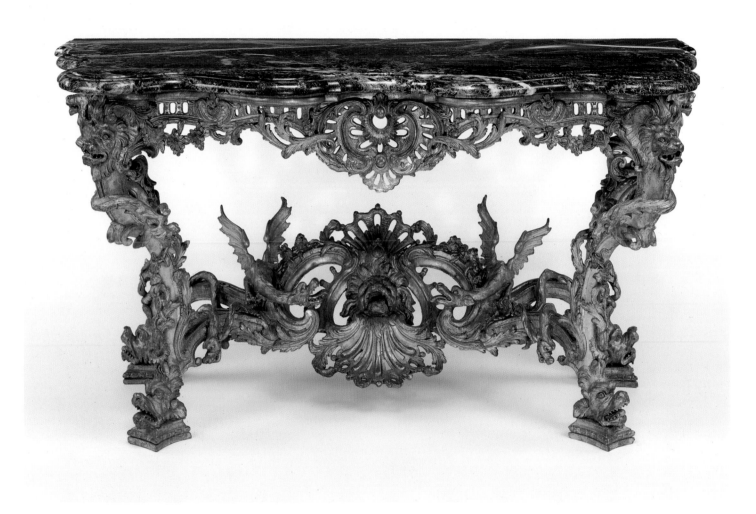

Side Table
French (Paris), ca. 1730
Gilded oak; *brèche violette* top
H: 89.3 cm (35 in.) W: 81.3 cm (67 in.) D: 81.3 cm (32 in.)
79.DA.68

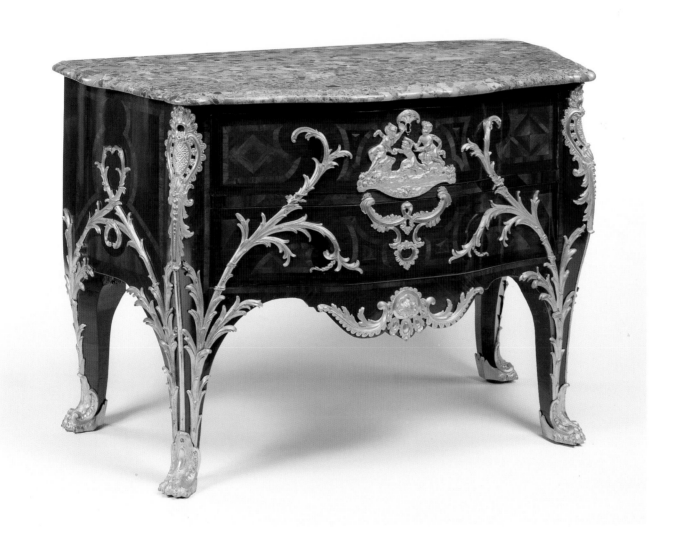

Commode
French (Paris) ca. 1735–40
Attributed to Charles Cressent (1685–1768)
Pine and walnut veneered with *bois satiné* and
amaranth; gilt-bronze mounts; *brèche d'Alep* top
H: 90.2 cm (35½ in.) w: 136.5 (53¼ in.)
D: 64.8 cm (25½ in.)
70.DA.82

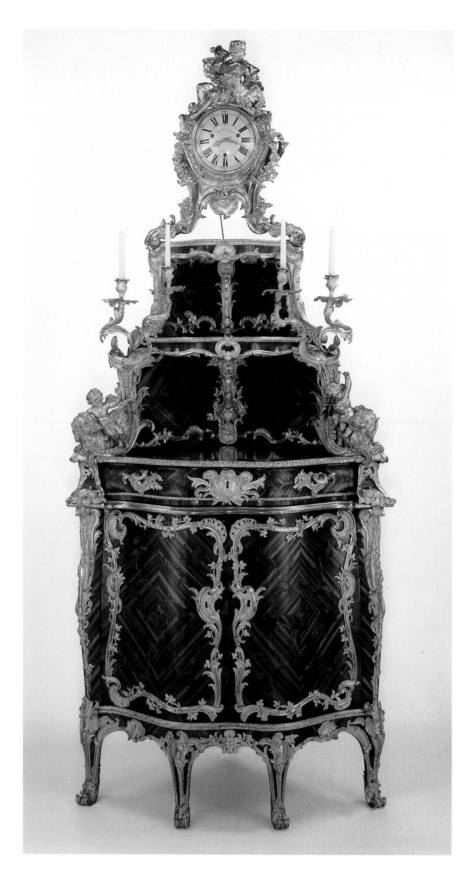

Corner Cabinet
French (Paris), cabinet 1744–53, clock 1744
Cabinet by Jacques Dubois (1694–1763);
clock movement by Etienne II Le Noir (1699–1778); clock dial
enameled by Antoine-Nicolas Martinière (1706–1784)
Oak, mahogany, and spruce veneered with *bois satiné* and king-
wood; gilt-bronze mounts; glass; enameled metal clock dial
H: 289.5 cm (114 in.) W: 129.5 cm (51 in.) D: 72 cm (28½ in.)
79.DA.66

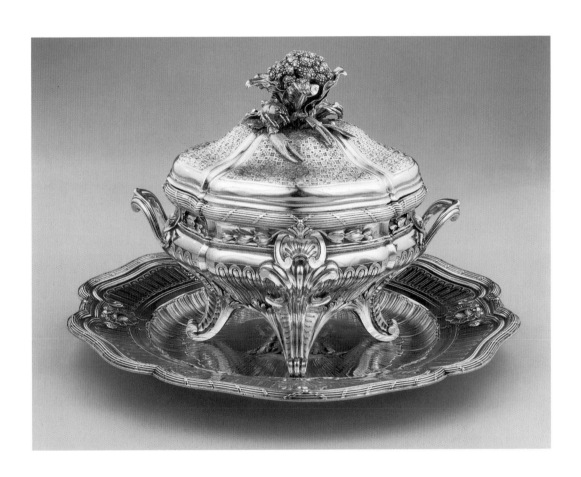

One of a Pair of Lidded Tureens, Liners, and Stands
French (Paris), 1744–50
Thomas Germain (1673–1748)
Silver
Tureen: H: 30 cm (11³⁄₁₆ in.) W: 34.9 cm (13¾ in.)
D: 28.2 cm (11⅛ in.)
Stand: H: 4.2 cm (1⅝ in.) W: 46.2 cm (18³⁄₁₆ in.)
D: 47.2 cm (18⁹⁄₁₆ in.)
82.DG.13

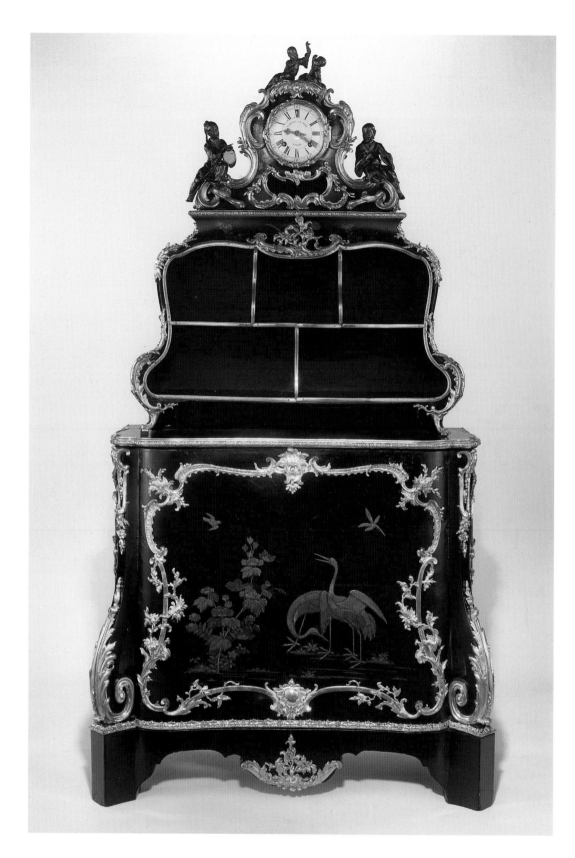

Cartonnier with Bout de Bureau and Clock
French (Paris); *cartonnier* and *bout de bureau*, ca. 1740; clock 1746
Cartonnier and *bout de bureau* by Bernard II van Risenburgh (after 1696–ca. 1766); clock movement by Etienne II Le Noir (1699–1778); clock dial enameled by Jacques Decla (active 1742–1764)
Oak veneered with ebonized alder and painted with *vernis Martin*; painted bronze figures; gilt-bronze mounts; glass; enameled metal clock dial
H: 192 cm (75⅜ in.) W: 103 cm (40⁹⁄₁₆ in.) D: 41 cm (16⅛ in.)
83.DA.280

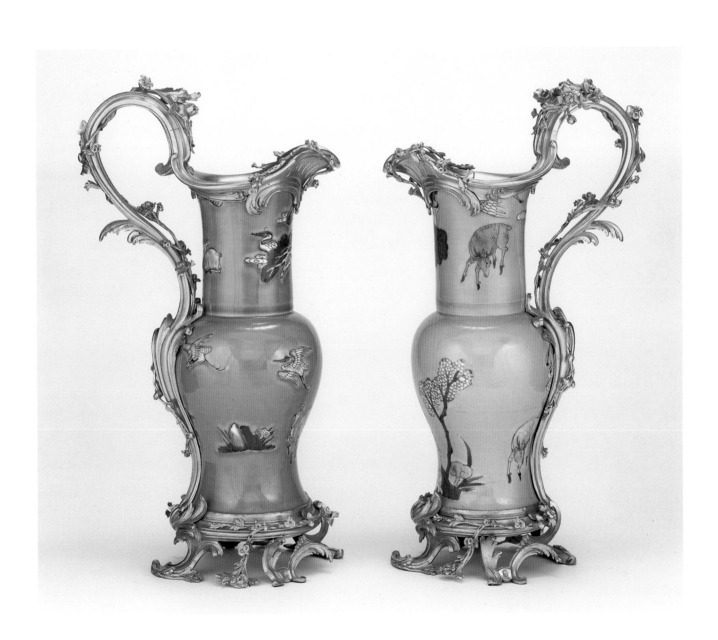

Pair of Ewers
Porcelain: China, Kangxi (1662–1722)
Mounts: French (Paris), 1745–49
Hard-paste porcelain, celadon ground color, underglaze
blue and copper red decoration; gilt-bronze mounts
H: 60 cm (23⅝ in.) W: 33 cm (13 in.) D:21.5 cm (8½ in.)
78.DI.9.1–.2

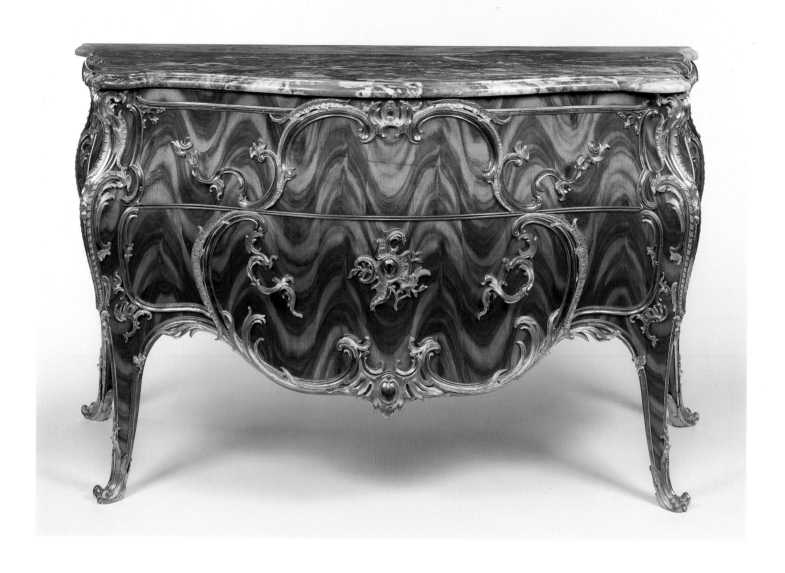

Commode
French (Paris), ca. 1745–49
Attributed to Jean-Pierre Latz (ca. 1691–1754)
Oak veneered with *bois satiné*; gilt-bronze mounts;
fleur de pêche marble top
H: 87.7 cm (34½ in.) W: 151.5 cm (59⅝ in.)
D: 65 cm (26⅝ in.)
83.DA.356

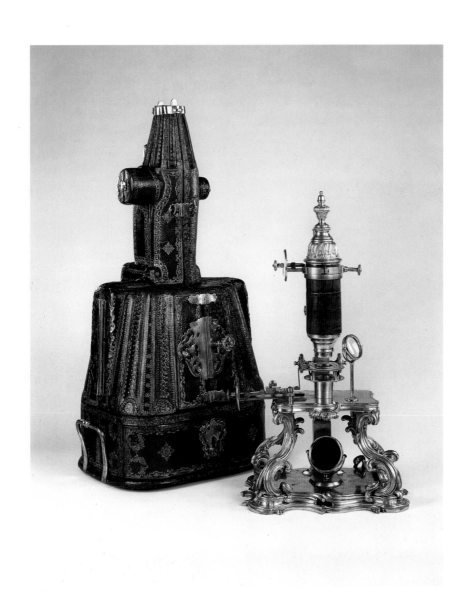

Microscope and Case
French (Paris), after 1749
Micrometric stage invented by Michel-Ferdinand
d'Albert d'Ailly, fifth duc de Chaulnes (1714–1769);
gilt-bronze mount attributed to Jacques Caffieri
(1678–1755)
Gilt bronze; enamel; shagreen; glass and mirror glass;
case of tooled and gilded leather, brass, velvet, silver
galon; slides of various natural specimens; and brass
implements
Microscope: H: 48 cm (18⅞ in.) W: 28 cm (11 in.)
D: 20.5 cm (8 1/16 in.)
Case: H: 66 cm (26 in.) W: 34.9 cm (13¾ in.)
D: 27 cm (10⅝ in.)
86.DH.694

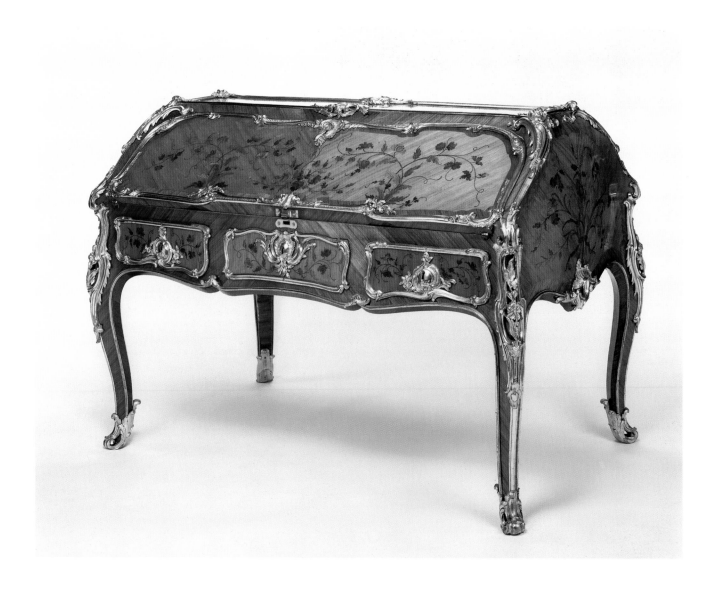

Double Desk
French (Paris) ca. 1750
Bernard II van Risenburgh (after 1696–ca. 1766)
Oak and mahogany veneered with tulipwood,
kingwood, and *bois satiné*; gilt-bronze mounts
H: 107.8 cm (42½ in.) W: 158.7 cm (62½ in.)
D: 84.7 cm (33⅜ in.)
70.DA.87

Bed (Lit à la Turque)
French (Paris), ca. 1750–60
Attributed to Jacques-Jean-Baptiste Tilliard (1723–1798)
Gilded beech; modern silk upholstery
H: 174 cm (68½ in.) w: 264.8 cm (104¼ in.)
D: 188 cm (74 in.)
86.DA.535

One of a Pair of Lidded Vases (Vases Oeufs)
French (Sèvres), ca. 1769
Figural painted reserve attributed to
Jean-Baptiste-Etienne Genest (1722/23 or 1730–1789)
Soft-paste porcelain, blue (*bleu Fallot*) ground color,
grisaille enamel decoration, gilding; gilt-bronze mount
H: 45.1 cm (17¾ in.) W: 24.1 cm (9½ in.) D: 19.1 cm (7½ in.)
86.DE.520

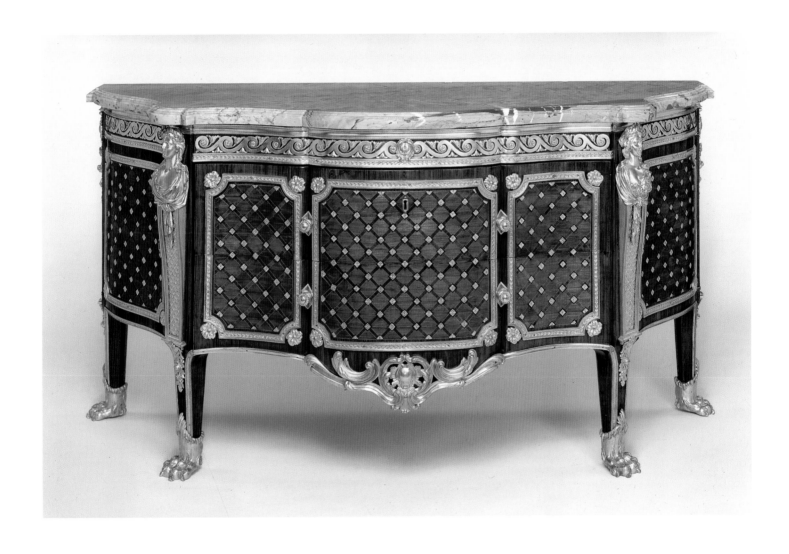

Commode
French (Paris), 1769
Gilles Joubert (1689–1775)
Oak veneered with kingwood, tulipwood, holly,
bois satiné, and ebony; gilt-bronze mounts;
sarrancolin marble top
H: 93.5 cm (36¾ in.) W: 181 cm (71¼ in.)
D: 68.5 cm (27 in.)
55.DA.5

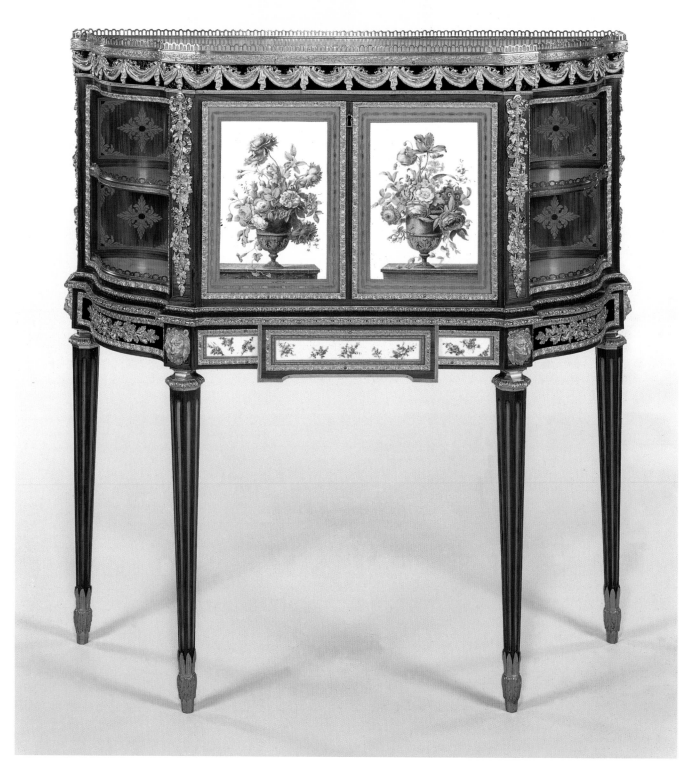

Secrétaire
French (Paris and Sèvres), ca. 1776–77
Secrétaire by Martin Carlin (ca. 1730–1785); porcelain plaques
from the Sèvres porcelain manufactory painted by
Edmé-François Bouillat (1739/40–1810) and by
Raux *fils aîné* (active 1766–1779)
Oak veneered with tulipwood and amaranth with holly and
ebony stringing; set with five soft-paste porcelain plaques
with borders of turquoise blue (*bleu céleste*) ground color,
polychrome enamel decoration, gilding; enameled metal;
gilt-bronze mounts; white marble top
H: 107.9 cm (42½ in.) W: 103 cm (40½ in.) D: 35.5 cm (14 in.)
81.DA.80

Still Life
French (Paris), 1791
Aubert-Henri-Joseph Parent (1753–1835)
Limewood
H: 58.7 cm (23⅛ in.) W: 39.7 cm (15⅝ in.)
D: 5.7 cm (2¼ in.)
84.SD.194

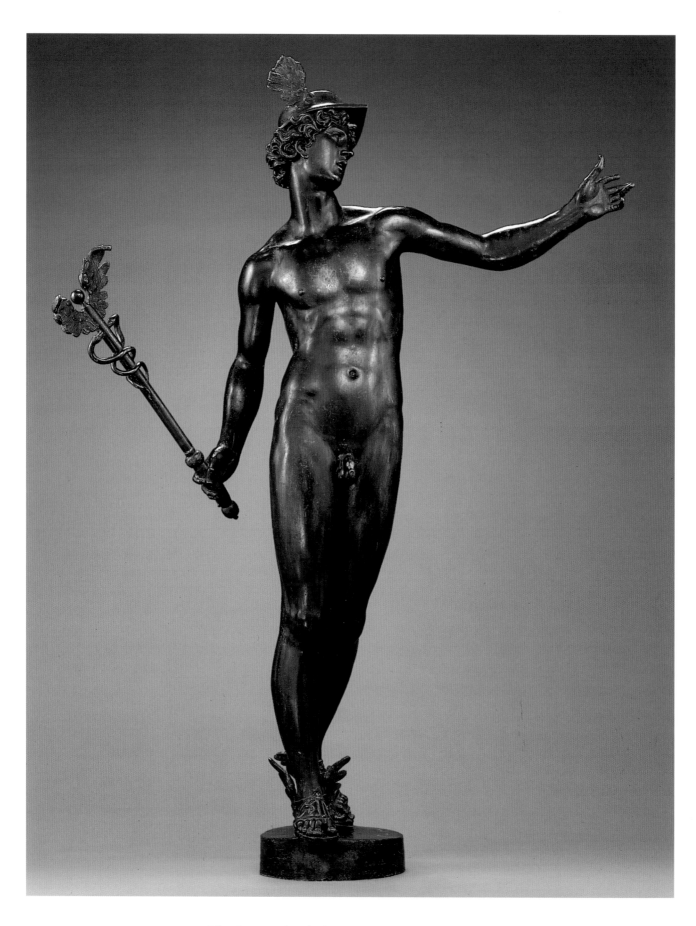

Johan Gregor van der Schardt
Dutch (active in Venice, Vienna, Nuremberg, and
Denmark), ca. 1530–1581
Mercury, ca. 1570–80
Bronze, H: 115 cm (45¼ in.)
95.SB.8

Sculpture

For all his love of Greek and Roman statues, for all his appetite for French furniture, Getty seems not to have had the slightest urge to buy European sculpture, despite its many links to the material he was collecting, and despite its being then relatively inexpensive. A few bronzes to put on commodes were all the Museum had until the income from Getty's bequest began to flow. It was obvious by then that the collection should be expanded to include European sculpture, and also decorative arts outside France.

From the Renaissance through most of the nineteenth century, sculpture was at least equal in prestige to painting, often superior. The rivalry between the two art forms was the subject of centuries of debate. So far as collectors of older art were concerned, however, the debate was settled in this century in favor of paintings, which became much more expensive than contemporary sculptures of equal importance. The Getty Museum has tried to take advantage of this often absurd situation.

In this late era, medieval and Renaissance sculptures, as with paintings and drawings, have proven hardest to buy. Most important objects are held by churches, museums, and public institutions, and export laws severely restrict the few works that can leave European countries. Our time is very different from the era in which large medieval and Renaissance collections were formed by the Metropolitan Museum, the Cleveland Museum of Art, and the Walters Art Gallery. So few medieval objects of any importance have been offered in the dozen years we have been collecting in this field that de facto we have abandoned this period, concentrating instead on works after 1500. Here, however, we have had surprising success.

Among our first Renaissance sculptures was a bronze bust of a young man by Antico, the Mantuan artist whose taste for classical antiquity resembles that of his older contemporary Mantegna, and who worked for the same ducal family of avid admirers of classical learning. We have also accomplished something of a coup with the acquisition of a previously unknown work, a marble bust of the infant *Saint Cyricus* by Francesco Laurana, the leading sculptor of Naples of the late fifteenth century.

The great strength of the sculpture collection is in works made by later Renaissance artists, especially in bronze. A *Satyr* by the great sculptor and raconteur, Benvenuto Cellini, is complex in pose and alive with the animal vigor of his race, half-goat and half-man. Giambologna's life-size female nude is a youthful masterpiece, not just a virtuoso performance of marble carving but also the creation of a pose of such complexity and anxious grace that it served as a challenge to painters and an example to other sculptors. Our collection is rich in examples of talented sculptors taking up this challenge. A marvelous bronze juggler by Giambologna's best follower, Adriaen de Vries, a Dutch émigré at the imperial court in Prague, embodies a similar taste in the expressive human body—expressive in this case of agility and balance. Something similar can be seen in the *Mercury* by de Vries's Flemish contemporary Johan Gregor van der Schardt, a large bronze that has a striking air of poise and refined grace.

One of the most exciting single purchases of the past dozen years is the marble *Boy with a Dragon*, carved at about the age of sixteen by the precocious Gianlorenzo Bernini, soon to become the presiding genius of sculpture and architecture in Rome. The cheeky little boy, maybe an infant Hercules, defeats a dragon with as much ease as the boy sculptor demonstrates in mastering a difficult pose and undercutting the brittle marble.

There is now a fine group of French sculptures in marble and bronze from the Fontainebleau school of the mid-sixteenth through the nineteenth century. The most impressive ensemble is a pair of large bronze groups by François Girardon and Gaspard Marsy, both acquired with pedestals made by the Boulle workshop. There are also French terracottas, such as Clodion's amusing exercise in antique eroticism, in which a vestal virgin

urges a hesitant girl toward a leering statue of Pan, whose lower parts are discreetly concealed by smoke from a censer.

There is an important group of sculpted portraits, not only from France but from Italy, Holland, England, and Germany as well. One of the most memorable is the most diminutive, Houdon's bust of the little daughter of a friend, whose adult pose gives to her childish innocence (and baby fat) a grownup dignity. Memorable in a different way is the bust portrait of an unknown man, carved in 1758 by the English sculptor Francis Harwood. The lustrous black stone mimics the skin of the man, who is portrayed with a resolute intelligence and seriousness that contrasts sharply with the blackamoor stereotype so common at the time.

The Department of Sculpture is by no means limited to sculpture. From the beginning, it has aimed at bringing together furniture and other works of decorative art made outside France, forming a collection parallel to our extensive holdings of French material. In the first few years, there were some long leaps. We bought an entire collection of twenty-eight Italian majolica objects of the Renaissance that had been assembled by a London collector—rare, well-preserved pieces of unusual beauty. In addition to the fascination of these objects and the stories depicted on them, majolica gives us an interesting link to the ancient tradition of Greek vase painting, so well represented at the Getty, and to the ceramics of France and Germany of the eighteenth century. A collection of glass was put together from two sources, primarily a large American private holding that had long been admired by experts. Again, there is a link with antiquity. The Getty glass, some seventy-one pieces, includes exceptionally fine examples from Venice, the dominant manufacturing and exporting center, and from Germany, Holland, and France.

Since these early group purchases, the collection has grown more slowly and the focus has been sharpened. Special preference has been given to furniture suitable for display in the galleries (in Malibu, this has meant paintings galleries), such as cassone and display cabinets; silver and goldsmiths' work; "applied sculpture," i.e., ceramic figures; and examples of Italian *pietre dure* and other precious manufactures. The idea is to give visitors a more vivid idea of the creativity that went into so many less-familiar categories of art beyond painting and sculpture, and to portray something of the taste and intellectual curiosity of previous centuries.

A good example is a display cabinet made in Augsburg in the early seventeenth century. Simple on the outside, it is wondrous when the doors are opened: inside there are cycles of religious and secular images carved in wood and semiprecious stone for the delight of collectors. Such people prized all things curious or beautiful, whether made by man or by nature. An exactly contemporary object that might have been coveted by just such a collector is the carved ivory cup of 1631 by Marcus Heiden, the greatest master of his trade, who was heavily patronized by the Medici dukes of Florence. An elephant tusk has been turned into one of the earliest and best realizations of the full-blown Baroque style of carving, bold in form and graced by chubby putti who play instruments with exuberant pleasure.

Collectors of the precious and curious had a love of jewelry that is hard to imagine today. A pendant of around 1540 very close in style to Cellini involved a nimble transformation: a strangely shaped pearl (*barocco*, giving the style of the next century its pejorative name) has been fashioned into the torso and shoulder of Hercules and given a landscape background and rich frame.

Finally, there is now an array of Italian furniture that spans three centuries. Though the collection is still very young, there are groups of marvelous pieces, particularly of the neoclassical period in Italy. A daybed, for example, designed in the 1830s by Filippo Pelagio Palagi for a palace near Turin, is a counterpart to our French neoclassical pieces, with their elegant combination of motifs from Greek, Roman, and even Egyptian antiquity.

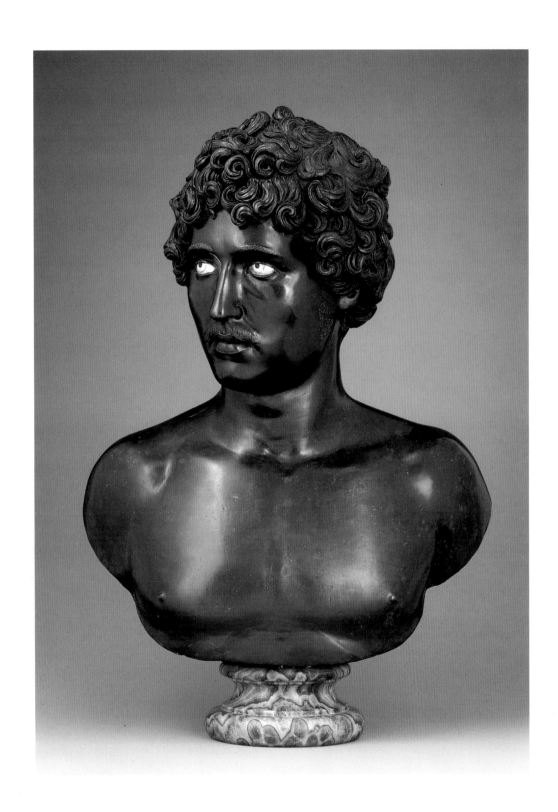

Antico (Pier Jacopo Alari-Bonacolsi)
Italian (Mantua), ca. 1460–1528
Bust of a Young Man, ca. 1520
Bronze with silver eyes, H: 54.7 cm (21½ in.)
86.SB.688

Benvenuto Cellini (?)
Italian (Florence, also active at Fontainebleau),
1500–1571
Hercules Pendant, ca. 1540
Gold, enamel (white, blue, and black), and a baroque
pearl, 6 x 5.4 cm (2⅜ x 2⅛ in.)
85.SE.237

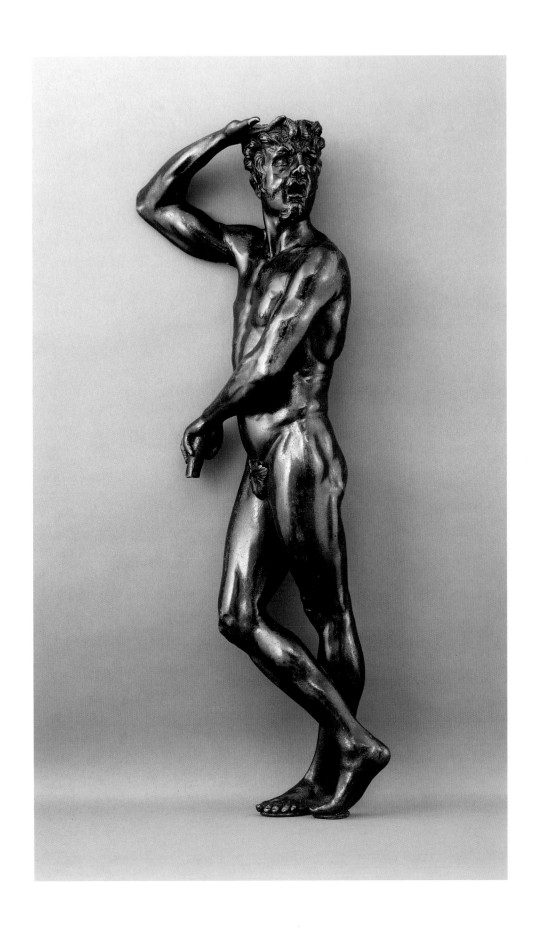

Benvenuto Cellini
Italian (Florence, also active at Fontainebleau),
1500–1571
Satyr, cast after a model of ca. 1542
Bronze, H: 56.8 cm (22⅜ in.)
85.SB.69

Attributed to Bernard Palissy
French (Saintes), 1510–1590
Oval Basin, ca. 1550
Lead-glazed earthenware, 48.2 x 36.8 cm
(18⅞ x 14½ in.)
88.DE.63

Orazio Fontana
Italian (Urbino), 1510–1571
Basin with Deucalion and Pyrrha, ca. 1561–71
Tin-glazed earthenware,
DIAM: 46.3 cm (18½ in.)
86.DE.539

Austria (Innsbruck)
Bowl, 1570–91
Colorless (grayish-brown) glass with diamond-point
engraving, gilding (including silver), and cold
painted decoration, H: 16 cm (6⁵⁄₁₆ in.)
DIAM: 40.4 cm (15¹⁵⁄₁₆ in.)
84.DK.653

Adriaen de Vries
Dutch, 1545–1626
Juggling Man, 1615
Bronze, H: 77 cm (30¼ in.)
90.SB.44

Gianlorenzo Bernini
Italian (Rome), 1598–1680
Boy with a Dragon, ca. 1614–20
Marble, H: 55.7 cm (22 in.)
87.SA.42

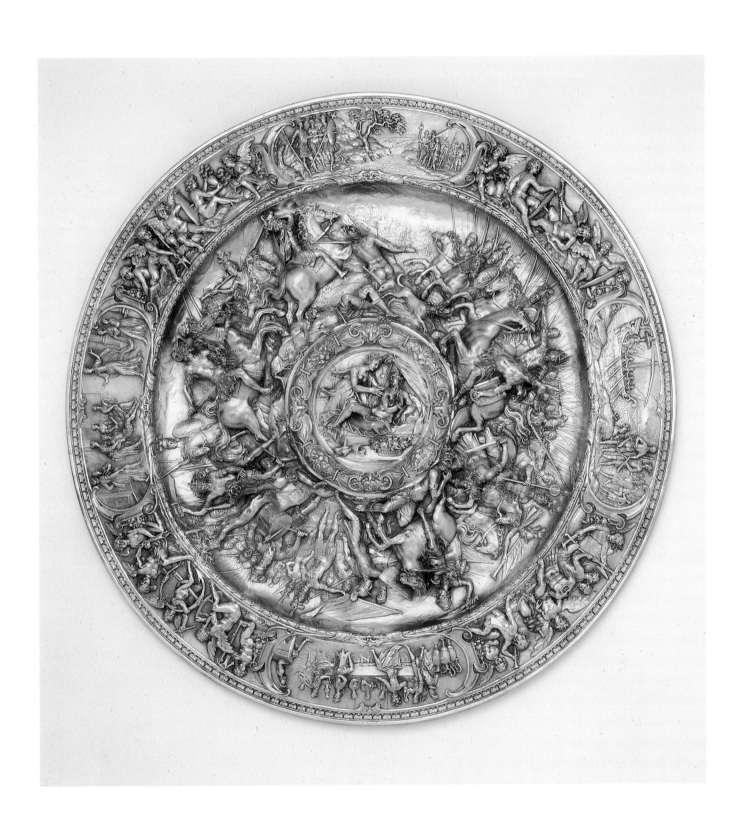

Perhaps modeled by Francesco Fanelli, Italian
(active in Genoa, England, and France) 1590?–after 1653
After a sketch by Bernardino Strozzi, Italian (Genoa),
1581–1644
Probably executed by a Dutch or Flemish silversmith
Basin with Scenes from the Life of Cleopatra, ca. 1620–25
Silver, DIAM: 75.5 cm (29¾ in.)
85.DG.81

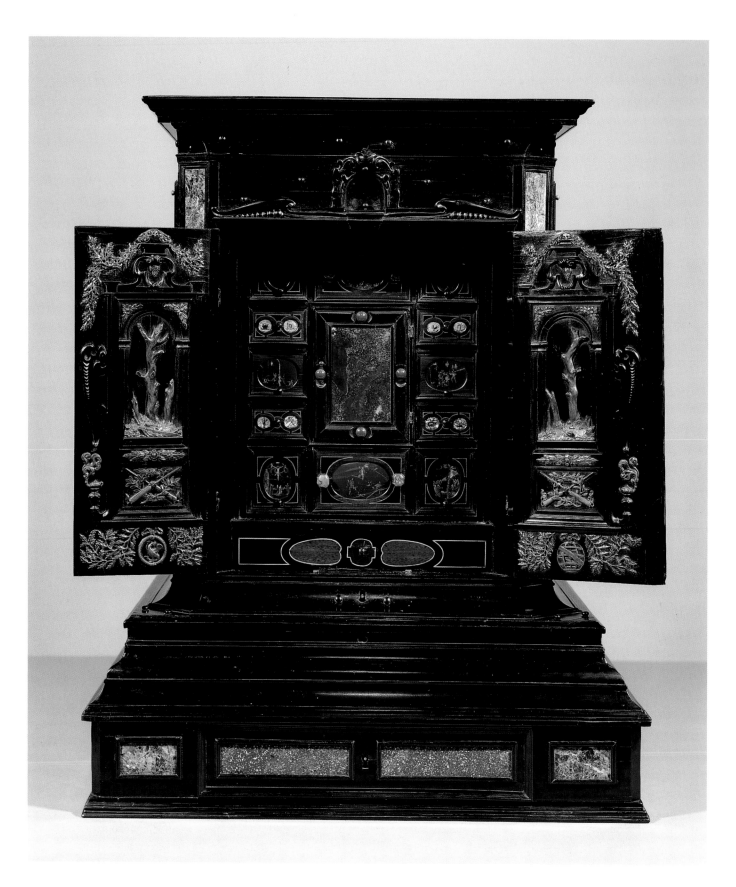

Germany (Augsburg)
Display Cabinet (Kabinettschrank), ca. 1620–30, with
several carvings by Albert Janszoon Vinckenbrinck,
Dutch (Amsterdam), 1604?–1664/5
Ebony, pearwood, oak, boxwood, walnut, chestnut,
marble, ivory, semi-precious stones, tortoiseshell, palm
wood, enamel, and miniature painting, H: 73 cm
(28¾ in.); W: 58 cm (22 13/16 in.); D: 59 cm (23¼ in.)
89.DA.28

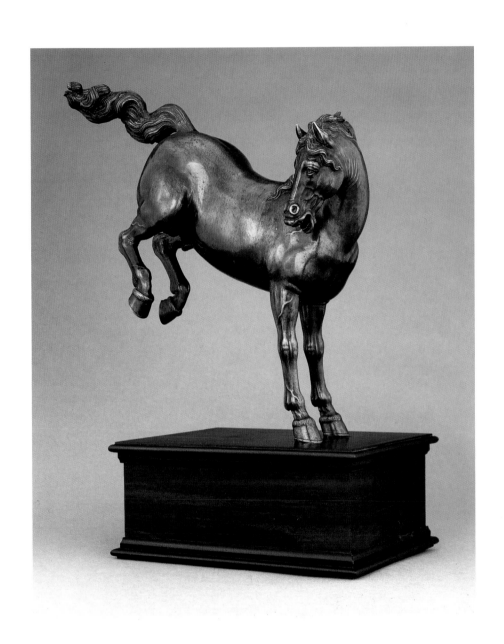

Caspar Gras
German (Innsbruck), ca. 1584/85–1674
Kicking Horse, ca. 1630
Bronze, H: 34 cm (13½ in.)
85.SB.72

Marcus Heiden
German (Coburg), active by 1618–after 1664
Covered Standing Cup, 1631 (the figural elements
probably added later in the seventeenth century)
Lathe-turned and carved ivory, H: 63.5 cm (25 in.)
91.DH.75.1-.2

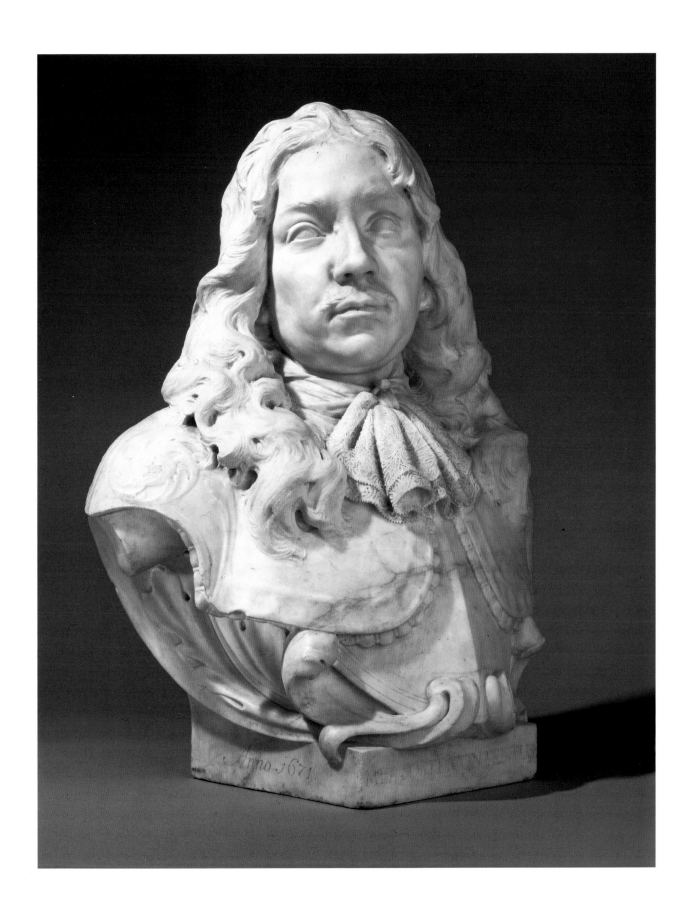

Rombout Verhulst
Dutch, 1624–1698
Bust of Jacob van Reygersberg (1625–1675), 1671
Marble, H: 63 cm (24¾ in.)
84.SA.743

Christoph Daniel Schenck
German, 1633–1691
The Penitent St. Peter, 1685
Limewood, 36.6 x 26.2 cm (14⅜ x 10½ in.)
96.SD.4.2

La Roldana (Luisa Roldán)
Spanish (Madrid), ca. 1655–ca. 1704
Saint Ginés de la Jara, 169(2?)
Polychromed wood (pine and cedar) with glass eyes,
176 cm (69¼ in.)
85.SD.161

Francis Harwood
English (active mainly in Florence), 1748–1783
Bust of a Man, 1758
Black stone (*pietra da paragone*) on a yellow Siena
marble socle, H: 69.9 cm (27½ in.) including socle
88.SA.114

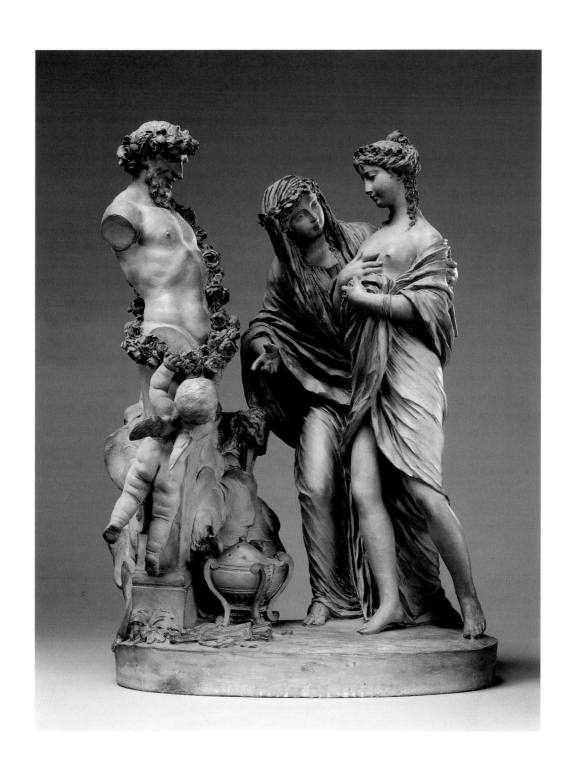

Clodion (Claude Michel)
French (born in Nancy, also active in Rome and
Paris), 1738–1814
Vestal Presenting a Young Woman at the Altar of Pan,
ca. 1775
Terra-cotta, H: 45 cm (17¾ in.)
85.SC.166

Jean-Antoine Houdon
French, 1741–1828
Bust of Louise Brongniart, ca. 1777
Marble, H: 46 cm (18⅛ in.) including socle
85.SA.220

Antonio Canova
Italian (Rome), 1757–1822
Apollo Crowning Himself, 1781–82
Marble, H: 84.7 cm (33⅜ in.)
95.SA.71

Filippo Pelagio Palagi
Italian (Bologna), 1775–1860
Day-Bed, designed 1832–35
Maplewood inlaid with mahogany, H: 80 cm (31½ in.)
L: 224 cm (88⅛ in.) D: 69 cm (27⅛ in.)
86.DA.511

Jean-Baptiste Carpeaux
French, 1827–1875
Bust of Jean Léon Gérôme (1824–1904), 1872–73
Marble, H: 61 cm (24 in.) including socle
88.SA.8

Saint Michael
Stammheim Missal
Hildesheim, ca. 1160
28.5 x 19 cm (11¼ x 7½ in.)
Ms. 64, L. 97. MG. 5, fol. 152

Illuminated Manuscripts

Forming an important collection of European paintings has been a slow, uncertain business. Forming an important collection of illuminated manuscripts was quicker: it was done for us. Peter Ludwig, the German chocolate manufacturer and versatile collector, had spent several decades buying most of the great manuscripts to appear in the postwar years, and the Getty Museum had the good fortune of being able to acquire his entire holding of 144 examples. In one leap, the Museum put itself in the ranks of the Pierpont Morgan Library and the Walters Art Gallery and brought a unique resource to the West Coast, which lacked any such collection of medieval and Renaissance illumination. The collection included the Mainz Sacramentary and the Beauvais Sacramentary, two examples of Ottonian illumination; the Helmarshausen Gospels, of the German Romanesque; a Gothic Apocalypse; and several Flemish manuscripts, including Simon Bening's Prayer Book of Albrecht of Brandenburg. Ludwig's material covered more than eleven hundred years and nearly every region of Europe, but it favored German, central European, and later Flemish manuscripts and was not strong in Italian or later French manuscripts. Beginning in 1984, a long series of purchases gradually reshaped the Getty collection.

One of the first additions remains among the finest, part of the Hours of Simon de Varie, with miniatures by the greatest French painter of the fifteenth century, Jean Fouquet, who combines a northern delicacy of color and detail with a robust gravity in the figures, reflecting his up-to-the-minute knowledge of contemporary Italian painting.

Our two most recent purchases rank among the most important books in the collection. The celebrated Stammheim Missal is a monument of Romanesque art and of German manuscript illumination. It was made for the Benedictine monastery of St. Michael at Hildesheim. The second is a magnificent copy of Boccaccio's *The Fates of Illustrious Men and Women*, with miniatures by the anonymous artist known as the Boucicaut Master, the leading Parisian painter at the beginning of the fifteenth century. Illustrating the many ways the lives of notable people can come to a bad end, the tales in this book are accompanied by more than fifty wonderfully inventive illustrations. It is one of a series of examples we have acquired of the so-called International Style of around 1400, which is typified by courtly elegance, lavish decoration, and sumptuous color.

An important Franco-Flemish manuscript came to the Getty Museum in 1987, *The Visions of Tondal*, with miniatures by Simon Marmion. It tells the story of an errant knight who is given a preview of the fate awaiting the wicked in hell. The text gave Marmion the opportunity to explore the landscape of hell in all its variety and wonder, and he ingeniously summons up the torments of the inferno in detail. With a text written long before Dante and pictures made a generation before Bosch, the book is an extraordinary performance by author, scribe, and illuminator.

Ludwig's collection had few secular manuscripts. In addition to the Boccaccio, we have acquired a copy of the great *Weltchronik* by Rudolf von Ems. It has nearly 400 lively illuminations by several anonymous painters from Bavaria who were gifted storytellers, a compendium of human history that was made to order for the Getty collection.

The collection contains a broad range of entire codices, but there are also many beautiful loose miniatures and cuttings, orphans of the vandalism performed on richly decorated manuscripts across the centuries. Some of these fragments allow us to represent artists and traditions that would otherwise be missing. One example is a brilliant initial with *The Conversion of Saint Paul* of around 1440–50, attributed to the great painter Pisanello. The artist ingeniously worked into the letter S the episode of the soldier being thrown down from his horse by God. Finally, the magnificent *Pentecost* by Girolamo da Cremona of about 1470 is as stately and ample as a Bellini altarpiece of the same era, though a tiny fraction of the size.

Saint Mark and incipit page
Gospel book
Germany (Helmarshausen), ca. 1120–40.
Leaf: 22.8 x 16.4 cm (9 x 6½ in.)
Ms. Ludwig II 3 (83.MB.67), fols. 51v–52

Two Fishermen, Believing Themselves at an Island,
Make Their Camp on the Back of a Sea Creature
Bestiary
Belgium (Flanders), ca. 1270
19 x 14.4 cm (7½ x 5⅝ in.)
Ms. Ludwig XV 3 (83.MR.173), fol. 89v

The Agony in the Garden
Gospel book
Turkey (Nicaea or Nicomedia), late thirteenth century
20.5 x 15 cm (8⅛ x 5⅞ in.)
Ms. Ludwig II 5 (83.MB.69), fol. 68

The Twelve Tribes of Israel
Rudolf von Ems, *Weltchronik*
Germany (Regensburg), ca. 1400–10
33.5 x 23.5 cm (13³⁄₁₆ x 9¼ in.)
Ms. 33 (88.MP.70), fol. 94

Master of Saint Veronica
*Saint Anthony Abbot Blessing the Animals, the Poor,
and the Sick*
Miniature, perhaps from a manuscript
Germany (Cologne), ca. 1400–10
23.6 x 12.5 cm (9⁵⁄₁₆ x 4⅞ in.)
Ms. Ludwig Folia 2 (83.MS.49), leaf 2

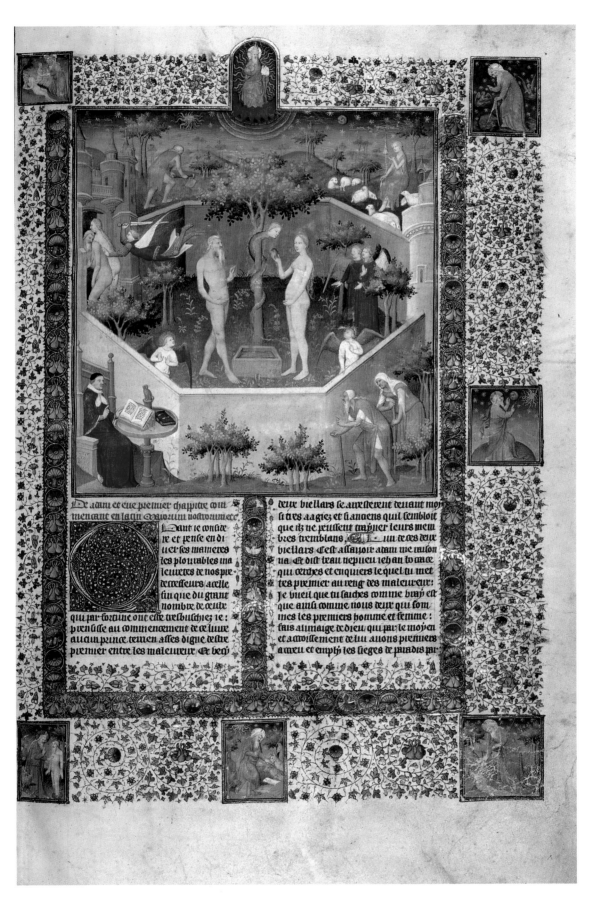

Boucicaut Master and Workshop
The Story of Adam and Eve
Giovanni Boccaccio, *Des cas des nobles hommes
et femmes*
France (Paris), ca. 1415
42.5 x 29.3 cm (16¾ x 11⁹⁄₁₆ in.)
Ms. 63 (96.MR.17), fol. 3

Spitz Master
Saint Christopher
Book of hours
France (probably Paris), ca. 1415–25
20.1 x 15 cm (7¹⁵⁄₁₆ x 5⅞ in.)
Ms. 57 (94.ML.26), fol. 42v

Attributed to Pisanello (Antonio di Pisano) and the
Master of Antiphonal Q of San Giorgio Maggiore
Initial *S* with *The Conversion of Saint Paul*
Historiated initial from a gradual
Italy (probably the Veneto, possibly Verona), ca. 1440–50
14.2 x 9 cm (5⁹⁄₁₆ x 3½ in.)
Ms. 41 (91.MS.5)

Jean Fouquet
Simon de Varie in Prayer Before the Virgin and Child
Hours of Simon de Varie
France (Tours and perhaps Paris), 1455
11.5 x 8.2 cm (4½ x 3¼ in.)
Ms. 7 (85.ML.27), fols. 1v–2

Girolamo da Cremona
Pentecost
Miniature from a devotional or liturgical manuscript
Italy (possibly Mantua), ca. 1460–70
20.1 x 12.9 cm (7¹⁵⁄₁₆ x 5¹⁄₁₆ in.)
Ms. 55 (94.MS.13)

Taddeo Crivelli
Saint Jerome
Gualenghi-d'Este Hours
Italy (Ferrara), ca. 1469
10.8 x 7.9 cm (4¼ x 3⅛ in.)
Ms. Ludwig IX 13 (83.ML.109), fol. 174v

ample ouuerte et moult
obscure / Ceste vallee estoit
tree parfonde plaine de
charbone ardans. Et sur
icelle vallee auoit bng
couuercle de fer en ronde
tout ardant moult grant
et massif a merueilles.
De celle horrible vallee par
tout tres obscure la puan
teur qui au sentir sourmon
toit toutes les puantes
Ha reure que oncq ame
sentist / Sur cest couuercle
descendoit lors vne grant
multitude de ames de pi

nees qui estoient illeacq
bruslees et artes et furet
couslees et passees parmi
cestuy ardant couuercle en
la maniere que len passe
vne faulse parmi lestam
ne et ainsi de la cheoient
ou feu diceulx charbone
ardans. Et la estoient les
tourmens a toute heure
renouuellez. Quant
lame de tondal apercheu
la grant horriblete diculx
tourmens elle en fut tou
te espouentee si dist en tres
grant paour a langele

Attributed to Simon Marmion
The Valley of Homicides
Les Visions du chevalier Tondal
Belgium and France (Ghent and Valenciennes), 1475
36.3 x 26.2 cm (14⁵⁄₁₆ x 10⁵⁄₁₆ in.)
Ms. 30 (87.MN.141), fol. 13v

Attributed to the Master of the *Jardin de vertueuse consolation*
Alexander Kills Clitus and Fights with a Lion
Quintus Curtius Rufus, *Livre des fais d'Alexandre le grant*
France and Belgium (Lille and Bruges), ca. 1468–75
43.2 x 33 cm (17 x 13 in.)
Ms. Ludwig XV 8 (83.MR.178), fol. 175

desconfist entre nuestam et
la ville de graue en guesdres.
Chappitre. xbv. vbj.e

T roie petites
lieues de gin
ue siet ladit
le et le chaste
au de naues
tam lequel
est au seigneur de borne lequel

fut informe veritablement/ne
scay parqui que le sire de borne
suivit passaige aux brabancos
et entrevient en sa terre par la
ville z pont de nuestam. Quant
ces nouuelles sui furent venue
si fut tout pensif z melancolie.
car il veoit quil nauoit pas
gens assez pour resister a tou
te la puissance de brabant ou

Master of the White Inscriptions
The Entry of the Brabants into Ravestein
Jean Foissart, *Chroniques*, Book 3
Belgium (Bruges), ca. 1480
48.2 x 35 cm (19 x 13¾ in.)
Ms. Ludwig XIII 7 (83.MP.150), fol. 318 (detail)

Gerard Horenbout (Master of James IV of Scotland)
Saint Francis
Spinola Hours
Belgium (Ghent or Mechelen), ca. 1510–20
23.2 x 16.6 cm (9⅛ x 6⁹⁄₁₆ in.)
Ms. Ludwig IX 18 (83.ML.114), fol. 258v

Joris Hoefnagel
Imaginary Butterfly, Marine Mollusk, and Common Pear
Mira calligraphiae monumenta
Austria (Vienna), 1561–62 and ca. 1591–96
16.6 x 12.4 cm (6⁹⁄₁₆ x 4⅞ in.)
Ms. 20 (86.mv.527), fol. 118

Michelangelo Buonarroti
Italian, 1475–1564
*The Holy Family with the Infant Saint John the
Baptist*, ca. 1530–32
Pen and brown ink, red chalk and black chalk over
stylus underdrawing, 29.9 x 31.1 cm (11 x 15.4 in.)
93.GB.51

Drawings

Manuscripts came to the Getty in a single coup. Drawings have mostly come one by one, year after year, for fifteen years; as we write, the collection has passed 500 drawings and is, sheet for sheet, one of the best anywhere. When it began, excellent drawings appeared to be relatively abundant in private hands and reasonably priced when compared to paintings, and so there seemed a real chance of forming a distinguished group that would be sufficient for a self-contained exhibitions program within a decade or so.

Leonardo da Vinci, Raphael, and Michelangelo—three painters for whom the discipline of drawing was the basis of their entire magnificent production—set an example that sustained an entire tradition for four centuries. Leonardo's sheet of preliminary studies for a painting of the infant Christ and the Virgin Mary shows the artist struggling to master the contours of an energetic group of figures, give them the illusion of weighty solidity, and suggest the play of light across them. Raphael's drawing of the figure of Paul in *Saint Paul Rending His Garments* is a good instance of the clarity of Raphael's line and the subtlety of his modeling. Michelangelo's majestic *Holy Family*, large and much more elaborately built up in layers, is anything but delicate—the figures have heroic proportions and impressive physical gravity.

Dürer is another foundation-stone for any drawings collection. Our four examples include his well-known study of a stag beetle, evidence of Dürer's omnivorous curiosity about the natural world, a characteristic that runs through the art of Germany and the Netherlands for several centuries, as we saw with Jan Brueghel (pp. 108, 119).

Rembrandt was the finest Dutch draftsman, and every drawings collection aspires to a strong group of his works. Ours is now the best in the United States, thanks to persistence, timing, and of course, money. We could not have predicted that sales would be made from Chatsworth, seat of the Duke of Devonshire and the greatest private trove of drawings, but in 1984 and 1985, a group of Rembrandts, among other masterpieces, was sold from that source, including three landscapes. These are miracles of efficiency: a minimum of pen strokes, laid down in mere minutes, summon up a field, distant buildings, trees, and even the summer atmosphere.

One of the joys of a growing collection are the constant new chances to make connections and contrasts between artists of different traditions. Our Rembrandt landscapes beg to be shown near those of Claude Lorrain: one of our four drawings by this French emigré in Rome represents harvesters at work in a field in the hills to the north of that city, where the heavy summer air is made palpable.

Drawings by Watteau are among the most beautiful ever made by anyone. We have been fortunate to buy three, including a study of a flute player seen from two different views, which Watteau made using his typical red, black, and white chalks, an effective shorthand to suggest the full color of the subject.

Drawings of the eighteenth and nineteenth centuries have been a particular focus since 1994. Few rococo works are as seductive as the large study by Gainsborough, using broad but accurate strokes of the pen, of a woman and child dressed to kill. Jacques-Louis David, whose two paintings are high points of our collection, is represented by a group of drawings, the most recent being a keen profile portrait David made in prison of André-Antoine Bernard, one of his revolutionary comrades.

We have formed a small but delightful group of later nineteenth-century drawings by Millet, Manet, van Gogh, and, most recently, Degas: an album that contains studies of singers, dancers, laundresses, and other slices of modern life, including a two-page spread showing a man in the company of women ironing—an activity associated at the time with loose morals—in which everybody is given the most graphic body language.

Leonardo da Vinci
Italian, 1452–1519
Three Sketches of a Child with a Lamb, ca. 1500
Black chalk and pen and brown ink, 21 x 14.2 cm
(8¼ x 5⁹⁄₁₆ in.)
86.GG.725

Martin Schongauer
German, 1450/53–1491
Studies of Peonies (Paeonia officinalis L.), ca. 1472
Watercolor and bodycolor, 25.7 x 33 cm (10⅛ x 13 in.)
92.GC.80

Titian (Tiziano Vecellio)
Italian, ca. 1480/90–1576
Pastoral Scene, ca. 1565
Pen and brown ink, black chalk, heightened with
white bodycolor, 19.6 x 30.1 cm (7¹¹⁄₁₆ x 11⅞ in.)
85.GG.98

Raphael (Raffaello Sanzio)
Italian, 1483–1520
Saint Paul Rending His Garments, ca. 1514–15
Metal point heightened with white bodycolor on
lilac-gray prepared paper, 23 x 10.3 cm (9¹⁄₁₆ x 4¹⁄₁₆ in.)
84.GG.919

Albrecht Dürer
German, 1471–1528
Stag Beetle, 1505
Watercolor and bodycolor, 14.2 x 11.4 cm (5⁹⁄₁₆ x 4½ in.)
83.GC.214

Peter Paul Rubens
Flemish, 1577–1640
Three Groups of Apostles in a Last Supper, ca. 1608–11
Pen and brown ink, 29.6 x 43.9 cm (11¹¹⁄₁₆ x 17¼ in.)
84.GA.959

Rembrandt van Rijn
Dutch, 1606–1669
Landscape with the Little Tower, ca. 1650–60
Pen and brown ink and brown wash, 9.7 x 21.5 cm
(3³⁄₁₆ x 8⁷⁄₁₆ in.)
83.GA.363

Claude Lorrain
French, 1600–1682
Landscape in Latium with Farm Laborers, ca. 1660–63
Pen and brown ink, brown wash, and black chalk,
22.4 x 36.1 cm (8¹³⁄₁₆ x 14¼ in.)
91.GG.70

Nicolas Poussin
French, 1594–1665
A Path Leading into a Forest Clearing, ca. 1635–40
Pen and brown ink and brown wash, 38.6 x 24.6 cm
(15³⁄₁₆ x 9¹¹⁄₁₆ in.)
96.GA.24

Adriaen van Ostade
Dutch, 1610–1685
Peasant Festival on a Town Street, 1674
Pen and brown ink, watercolor, and bodycolor,
20.2 x 31.5 cm (8 x 12⅜ in.)
85.GC.439

Jean-Antoine Watteau
French, 1684–1721
Two Studies of a Flutist and One of the Head of a Boy,
ca. 1716–17
Red, black, and white chalk, 21.4 x 33.6 cm
(8⁷⁄₁₆ x 13³⁄₁₆ in.)
88.GB.3

Thomas Gainsborough
British, 1727–1788
A Lady Walking in a Garden with a Child by Her Side,
ca. 1785
Black chalk and stumping on light brown paper,
heightened with white chalk, 50.5 x 22.1 cm
(20 x 8¹¹⁄₁₆ in.)
96.GB.13

Jacques-Louis David
French, 1745–1825
Portrait of André-Antoine Bernard, called Bernard des Saintes, 1795
Pen and India ink and wash, heightened with white bodycolor over pencil, DIAM: 18.2 cm (7⅛ in.)
95.GB.37

Joseph Mallord William Turner
British, 1775–1851
Conway Castle, North Wales, ca. 1800
Watercolor and gum arabic with graphite
underdrawing, 53.6 x 76.7 cm (21⅛ x 30⅛ in.)
95.GC.10

Édouard Manet
French, 1832–1883
Bullfight, 1865
Watercolor, 19.3 x 21.4 cm (7⁹⁄₁₆ x 8⁷⁄₁₆ in.)
94.GC.100

Edgar Degas
French, 1834–1917
Ernest Reyes Seated Amongst Washerwomen, ca. 1877
Pages of an album of pencil sketches, 24.7 x 67.1 cm
(9¾ x 26½ in.)
95.GD.35 fols.4–5

Vincent van Gogh
Dutch, 1853–1890
Portrait of Joseph Roulin, ca. 1888
Reed and quill pen and brown ink and black chalk,
32 x 24.4 cm (12⅝ x 9⅝ in.)
85.GA.299

Paul Cézanne
French, 1839–1906
Still Life, ca. 1900–06
Watercolor and graphite, 48 x 63.1 cm (18¹⁵⁄₁₆ x 24⅞ in.)
83.GC.221

Edward Weston
American, 1886–1958
Charis Nude, 1936
Gelatin silver print, 24.1 x 19.2 cm (9½ x 7⁹⁄₁₆ in.)
84.XM.1381.1

Photographs

The Getty Museum began a collection of photographs because it was presented with a historic opportunity. In an almost simultaneous series of purchases that took the art world by surprise, we added holdings of the two most notable American collectors of their time, Samuel Wagstaff and Arnold Crane, to choice parts of André and Marie-Thérèse Jammes's distinguished holding of French photographs, the collections of Bruno Bischofberger, and the joint holdings of Volker Kahmen and George Heusch. Overnight, the Getty had some 26,000 master photographs and thousands more in albums and books, all chosen by experts with adventurous tastes who regarded photography as a serious art form. From the beginning, the Getty collection was one of the finest anywhere.

The initial purchases emphasized the earlier eras of photography and spanned the simultaneous development of the medium in England and France, from its birth in the 1830s through the 1860s. Included were major groups by such key European pioneers as Talbot, Bayard, Le Gray, Nadar, Fenton, and Cameron.

There were also American photographers in quantity: daguerreotypes by Southworth and Hawes, early views of post–Gold Rush California by Carleton Watkins, and Civil War scenes by Mathew Brady's assistants Timothy O'Sullivan and Alexander Gardner, among others. Photography was the Getty Museum's debut in twentieth-century art as well. Among European and American modern masters, we had acquired, for example, 200 works by Man Ray, 100 by László Moholy-Nagy, 173 by Albert Renger-Patzsch, 1,000 by Walker Evans, and 1,200-odd works by August Sander. Big and diverse as the new collection was, much was missing.

For the past twelve years, the curator, Weston Naef, has gone after certain categories of photographs that would compensate for the largely unplanned shape of the collection and give it a distinctive character. Painters who were also active as photographers have been sought out—Degas and Eakins, to name two of the best known. Works by the photographers of the American West have also had special emphasis, as have works by artists who flourished in Los Angeles.

We have concentrated on the major twentieth-century masters and on art movements of particular importance. There is a rich group of pictures made at the Bauhaus and a comparable group of Italian Futurist photographs. We have been able to acquire the best of the photographs given to Georgia O'Keeffe by her mentor and husband, Alfred Stieglitz. Groups of pictures have been bought from the studios or collectors of other great modernists, such as Charles Sheeler, Imogen Cunningham, Doris Ulmann, André Kertész, Harry Callahan, Frederick Sommer, and Manuel Alvarez Bravo.

Buying groups has meant rapid growth. Often the greatest finds, however, were single pictures. *The River Scene* of 1858 by Camille Silvy, for instance, was a famous image in its time, a perfectly composed view of a river fully in the spirit of contemporary French paintings, yet exact in a way that only the new art of photography could be. A key 1996 purchase—a daguerreotype view by John Plumbe, Jr., of the Capitol in Washington, D.C., made in 1846 before the Senate and House wings were added—is the finest and earliest photograph of this building in existence.

We exhibit photographs as works of art in their own right. Sometimes this means searching for the best available print from a given negative. A case in point is Ansel Adams's *Moonrise, Hernandez*, the famous scene of the moonlit desert hamlet in New Mexico. Although there may be as many as a thousand prints of this photograph, and an endless number of reproductions in books and magazines, the print from 1948 in the Getty collection was one of the few made before Adams "intensified," or chemically altered, the negative to create more brilliance and contrast. The early prints are more subtle, and Adams expressed special satisfaction with ours, which he had made as a gift to a friend.

John Plumbe, Jr.
American (b. Wales), 1809–1857
The United States Capitol, 1846
Half-plate daguerreotype, 12.1 x 15.3cm (4¾ x 6 in.)
96.XT.62

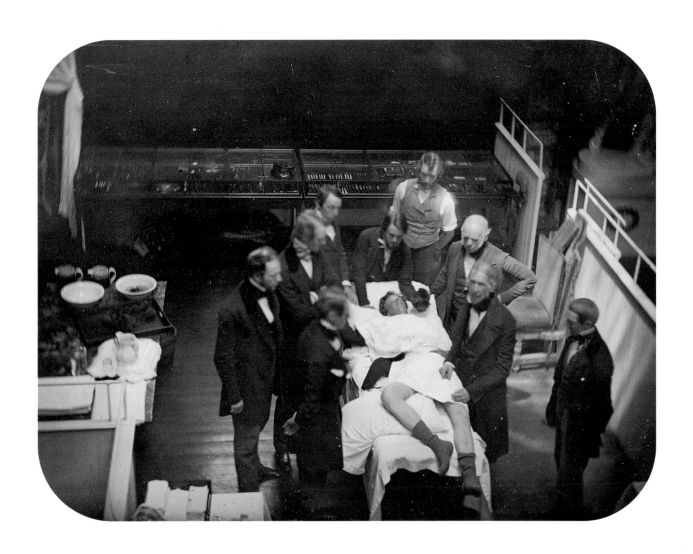

Albert Sands Southworth and Josiah Johnson Hawes
American, 1811–1894; 1808–1901
Use of Ether for Anesthesia, Massachusetts General Hospital, early 1847
Whole-plate daguerreotype, 14.6 x 19.9 cm
(5¾ x 7⅞ in.)
84.XT.958

David Octavius Hill and Robert Adamson
British, 1802–1870; 1821–1848
Lady Elizabeth Eastlake, 1843–48
Salt-fixed print from a paper negative, 20.9 x 14.3 cm
(8³⁄₁₆ x 5⅝ in.)
84.XM.445.21

Roger Fenton
British, 1819–1869
Pasha and Bayadère, 1858
Albumen print, 45 x 36.3 cm (17¹/₁₆ x 14¼ in.)
84.XP.219.32

Camille Silvy
French, 1834–1910
River Scene—La Vallée de l'Huisne, negative 1858;
print 1860s
Albumen print, 25.7 x 35.6 cm (10⅛ x 14 in.)
90.XM.63

Gustave Le Gray
French, 1820–1882
Seascape with Sailing Ship and Tugboat, 1857
Albumen print, 30 x 41.2 cm (11¹³⁄₁₆ x 16¼ in.)
86.XM.604

Carleton Watkins
American, 1829–1916
Cape Horn, Columbia River, Oregon, negative 1867;
print ca. 1875
Albumen print by Isaiah West Taber, 40.5 x 52.3 cm
(16 1/16 x 20 11/16 in.)
85.XM.11.2

Timothy O'Sullivan
American, 1840–1882
Ancient Ruins at Cañon de Chelle, New Mexico, 1873
Albumen print, 27.5 x 19.2 cm (10⅞ x 7⁹⁄₁₆ in.)
84.XM.484.4

Eugène Atget
French, 1857–1927
Quai Conti 3, 1900
Albumen print, 20.8 x 17.8 cm (8 ³⁄₁₆ x 7 ¹⁄₃₂ in.)
90.XM.45.1

Lewis Hine
American, 1874-1940
Self-Portrait with Newsboy, 1908
Gelatin silver print, 13.9 x 11.8 cm (5 7/16 x 4 11/16 in.)
84.XM.967.1

Alfred Stieglitz
American, 1864–1946
Georgia O'Keeffe: A Portrait, June 4, 1917
Platinum print, 24.4 x 19.5 cm (9⅜ x 7¹¹⁄₁₆ in.)
91.XM.63.3

Gertrude Käsebier
American, 1852–1934
Silhouette of a Woman, ca. 1899
Platinum print, 20 x 10 cm (7⅞ x 3¹⁵⁄₁₆ in.)
87.XM.59.28

Paul Strand
American, 1890–1976
Black Bottle, negative ca. 1919; print 1923–39
Gelatin silver print, 35 x 27.6 cm (13¹³⁄₁₆ x 10¹⁵⁄₁₆ in.)
86.XM.686.5

Man Ray
American, 1890–1976
Tears, 1930–33
Gelatin silver print, 22.9 x 29.8 cm (9 x 11¾ in.)
84.XM.230.2

Walker Evans
American, 1903–1975
Sidewalk Portrait of Three Men, 1936
Gelatin silver print, 17.7 x 24 cm (7 x 9⁷⁄₁₆ in.)
84.XM.956.303

Ansel Adams
American, 1902–1984
Moonrise, Hernandez, New Mexico,
negative October 31, 1941; print December 16, 1948
Gelatin silver print, 34.9 x 44 cm (13¾ x 17⁵⁄₁₆ in.)
85.XM.198

Charles Sheeler
American, 1883–1965
Wheels, 1939
Gelatin silver print, 16.8 x 24.4 cm (6⅝ x 9⅝ in.)
88.XM.22.7

Weegee (Arthur H. Fellig)
American (born Austria), 1899–1968
Their First Murder, ca. 1936
Gelatin silver print, 25.7 x 27.9 cm (10⅛ x 11 in.)
86.XM.4.6

El Lissitzky
Russian, 1890–1941
Kurt Schwitters, ca. 1924–25
Gelatin silver print, 11.1 x 10 cm (4⅜ x 3¹⁵⁄₁₆ in.)
95.XM.39

August Sander
German, 1876–1964
Young Farmers, ca. 1913
Gelatin silver print, 23.5 x 17 cm (9¹³⁄₁₆ x 6¹¹⁄₁₆ in.)
84.XM.126.294

Afterword

We have written, maybe a little presumptuously, about "a museum for the new century." Better to say "for the first part of the new century." Change has been so rapid and hard to predict during our careers that we would be foolish to plan for more than a few decades. We have built a museum based on assumptions about the time ahead, by extrapolation from trends in museums and the population, by guesswork, and by faith and hope.

We have assumed, for one thing, that art museums will be more important for society in the next century, not less. Museums give people direct, firsthand experience of real works of art, in all their singular presence and with all their unreproduceable subtleties. There isn't likely ever to be an adequate substitute for this, including that glib oxymoron of our time, "virtual reality." Many museum people these days are worrying that potential visitors may soon prefer to sit at home in front of screens displaying, free of charge, an endless succession of bright, sharp electronic reproductions. The better these get, the thinking goes, the less people will care about seeing the originals. The contrary seems more likely. We think the coming flood of electronic images will probably raise consciousness about art and stimulate an appetite for seeing it— will bring more visitors, in fact, just as the color magazines and Skira art books in the 1950s and 1960s did, helping to propel the great museum boom of the past half-century.

We are assuming that the audience of the next century will not be any readier than visitors today to have a profitable experience looking at works of art unless there are miracles in the public schools—and school reform alone won't be sufficient. Most people visiting museums will continue to need all the help they can get. Furthermore, as the population gets more diverse, museums will not succeed unless they recognize that visitors cannot be expected to bring a single set of cultural assumptions to the visit, but many. Museums are going to have to articulate their assumptions and listen to those of others. Museums will need to be more than well stocked, handsome, and fluent in art history. They will have to re-examine how they present their collections and see them in new and more complex ways, then be versatile interpreters of the material for people of varying experience and different styles of learning.

The popularity of the Getty Museum in Malibu has taught us that there is a place for museums that put the permanent collection, rather than loan shows, in center stage. Museums that do so are bucking a strong current. In the past few decades, caught in a squeeze between rising costs and flat endowment income, American museums have managed to balance their books by using loan exhibitions as the main attraction to generate income from larger numbers of visitors, who pay admission and spend money for merchandise. Until recently, people had come mostly to see the collection. Now they come to see the show, often walking right by the permanent collection (which, ironically, may have far more important works of art to see). Loan shows have redefined museum-goers' expectations. They have the excitement of an event, they provide some kind of storyline and interpretive help, and they have a beginning, middle, and end, like a movie. They certainly have their place, but they are only part of what museums offer; and a major task for museums in the new century will be to reintroduce visitors to the less-structured pleasures of the permanent collection. This will take inducements beyond merely putting fine works of art in beautiful galleries. It will take, among other things, a wider range of interpretive devices than is normally found in museums today and a lot more attention to visitors' comfort.

What about growth? the reader may wonder. Museum collections get bigger, especially those of rich museums, and the Getty is bound to have many opportunities. The audience is expected to grow as well, putting a squeeze on the buildings. There is some room for

expansion in the galleries and storerooms of the new museum, but not a great deal. Furthermore, given the constricted site of the Getty Center, it is practically impossible to add to the buildings there. We knew this from the beginning and assumed that if our successors in the new century decide that the Getty Museum should expand again, it ought not to be at the Getty Center or in Malibu but in some other place altogether, depending on where it can do the most good—such as downtown or in the San Fernando Valley. That would be a happy prospect. There is already a large general art museum, the Los Angeles County Museum of Art. It seems to us that for the Getty, the sprawling, shifting geography of Los Angeles calls for a different kind of expansion, not agglomeration but dispersion.

It may appear perverse that in a city whose Euro-American population is now a minority, and where people with African, Asian, and Latin roots predominate, the Getty Museum plans to continue collecting only art of the European tradition. But we see this as an advantage. We assume that there will always be a place for such a museum in the archipelago of specialized museums in Los Angeles, not for the sake of a white audience but for everyone. To avoid the intellectual and cultural isolation such specialized collections could bring, however—not to mention the apparent snobbery—we plan temporary exhibitions from time to time that will draw on the art of other cultures and examine connections with the European tradition.

Our ideal for the new century is that everyone in the Los Angeles region who might want to visit the Getty Museum will actually do so sooner or later. This includes hundreds of thousands of non-museum-goers, maybe millions. We have no illusions about the task: it will take years of cultivating relations with schools, community organizations, and the media in all languages. Some of this work will be done by children who come in school groups, in vastly greater numbers than came to the Museum in Malibu, then go home with our invitation to return with their parents. The process has begun.

Our aim is to give joy to a large lay population, to teach, to change lives. It is also to add to knowledge about the history of art, in particular about the works in our own collection. (Whichever new directions research may take, information about particular works will always be needed.) In the new century we will continue to bring scholarly colleagues to the Museum, to foster their work, organize symposia, and publish books as vigorously as possible.

This book goes to press just as the works of art in the last chapter are being packed, soon to be installed in the galleries of the new museum at the Getty Center, and while designs are being developed for the Getty Villa. In a matter of months, another era will open for the Museum and its audiences, and in just a few more years, a new century will begin. We enter this era with gratitude for the opportunity J. Paul Getty's bequest has given us and with the hope that we have begun to do it justice.

Appendix I
The Programs of the J. Paul Getty Trust

Research Institute for the History of Art and the Humanities

The Getty Research Institute for the History of Art and the Humanities is devoted to critical inquiry into past and present cultures. It offers a range of scholarly and public programs that seek a better understanding of art within broad historical and cultural contexts. Each year it brings together an international group of scholars who, while pursuing their own projects, also exchange informally and in organized programs ideas on a theme selected by the Institute. To support their work and scholarship worldwide, the Institute maintains extensive resource collections, including more than 700,000 volumes on the history of art, architecture, and related fields in the humanities and social sciences, as well as rare archival materials and nearly two million documentary photographs. Through its publications program, the Institute makes available new editions of important works, including translations into English of texts that have not been previously translated, and current scholarly debates. It also offers a range of scholarly and public programs, such as performances, lectures, and exhibitions—often collaborations with other cultural organizations, community groups, and artists.

Conservation Institute

The Getty Conservation Institute works internationally to further the appreciation and preservation of the world's cultural heritage for the enrichment of present and future generations. The Institute is committed to exploring new ideas and approaches to cultural preservation; advancing research and the application of knowledge in the arts and sciences to conservation; collecting and disseminating information to professionals and the public worldwide; and changing common perceptions and attitudes in order to encourage community involvement in safeguarding monuments, sites, artifacts, and works of art that form an irreplaceable record of human achievement. Through courses, conferences, and field projects, the Institute promotes comprehensive site management that seeks to incorporate the needs of all who have an interest in a site. It also addresses the challenge of preserving the architectural and artistic heritage of inhabited places. The Institute's research and training in conservation of objects and collections range from specific problems of treatment to broader issues of the museum environment and preventive conservation. It develops practical applications in these areas and disseminates them through courses and publications. To increase conservation knowledge and awareness, the Institute strives to reach not only conservation professionals but also the general public.

Education Institute for the Arts

The Getty Education Institute for the Arts is dedicated to improving the quality and status of arts education in the nation's schools. It works with local, state, and national partners to transform how the arts are perceived by the public and taught in schools. It supports staff development programs for teachers, as well as projects involving the implementation of discipline-based art education, a comprehensive approach to arts education that includes content from four disciplines: art making, art history, art criticism, and aesthetics. The Institute supports research and fosters collaboration among scholars, teachers, art specialists, and school administrators that advances the development of discipline-based art education theory. It also supports curriculum development by producing classroom instructional materials.

Information Institute

The Getty Information Institute enhances worldwide access to art and humanities information for research and education through the use of computer technology. In collab-

oration with institutions internationally, it addresses the research needs, standards, and practices that can bring the full benefits of digitized information to the research community. The Institute initiates and supports partnerships in three principal areas: technical and terminological standards, research databases, and policy initiatives. Standards projects facilitate information retrieval, protect the long-term value of data, and permit individuals and institutions to share information. Databases provide researchers with art-historical information otherwise inaccessible to them, and the Institute's strategic initiatives are designed to focus the attention of policy makers on the value of cultural content on the Internet.

Grant Program

The Getty Grant Program works to strengthen the fields in which the Getty is active by funding exceptional projects undertaken by individuals and organizations throughout the world. It funds a diverse range of projects that promote research in the history of art and related fields, advancement of the understanding of art, and conservation of our cultural heritage. Scholarship grants assist institutions such as museums, universities, libraries, and archives, as well as scholars working individually or in teams. Some awards fund specialized publications, as well as interpretive projects in museums aimed at the general public. Conservation grants support projects related to museum collections and historic buildings. In addition to its support for projects worldwide, the Grant Program maintains a particular commitment to Los Angeles by offering a category of grants specifically for the local community.

Leadership Institute for Museum Management

The Leadership Institute for Museum Management, administered for the Getty by the American Federation of the Arts, offers executive education for museum professionals. Its major program, the Museum Management Institute, is a residential seminar for senior-level museum professionals. Held each summer at the University of California at Berkeley, the three-week course provides participants with instruction in the latest management theories and practices to help them successfully lead their organizations in an increasingly complex environment. Distinguished faculty of the Museum Management Institute cover topics such as finance, legal issues, marketing and development, and strategic planning through a mix of lectures, discussions, and case studies. Participants represent museums of all types; some attend on minority scholarships.

Appendix 2
Trustees and
Senior Staff

Trustees of the J. Paul Getty Trust and Museum
1954 to the Present

J. Paul Getty	1953–1976
George F. Getty II	1953–1973
J. Ronald Getty	1953–1984
Wilhelm R. Valentiner	1953–1958
David S. Hecht	1953–1959
J. Paul Getty, Jr.	1953–1972
Gordon P. Getty	1955–1966
	1973–present
Barnabas Hadfield	1961
Karl Birkmeyer	1961–1964
Norris Bramlett	1961–1992
Stuart T. Peeler	1965–present
Harold E. Berg	1975–1990
Federico Zeri	1975–1984
Stephen Garrett	1977–1982
J. Patrick Whaley	1977–present
John Connell	1979–1984
Otto Wittmann	1979–1989
John T. Fey	1979–1992
Harold M. Williams	1981–present
Franklin D. Murphy	1981–1991
Rocco B. Siciliano	1982–1995
Jon B. Lovelace	1982–1995
Jennifer Jones Simon	1984–1991
Kenneth N. Dayton	1985–1993
Robert F. Erburu	1987–present
Vartan Gregorian	1988–present
Herbert L. Lucas, Jr.	1988–present
John C. Whitehead	1989–1995
Frank G. Wells	1990–1994
Sr. Magdalen Coughlin	1991–1994
Helene L. Kaplan	1992–present
David P. Gardner	1992–present
Blenda J. Wilson	1993–present
Agnes Gund	1994–present
David I. Fisher	1995–present
John F. Cooke	1995–present
Ramon C. Cortines	1996–present
Ira E. Yellin	1996–present

Senior Staff of the J. Paul Getty Museum
1954 to the Present

Directors

Wilhelm R. Valentiner 1954–1955
George F. Getty II 1961–1973
J. Paul Getty 1973–1976
Norris Bramlett (acting) 1976–1977
Stephen Garrett 1977–1982
John Walsh 1983–present

Chief Curators

Paul Wescher 1954–1959
Karl Birkmeyer (acting) 1955–1956
 1958
Anne Marian Jones 1960–1965
Burton Fredericksen
 Curator 1965–1971
 Chief Curator 1971–1977
Otto Wittmann (acting) 1980–1983
Deborah Gribbon 1991–present

Deputy, Associate, and Assistant Directors

Stephen Garrett
 Deputy Director 1973–1976
Stephen Rountree
 Deputy Director 1982–1983
 (since 1984 Director, Operations and Planning, J. Paul Getty Trust)
Barbara Whitney
 Assistant Director for Administration
 1983–1990
 Associate Director, Administration and Public Affairs
 1991–present
Deborah Gribbon
 Assistant Director for Curatorial Affairs
 1984–1990
 Associate Director and Chief Curator
 1991–present
Bret Waller
 Associate Director for Education and Public Affairs
 1985–1990
Marion True
 Assistant Director for Villa Planning
 1995–present

Heads of Departments

Antiquities

 Jiří Frel 1973–1986

 Marion True 1986–present

Antiquities Conservation

 David Rinne 1974–1976

 Zdravko Barov 1977–1985

 Jerry Podany 1986–present

Bookstore

 Roberta Stothart 1974–1987

 Julie Wick 1988–present

Decorative Arts

 Gillian Wilson 1971–present

Decorative Arts and Sculpture Conservation

 Patrice Pinaquy 1977–1979

 Barbara Roberts 1981–1988

 Brian Considine 1989–present

Director's Office

 Judy Dillin 1977–1980

 (since 1983 with Getty Research Institute)

 Patricia Howard 1980–1995

 Frances Biral 1995–present

Drawings

 George Goldner 1984–1993

 Nicholas Turner 1994–present

Education and Academic Affairs

 Laurie Fusco (Academic Affairs)

 1978–1986

 Cathryn La Scola (Education)

 1981–1986

 David Ebitz 1987–1992

 Diane Brigham 1994–present

Exhibition Design

 Merritt Price 1995–present

Exhibitions

 Irene Martín 1994–present

Grounds

 Richard Naranjo 1974–present

Library (since 1983 part of Getty Research Institute)
 Katherine Jones Isaacson 1973–1979
 Anne-Mieke Halbrook 1979–1983
 (now Head, Collection Management and Research Services, Getty
 Research Institute)

Manuscripts
 Thomas Kren 1984–present

Museum Collections Information Planning
 Kenneth Hamma 1997–present

Museum Information Systems
 Robin Lilien 1994–present

Museum Services (part of the Scientific Department of Getty Conservation Institute)
 Frank Preusser 1983–1987
 David Scott 1987–present

Paintings
 Burton Fredericksen 1977–1984
 (since 1984 Director, Provenance Index, Getty Information Institute)
 Myron Laskin 1984–1989
 George Goldner 1990–1993
 David Jaffé 1994–present

Paintings Conservation
 Judith Meller 1972–1976
 Carol Mancusi-Ungaro 1976–1977
 David Bull 1978–1980
 Andrea Rothe 1981–present

Paper Conservation
 Marc Harnly 1997–present

Personnel and Administrative Services
 Alison Sowden 1985–1990
 Kristin Kelly 1990–present

Photographs
 Weston Naef 1984–present

Photographic Archive (since 1983 part of Getty Research Institute)
 Laurie Fusco 1976–1978
 George Goldner 1979–1983

Photographic Services
 Donald Hull 1970–1986
 Charles Passela 1987–present

Plant

Robert Damm	1973–1974
Melvin Marant	1975–1980
Howard Sherman	1980–1996
Oren Gray	1996–present

Preparation

Fritz Frauchiger	1973–1974
Steven Poucher Colton	1974–1976
James Ford	1976–1979
Bruce Metro	1979–present

Public Information and Visitor Services

Deborah Ashin	1974–1979
Cathryn La Scola	1979–1981
Barbara Brink	1981–1983
Jean Keefe Parry	1983–1985
Lori Starr	1986–1995
(since 1995 Director, Public Affairs, J. Paul Getty Trust)	
Sue Runyard	1996–present

Publications

Sandra Knudsen Morgan	1978–1986
Christopher Hudson	1986–present

Ranch Operations (to 1983)

Ralph Blackburn	1974–1983

Registration

Pamela Wiget	1973–1975
Sally Hibbard	1975–present

Sculpture and Works of Art

Peter Fusco	1984–present

Security (since 1993 administered by J. Paul Getty Trust)

Robert Williams	1973–1974
Andrew Blakley	1974–1985
Wilbur Faulk	1985–1993
(since 1993 Director of Security, J. Paul Getty Trust)	
Stanley Friedman	1994
Michael Moore	1995–present

Transition

Quincy Houghton	1994–present

Index

Photo Credits

page i: Tom Bonner

pages ii–iii: Julius Shulman

pages iv–v: Julius Shulman

pages vi–vii: Julius Shulman

pages viii–ix: Warren Aerial Photography

pages x–xi: Tom Bonner

pages xii–xiii: Tom Bonner

pages xiv–xv: Tom Bonner

pages xvi: Tom Bonner

page 9: Tom Bonner

page 14: Photo courtesy Eileen Vogler

page 18: *Art News,* February, 1974, cover

page 19: *Time*, February 24, 1958, cover. © 1958 Time Inc. Reprinted by permission

page 38: Bettman Archive and Newsphotos

page 40: Julius Shulman

page 45: Ikona/Luciano Pedicini/Archiio dell'Arte, Naples

page 47: Norman Neuerburg

page 56: Julius Shulman

page 58: Julius Shulman

page 59: Julius Shulman

page 60: Julius Shulman

page 61: Julius Shulman

page 80: Tom Bonner

page 83: Joe Deal

page 84: upper right: © Scott Frances/Esto; all others © Ezra Stoller/Esto

page 85: By permission of the Trustees of Dulwich Picture Gallery

page 89: Warren Aerial Photography

page 90: Warren Aerial Photography

page 91: Vladimir Lange

page 92: Tom Bonner

page 93: Drawings by Elisabeth Le Roy Ladurie, reprinted from Bruno Pons, *French Period Rooms*, Editions Faton et Bruno Pons, Dijon, 1995

page 94: Tom Bonner

page 97: Tom Bonner

DATE DUE